TECHNIQUES OF THE
WORLD'S GREAT PAINTERS

TECHNIQUES OF THE
WORLD'S GREAT PAINTERS

Consultant Editor
WALDEMAR JANUSZCZAK

GREENWICH
EDITIONS

A QUANTUM BOOK

This edition printed in 2004 by
GREENWICH EDITIONS
The Chrysalis Building
Bramley Road, London W10 6SP

An imprint of Chrysalis Books Group plc

ISBN 0-86288-742-9

QUMTGP

This book was produced by
Quantum Books Ltd
6 Blundell Street
London N7 9BH

Printed in Singapore by
Star Standard Industries

Quarto would like to give special thanks to the photographers taking the details of the paintings: Mike Fear (in London galleries), the family of the late Tom Scott (in Edinburgh), Claude O'Sughrue (in Montpellier), Hans Hinz (in Bern), Otto Nelson (in New York). Thanks also go to all the art galleries, public collections and private collectors who have contributed to the book, particularly to the staff of the National Gallery, London, Tate Gallery, London, and Museum of Modern Art, New York for their kind help and enduring patience.

Contents

Introduction 6

Giotto 10
The Nativity (Arena Chapel, Padua)

Duccio de Buoninsegna 14
The Virgin and Child with Saints Dominic and Aurea

Jan van Eyck 18
The Arnolfini Marriage

Piero della Francesca 22
The Baptism of Christ

Leonardo da Vinci 26
The Virgin of the Rocks

Hieronymous Bosch 30
The Carrying of the Cross

Titian 34
The Death of Acteon

Nicholas Hilliard 38
A Youth leaning against a Tree Among Roses

Caravaggio 40
The Supper at Emmaus

El Greco 44
Christ driving the Traders from the Temple

Diego Velazquez 48
The Water Seller of Seville

Peter Paul Rubens 52
Portrait of Susanna Lunden, née Fourment

Rembrandt van Rijn 56
The Feast of Belshazzar: The Writing on the Wall

Jan Vermeer 60
The Guitar Player

Antoine Watteau 64
Fêtes Vénitiennes

Joshua Reynolds 66
Mrs Hartley as a Nymph with Young Bacchus

Thomas Gainsborough 70
Portrait of the Artist's Wife

William Blake 74
The Body of Abel found by Adam and Eve

John Constable 76
Chain Pier, Brighton

Auguste-Dominique Ingres 80
Oedipus and the Sphinx

Eugène Delacroix 82
Taking of Constantinople by the Crusaders

William Turner 84
Snow Storm

Jean Millet 88
Walk to Work

William Holman Hunt 92
The Awakening Conscience

Gustave Courbet 94
The Meeting (Good Day Monsieur Courbet)

Edouard Manet 98
The Picnic

Claude Monet 102
Autumn at Argenteuil

Pierre Auguste Renoir 106
Woman's Torso in Sunlight

Edgar Degas 110
After the Bath, Woman Drying Herself

Georges Seurat 114
Bathers, Asnières

Vincent van Gogh 118
Chair with Pipe

Edward Munch 122
Jealousy

Paul Cézanne 124
Still Life with Plaster Cast

Paul Gauguin 128
Christmas Night or The Blessing of the Oxen

Henri Matisse 132
Portrait of André Derain

Pablo Picasso 136
Still Life with Chair Caning

Wassily Kandinsky 140
With Black Arch

Pierre Bonnard 142
Interior at Antibes

Fernand Léger 146
Still Life with Beer Mug

Edward Hopper 150
House by the Railroad

Salvador Dali 152
The Persistence of Memory

Paul Klee 154
Ad Parnassum

Piet Mondrian 158
Composition with Red, Yellow and Blue

Max Ernst 160
Vox Angelica

Jackson Pollock 164
Autumn Rhythm

Jasper Johns 168
Flag

Frank Stella 172
Getty Tomb (II)

Richard Hamilton 174
Towards a definitive statement...

Roy Lichtenstein 178
Whaam!

David Hockney 182
Mr and Mrs Clark and Percy

Glossary 186

Index 189

Acknowledgements 192

Editor's note

This book contains 50 chapters, each of which deals
in detail with one work by each of 50 great painters.
Each chapter contains

1.
Textual introduction to the work and technique of
the artist.

2.
Reproduction of the whole picture under discussion.

3.
Step-by-step outline of the painting process. It has
obviously not been possible to say in detail how each
artist *actually* painted the work. These outlines,
however, give a clear and simple guide to the
probable main stages in the painting process.

4.
Actual size detail from the work under discussion.
This feature gives a clear indication of the scale
of the work.

5.
Other details relevant to the artist's technique,
together with a key showing the exact part of
the picture being shown.

6.
Exact dimensions and other technical details of
the painting.

Introduction

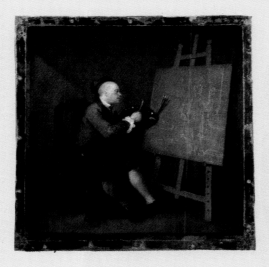

*T*he history of painting techniques is as realistic and accurate a guide to the development of Western art as any aesthetic assessment or biographical essay. Indeed, technical considerations perhaps provide more crucial insights into the history of art than a bookcase crammed with artistic biographies. For instance, the reason artists had been painting landscapes for 500 years without becoming Impressionists lies not so much in subject matter, or even in aspiration, but in technique.

Major developments in technique have tended to go hand in hand with innovations in the materials available to the artist. Jan van Eyck may not have been the inventor of oil paints, as has traditionally been supposed, but he was the first great master of the medium — a medium without which it would have been impossible to produce the smooth, glassy surfaces and the brilliant illusionism of his Arnolfini marriage portrait. Before van Eyck, artists working in fresco or in tempera did not have the means at their disposal to achieve the dazzling *trompe l'oeil* effects which he attempted.

Van Eyck's Arnolfini portrait is the first great demonstration of the reasons why oil paints were to become the Western artist's favourite medium, unchallenged in popularity until the arrival of synthetic polymers in the last 30 years or so. Although the very slow drying time might have appeared the medium's major disadvantage, this in fact proved a crucial aid to the painter. X-rays reveal that van Eyck was able to make changes in his composition during the painting process while the fresco painter could never allow himself this essential freedom, and those who worked in tempera found that their colours did not have the necessary covering power.

The new medium gave rise to a quest for increased naturalness which preoccupied artists in the fifteenth and sixteenth centuries and which found a perfect champion in Leonardo da Vinci. This quest could best be conducted with paint which dried to a shell-like hardness, but which, as the Venetians discovered, could also soak up and reflect real light, as did the sea ringing the city in which they worked.

The high humidity of Venice made fresco painting difficult, but the flexibility of oils and the replacement of wooden panels by canvas meant that the work could be done in the studio, rolled up and finally installed in its proper location. Working in the studio ensured not only that the lighting could be controlled, but also that models could be used to increase a previously limited catalogue of poses and to provide the gods and heroes painted in Venice with accurate human anatomies.

However, it was not until Titian in his old age began to deal in more reflective moods that oil paints gained a measure of independence from the task of imitating the visible world. The freedom of the brushwork in Titian's late paintings revealed the medium's hitherto unleashed powers of expression. For the first time, individual

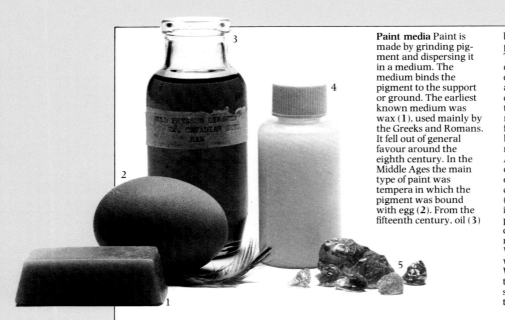

Paint media Paint is made by grinding pigment and dispersing it in a medium. The medium binds the pigment to the support or ground. The earliest known medium was wax (1), used mainly by the Greeks and Romans. It fell out of general favour around the eighth century. In the Middle Ages the main type of paint was tempera in which the pigment was bound with egg (2). From the fifteenth century, oil (3) became increasingly popular as a medium. The slow drying time, despite the addition of drying agents, was both an advantage and a disadvantage. Corrections were easier to make than with the faster drying tempera, but the painting could not proceed so quickly. As a medium, oil has dominated painting ever since. During this century acrylic medium (4) made from polymerized resin has become popular thanks to its quick drying time, resilience and flexibility. Watercolour is bound with gum arabic (5). When mixed with water, the paint can be applied smoothly and it adheres to the surface when dry.

brushstrokes were allowed to show through and disturb the illusions.

Rubens and Rembrandt took the next steps. While Caravaggio's dramatic studio light effects had already put light and shadow through their expressive paces, Rembrandt was the first painter who took a highly sensuous pleasure in oil paints. The biographer Houbraken wrote that one could take a late Rembrandt portrait by the nose, so thickly were the colours applied. Looking at a detail of Rembrandt's treatment of drapery, it becomes possible to trace a line of descent from these swiftly modelled brushmarks through van Gogh to Jackson Pollock.

Rembrandt's revolutionary late style was the result of practical as well as aesthetic considerations. While some of their contemporaries accused Rembrandt and Titian of leaving their pictures unfinished, these artists persisted in trying to find ways of speeding up the painting process. Other painters also found ways of avoiding the laborious processes involved in producing a picture. Rubens and the English portraitists, for example, relied on increasingly specialized contributions from studio hands. Gainsborough's feathery touch dwelt on faces and hands, but seems to have hardly ever settled on the rest of the canvas while Constable skimmed over the surface and hunted for elusive atmospheric conditions. But it was the Impressionists who set themselves the sternest task of all when they attempted to find a technique with which to capture a mere instant in time.

The apparently loose system of dabs and dashes employed by Monet and Renoir to preserve the spontaneity of an autumn moment at Argenteuil, or to capture the dazzle of sunlight on a woman's torso, involved the spectator more directly than ever before. Colours laid down separately, side by side, mixed not on the canvas but in the spectator's eye. Rather than a solid carefully built-up surface, the eye perceives a mosaic of fragmented brushstrokes which only form a vibrant whole from a distance. Other artists had intuitively achieved similar effects in details, but the whole of Impressionist painting chases after an elusive moment, aided only by a scholarly colour theory and the sudden rush of scientific activity which left the nineteenth century artists rich in new pigments. No matter how energetically the spectators squinted, they could no longer pretend to be looking through an open window. The colours, squeezed liberally from a tube, seem to have settled on the surface of the canvas as impermanently as snow flakes.

The Post-Impressionists subsequently felt the need to challenge this impermanence, but, nevertheless, the methodical working up of a picture in layers had been irrevocably

challenged and replaced by a system of work that focused evenly across the canvas. As Cézanne said, the painter could now treat the entire work all at once and as a whole. The gates were open for an idea to reach the surface of the canvas without undue delay.

Seurat turned a spontaneous Impressionist technique into a system by purifying the colours still further and reducing the dabs to dots. Van Gogh was more concerned with the expressive brushstrokes with which the Impressionists had begun to apply their colours; Gauguin noticed that, just as these brushstrokes no longer modelled themselves on visible forms, so colours were endowed with their own expressive values and need not mirror those outside the canvas.

However, these technical innovations were concurrent with, and, to a great extent, dependent on developments in artists' materials. The general availability of ready-made canvases and mass-produced brushes, and the dramatic expansion of the artist's palette in the nineteenth century had a far more profound effect on the course of Western art than the career of any one artist. It is easy to go painting out of doors when all you have to do is pack a bag with canvas and tubes of paint; it is quite a different matter if the canvas first has to be measured, stretched and primed, the colours mixed and then stored in unreliable containers.

In this century, it is debatable whether, had synthetic household paints not been developed, Jackson Pollock could have found a paint which flowed so freely from the can that it responded to his every instinctive movement, and dried quickly and effectively into puddles and dripped lines. Similarly it is unlikely that if David Hockney had not had acrylics at his disposal, Mr and Mrs Ossie Clark could have been treated to such a cool, modern interior, so unlike the cluttered home shared by the Arnolfinis.

One half of *Techniques of the World's Great Painters* deals in detail with the frantic activity on the surface of the canvas which characterizes the art of the nineteenth and twentieth centuries. The other looks in depth at the artists who paved the way for the Impressionist breakthrough. In the artistic deluge which followed, when the canvas was recognized as a self-sufficient object, then abstraction became possible. Picasso introduced foreign elements such as pieces of newspaper and chair caning onto the surface; Max Ernst invented new techniques such as frottage, which allowed chance to play a major part in the appearance of the image. Technique increasingly became not only a painter's language, but also his subject matter, a process which found its ultimate expression in the drip paintings of Jackson Pollock. The actual production of pictures — the subject of this book — had become as important as the final product.

Waldemar Januszczak

Giotto

(born 1267, died 1337, artist of the Florentine School)
The Nativity
painted 1302–5, fresco Arena Chapel, Padua

Giotto, regarded by many as the founder of modern painting, was a major exponent of fresco, a technique of wall painting known in classical antiquity and revived in the thirteenth century in Rome, where Giotto worked as a young artist. In scale and scope, wall painting was the most important art form in fourteenth century Italy. Giotto's paintings in the Arena Chapel in Padua are among the most perfectly preserved examples of fresco. *Buon fresco* or true fresco, is brush painting on freshly applied, wet lime plaster, using water as the vehicle so that the substance of the paint penetrates the plaster, and, as the plaster dries, the pigment is bound into the crystalline structure. A second main type of fresco is *secco fresco* in which pigment is applied to dry plaster using an organic medium such as egg or size which acts as both vehicle and binder. The *secco* technique had to be used with certain pigments, such as azurite and malachite. *Secco fresco* may be less permanent than *buon fresco* because the paint only forms a crust on the smooth plaster and tends to flake off. Giotto used both techniques for the Arena Chapel.

Fresco was an orderly, methodical process involving the application of several layers of plaster and one of paint. The first preparatory layer, the *arriccio*, made of coarse lime and sand plaster, is applied to the bare masonry. The drawing called the *sinopia*, is made on this. Next, a smooth layer, the *intonaco*, is applied. The paint is laid on this plaster while it is still wet. This meant that only that area of plaster which could be painted over in one day was laid down. For this reason, this stage was termed the *giornata*, from *giorno* meaning day. To avoid splattering and damaging subsequent sections, work proceeded from the top left-hand corner, across and downwards.

It is likely that, for a design as complicated yet unified as the Arena Chapel, some preparatory drawings were done. The technique makes design changes and extensive alterations difficult – for an extensive change, whole sections of plaster had to be lifted out. Minor alterations would have been executed in *secco fresco*. Because the painting had to be completed while the plaster was still wet, the fresco painter needed a well-trained, rapid and resolute hand. These complexities gave fresco its prestige.

1. The bare masonry was first covered in a coarse, thick layer of lime and sand plaster, called the *arriccio*.

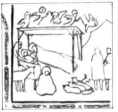

2. The composition may then have been drawn in on the plaster. This stage is called the *sinopia* because of the red earth pigment, sinoper, which was used generally mixed with ochre.

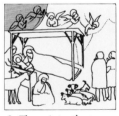

3. The painter then applied as much smooth plaster, the *intonaco*, as he could paint in one day and rapidly redrew the outlines. The normal painting process began at the top left-hand corner.

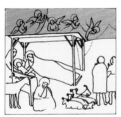

4. On day two, angels and the top of the mountain were painted. The artist worked systematically across the wall and downwards. The sky was added later in *secco fresco* after the *intonaco* had dried.

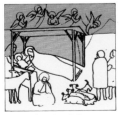

5. On the third day, the large, but relatively uncomplicated area of the stable and background was executed.

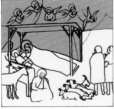

6. Day four was devoted to painting the Virgin's head.

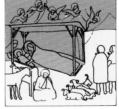

7. On day five the figure of the Virgin was worked on. The figure was underdrawn in *buon fresco*, and the blue robe then painted in *secco fresco* which did not follow the contours of the underpainting.

8. On day six the ox and ass were painted.

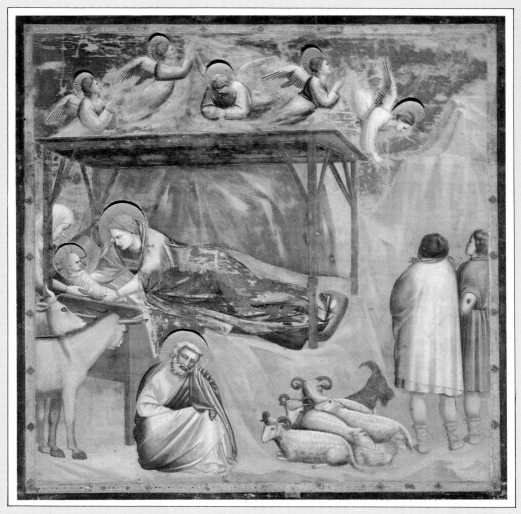

The adjustment made to the upper contour of the reclining Virgin's body is clearly visible. The final form, painted using *secco fresco* is visibly lower than was intended when the layer of plaster was applied and the under-drawing painted in. The red undermodelling is also visible on the figure of the Virgin where the blue paint has flaked off.

Around 1390, Cennino Cennini wrote the earliest known Italian treatise on painting techniques. It is a valuable source of information on both fresco and tempera techniques.

9. On day seven the figure of Saint Joseph was painted. His blue tunic was executed in *secco fresco*.

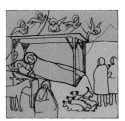

10. On day eight the sheep were painted, followed by the shepherds on day nine.

In fresco painting, the work was divided into daily sections, the *giornate*. This was because the paint had to be applied to the *intonaco* layer while it was still wet. The edges of each day's section were undercut to help dovetail the joins. The daily stages in *The Nativity* are shown (right).

Day 1 | 4 | 7 | 5 | 3 | 2 | 8 | 9
| 6

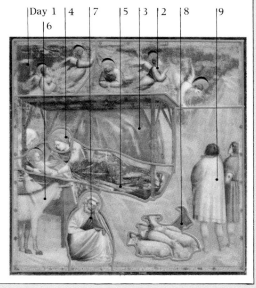

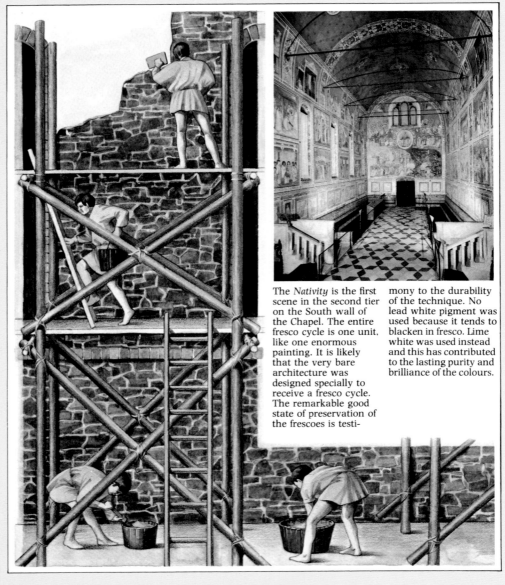

The *Nativity* is the first scene in the second tier on the South wall of the Chapel. The entire fresco cycle is one unit, like one enormous painting. It is likely that the very bare architecture was designed specially to receive a fresco cycle. The remarkable good state of preservation of the frescoes is testi- mony to the durability of the technique. No lead white pigment was used because it tends to blacken in fresco. Lime white was used instead and this has contributed to the lasting purity and brilliance of the colours.

The paint in these details (**right, far right**) from the *Flight into Egypt* section of the Arena Chapel fresco sequence was applied using *secco fresco*. Cennini's instructions stipulate: 'If the blue is good and deep in colour, put into it a little size . . . likewise put an egg yolk into the blue; and if the blue is pale, the yolk should come from one of these country eggs for they are quite red. Mix it up well. Apply three or four coats to the drapery with a soft bristle brush.' Paint applied in this way forms a thin crust over the dry plaster

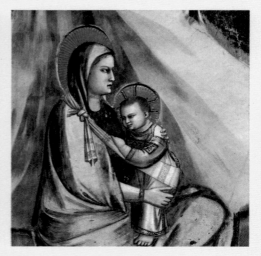

and is prone to flaking off. Where this has occurred here the red undermodelling is clearly visible.
The white pigment which Giotto would have used was lime white. However, some problems have occurred, for example in the *Flight into Egypt* some of the blue pigment azurite has flaked off. It had been applied using *secco fresco*.

In fresco, colours are premixed and applied in a direct manner; strokes cannot be altered by overpainting, and effects of colour gradation are achieved by hatching or placing separate strokes side by side. A methodical system using a sequence of five measured tones for each individual pigment was evolved to describe form and volume. Cennini described it and frequently warned the artist never to abandon 'the sequence of colours by yielding or invading the location of one colour for another.' Cennini also advised the artist to used glazed goblets with 'a good heavy base . . . so as not to spill the colours,' and to use a combination of pointed minever and bristle brushes, either broad flat brushes or fine bristles, which would have been fitted into a quill.

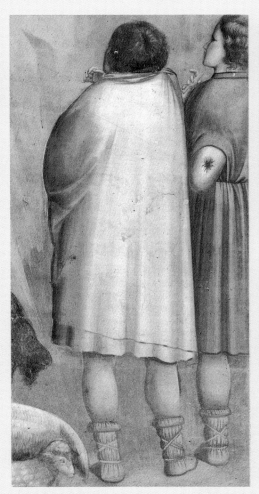

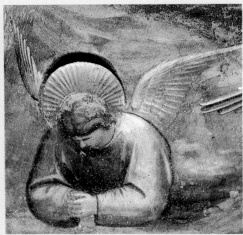

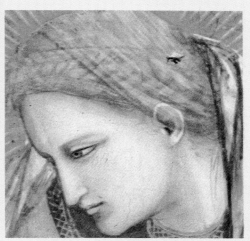

The haloes of the Angels were modelled in thick plaster, like 'ointment or dough', as Cennini put it. The radiating beams were indented with a wooden slice. They attempt to convey an effect of perspective.

The flesh areas on the figures were under-drawn in brown — a mixture of yellow ochre, red earth, lime white and black. They were then painted over in green earth to emphasize the shadows. The modelling was painted in tones of red and white. To differentiate between old and young, less white was used in the flesh and more in the hair of the older figures.

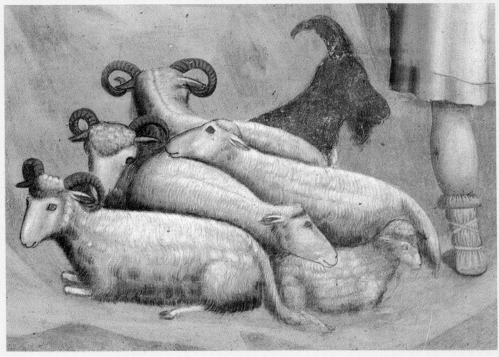

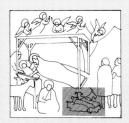

When the paint for the sheep had been applied to the wet plaster, the artist had, as always, no opportunity to work it. Brushstrokes were applied side by side. They were blended by hatching with the point of a brush.

Duccio de Buoninsegna

(active 1278–1319, artist of the Sienese School)
The Virgin and Child with Saints Dominic and Aurea
painted c.1300, egg tempera on wood, central panel $24\frac{1}{8} \times 15\frac{3}{8}$in
$(62 \times 38$cm); wings $17\frac{3}{4} \times 8\frac{1}{8}$in $(44 \times 20$cm), $17\frac{3}{4} \times 7$in $(44 \times 17 \cdot 5$cm)

This tabernacle by Duccio was painted in egg tempera. After walls and parchment, wood was the most important support for medieval painting. It was readily available, easy to cut and carve, and the final object was as substantial as the metalwork, sculpture, or even architecture which it was sometimes intended to imitate.

The uneven surface of the wood was first covered by preparatory layers of gesso, which is made of gypsum mixed to a thick paste with animal glue. The gesso was applied with a slice and then with a brush all over the wooden structure, beginning with the rougher *gesso grosso*, and finishing with the smooth *gesso sottile*. To ensure that the gesso adhered well, the wood was sized and sometimes strips of linen applied to cover any knots or joints. When it was finished, the ground was brilliantly white, rather thick and polished to an ivory-like smoothness. These qualities were important for the final effect of the painting.

A careful drawing was executed on this ground, first in charcoal and then in black paint. The main outlines were incised into the gesso. Design changes were difficult after this.

The gilded areas were prepared with several coats of red bole. It provided a slightly elastic underlayer for the subsequent burnishing and decoration of the gold and its colour gave the gold a rich, warm tone. The gold leaf was made to adhere with egg white and burnished until it was 'dark from its own brilliance'.

Painting, beginning with drapery and then flesh, was the final stage in this orderly sequence. The pigments were ground with water on a porphyry slab and the egg yolk was added as they were used. Each colour was treated individually, and mixtures, except for white, were generally avoided. In modelling the form, a series of pre-mixed tones, ranging from dark to light for each pigment, was used in strict sequence.

The painter kept methodically to the tonal sequence and worked with small, hatching brushstrokes which followed the form being described. The rapid drying of tempera paint was an advantage because one stroke could be painted over the next almost immediately. However, this meant that the artist had to rely on the network of brushstrokes to achieve blended tonal transitions and it was difficult for the artist or his assistants to make adjustments at any stage in the procedure. Thus tempera painting needed discipline and method.

1. Painters and carpenters were organized in different guilds. A carpenter would have completed the bare wooden structure to order and delivered it to Duccio's shop.

2. Faults in the wood were corrected and often a layer of linen was put over the entire structure. This was then covered with up to eight coats of gesso.

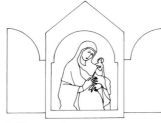

3. The gesso layer was scraped and polished smooth, and the design then defined in paint. Contours and major drapery folds were incised with a metal point.

4. Up to six coats of red bole bound with egg white were brushed on and gold applied leaf by leaf. The gold was burnished and designs inscribed or punched onto it.

5. Drapery painting was completed before flesh painting began. All flesh areas were underpainted in one or two coats of green earth and lead white. The green earth was intended to be left uncovered in the shadows.

6. The flesh colours were finally painted in and details reinforced in black and sinoper. Gold lines were applied on top of the drapery by adhering scraps of gold to a sticky oil mordant.

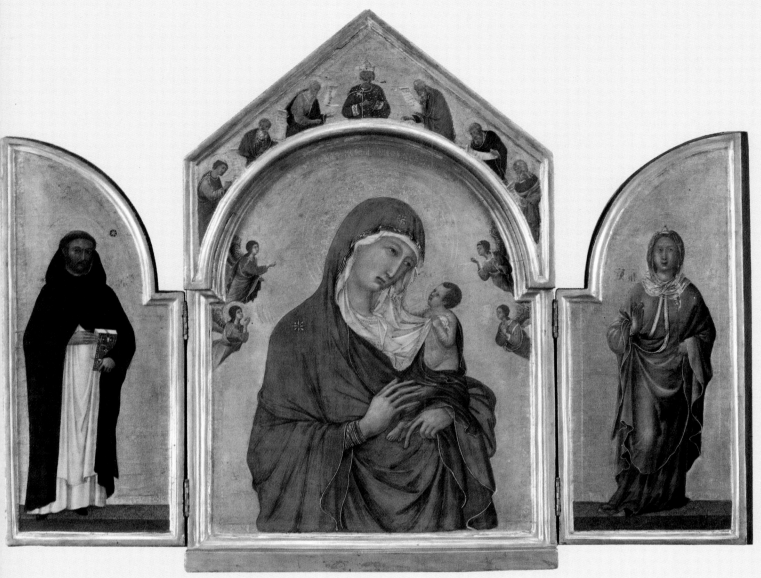

Tabernacles were painted and decorated inside and out. The shutters protected the image when it was not being venerated. The close similarity between this tabernacle and another by Duccio indicates a degree of mass production by carpenters for painters. Not all paintings were commissioned, and it is likely that a workshop would have kept some panels in stock.

Painting of this period can only be understood if it is realized that 'Duccio' was also a trademark. A master coordinated a workshop with apprentices and assistants, and a painting was a collaboration involving the distribution of work during all stages of production, even on small paintings. In tempera painting, the complex combination of different materials — wood, gesso, gold, and pigments bound by egg yolk — required a particularly orderly and methodical technique. This remained little changed by several generations of artists. Writing around 1437,

Cennini described with pride the technique as it had been handed down from master to pupil since Giotto. The technique of painting in tempera was founded on an intimate understanding of the individual properties of the materials used.

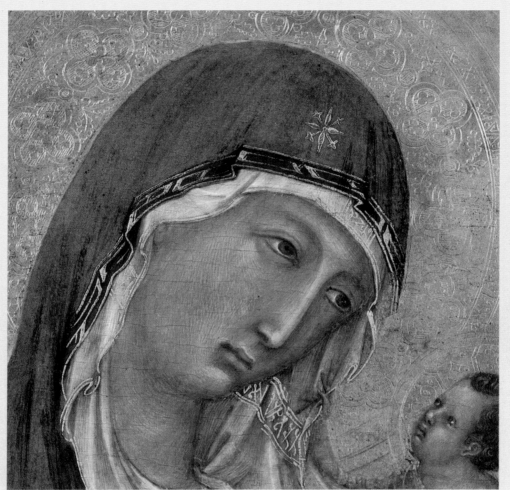

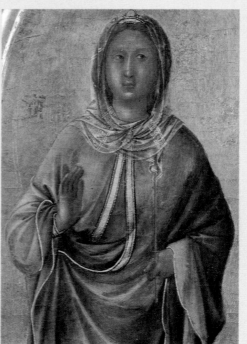

The outer circles of the Virgin's halo were drawn using a compass. The decorative areas within the circles were executed using a single horseshoe-shaped punch, freehand drawing, and using a point for the hatched areas.

Ultramarine, obtained from the semi-precious stone lapis lazuli, was used for the Virgin's robe. This was the most expensive pigment available and, in order to show off its quality, the amount of white used in the under-modelling was limited.

Actual size detail
Egg tempera paint was applied in thin, flat layers and dried to a smooth enamel-like surface texture. Brushwork is not a feature of the technique but the small hatching strokes are typical and inevitable. They are anonymous rather than expressive of an individual personality. Three tones of flesh colour were often used but did not obscure the green earth under-painting. A lighter flesh tone followed by pure white was used for the highlights. Sinoper and black were used for the accents of the eyes, nose, and other details.

The glittering effect of the angels' wings was achieved by painting solidly over the gold background and then carefully scratching the dry paint away to expose the gold again. The fine web of lines over the drapery was achieved in the opposite way. When the painting was finished, a thick, sticky oil mordant was painted on top, and scraps of gold leaf were stuck on to it. When the mordant was completely dry, the excess gold leaf was brushed away.

Drapery painting followed a methodical sequence, using five pre-mixed tones which ranged from pure colour in the shadows to white in the highlights. The variations in tone and brushwork were calculated to create the effect of blended modelling. However, because egg tempera dries fast, the small pointed brushstrokes which always follow the form are clearly visible.

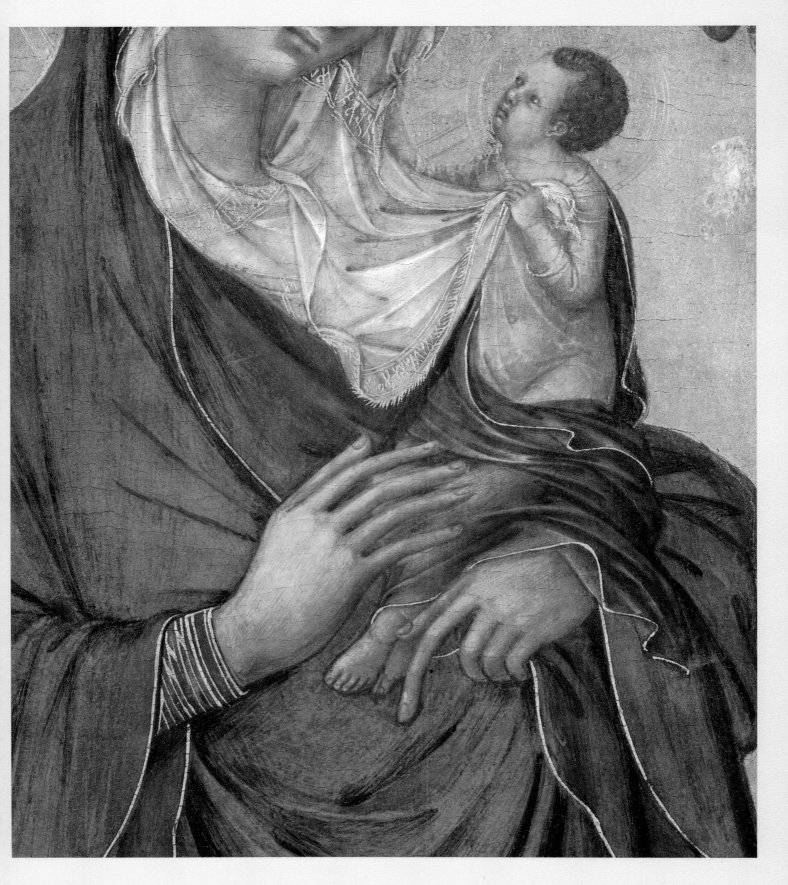

Jan van Eyck

(active from 1422, died 1441, founder of the Flemish School)
The Arnolfini Marriage
painted 1434, oil on oak, $33\frac{1}{5} \times 24\frac{1}{4}$in ($84 \cdot 5 \times 62 \cdot 5$cm)

Jan van Eyck did not 'invent' oil painting, although he is frequently credited with so doing, as a new type of painting did emerge around 1420. Oil painting on panel was first described by a German monk, Theophilus, in a treatise on medieval arts around 1100. The main limitation of oil was its slow drying time which, in Theophilus' view, was 'excessively long and tedious in the case of figures'. There followed three hundred years of experiment and improvement. A particular advance was the introduction of metallic drying catalysts in the late fourteenth century.

There is considerable technical consistency among early Netherlandish painters. They painted on oak panels, on white chalk grounds; the drawing was generally done on a preparatory layer which was then rendered impermeable by a preliminary coating of oil. As in Italian panel painting, the ground was bound with animal skin glue, which completely obscured the wood grain, and was polished smooth. The smoothness and whiteness of the ground, which provided a source of reflected light, plays a vital part in the final effect. Netherlandish artists used the same range of pigments as Italian artists painting with egg, but the oil gave the colours greater saturation, and increased the range of both transparency and opacity. Paint was prepared in individual workshops; pigments were ground in oil, usually linseed, on a stone slab and, when required, more oil was added to make a workable paint. It is not known whether a volatile diluent such as turpentine was used. A crucial factor in understanding the appearance of van Eyck's paintings is the optical effect of oil on the pigments and how the layered application of the paint exploited this. The painting proceeded from light to dark, from opaque to transparent. The paint is thinnest in the light areas and thickest in the shadows. It is still 'medieval' in that each colour area is treated individually and its boundaries respected; pigments are rarely mixed together and paint is applied in flat thin coats. This picture, the first full length double portrait in a naturalistic interior, is a fine example of van Eyck's technique. Van Eyck's superlative mastery of oil painting rapidly gave rise to the legend that he invented the process.

1. The painting was executed on a panel made of two pieces of oak with the grain running vertically. Oak has a close grain.

2. The animal skin glue and chalk ground was applied in a uniform layer, and polished smooth. It totally obscures the wood grain.

3. Van Eyck next began the underdrawing which was very detailed. It was painted on in an aqueous medium with a fine brush.

4. Van Eyck next made the ground non-absorbent by applying a film of drying oil.

5. Van Eyck's technique can be described in general terms. In the lower layers of the painting the colour areas were blocked in. The pigment was mixed with a limited amount of opaque white.

6. A middle tone was achieved in a second layer, which used less white and proportionately more coloured pigment.

7. The final description of form and volume was created in the upper layers using transparent pigments which, by their varying thicknesses, enhanced the modelling.

8. The back of the panel was covered by a thick white layer containing vegetable fibres which was covered by thin, black painted layer. This helps prevent the panel from warping. It is not known if this layer is original.

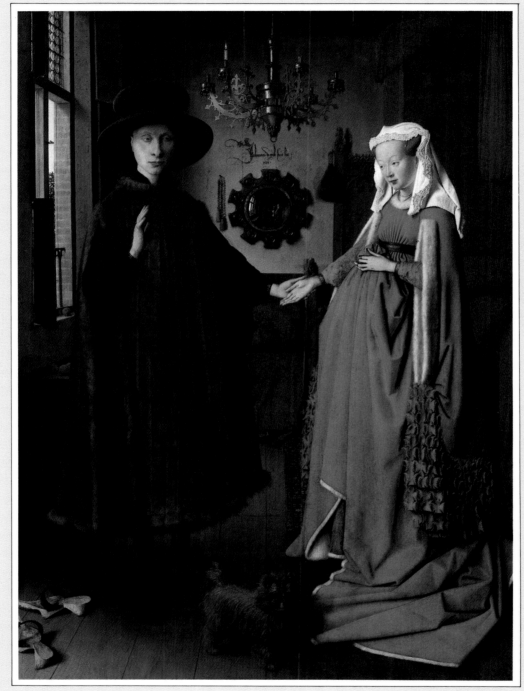

The principle of construction in this picture is to use the effects of light reflected back from a pale opaque base, through layers of paint, which increase in transparency and saturation and act as filters. The amount of opaque white pigment in the lower layers was lessened in successive applications, so that the upper layers might rely on transparent pigments to enhance the modelling and modulate the optical effects. The brilliance and transparency of these layers may have been increased by the addition of a little varnish to the paint.

In the red cushion the painting sequence was probably from an opaque vermilion and white through to a transparent red lake in the shadow area.

The modelling may have been achieved by applying first a pale opaque layer of malachite, a traditional green pigment, mixed with lead white, then malachite with less white followed by more saturated, transparent layers of malachite, perhaps mixed with some yellow. Final glazes of verdigris (copper resinate) may have been painted on. All the layers are superimposed.

The inscription, 'Jan Eyck fuit hic 1434' ('Jan Eyck was here 1434'), is juxtaposed with his picture in the mirror. However, the artist' presence is not emphasized. The paint surface is smooth and there are no traces of brushstrokes. Tonal transitions are blended imperceptibly. Every object is described in equally focused detail, as it is revealed by the light. Paintings in oil look more realistic than works in egg tempera. The drying process gave the artist time to study and invisibly adjust final effects. The optical properties of oil encouraged a more accurate reproduction of light, texture and colour.

Infra-red photography can be used to reveal some of the underdrawing or alterations in a painting. Here, adjustments to the position of the hand are clearly visible.

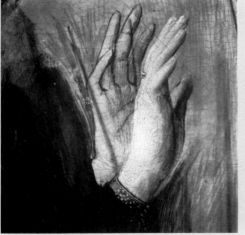

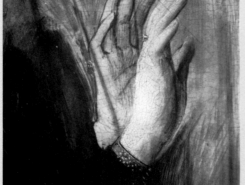

The flesh painting relies on the effect of the white ground shining through thin layers of pinks and browns. White pigment is used very sparingly and is mostly confined to the accented highlights.

Alterations in the position of the foot have become visible because oil increases in transparency as it ages.

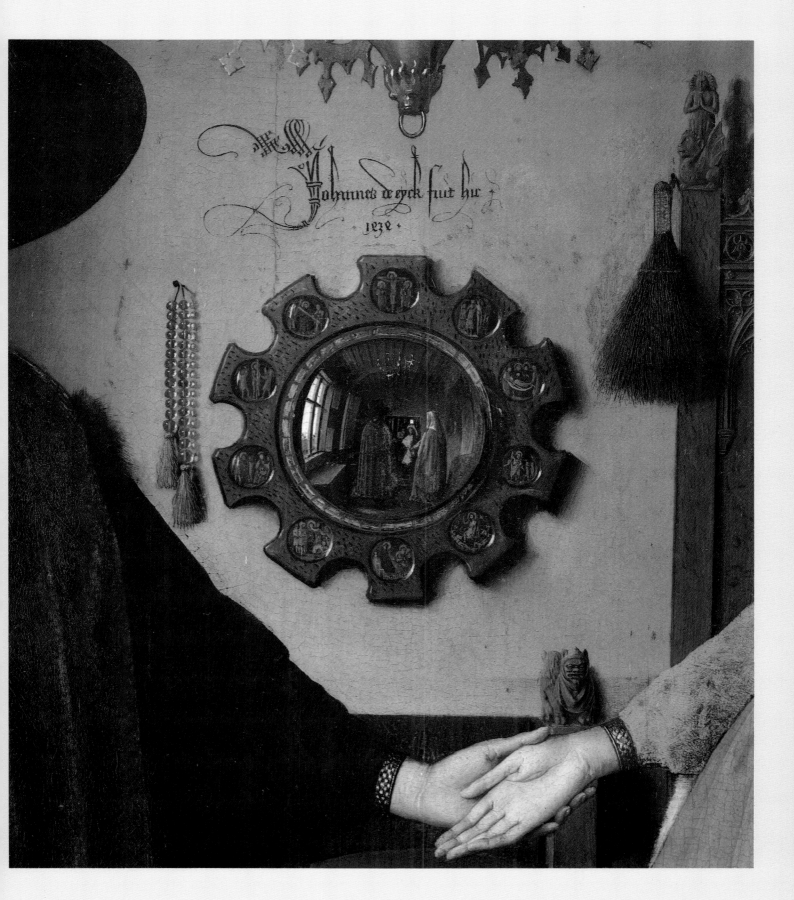

Piero della Francesca

(active from 1410/20–1492, artist of the Florentine School)
The Baptism of Christ
painted c.1442, egg tempera and oil on wood, 66 × 45¾in (167 × 116cm)

Piero della Francesca is now considered one of the most important painters of the fifteenth century Italian Renaissance, although his work was overlooked for a long time. Piero came from Borgo San Sepolcro – a small town in Umbria. *The Baptism* was thought to have been painted for a church in this town. Piero worked in Florence under the Venetian master Domenico Veneziano and Piero's early work shows in particular how he assimilated for example Florentine ideas on perspective and the organization of space.

Some of Piero's later paintings reflect a strong Flemish influence, most likely due to the presence of Flemish paintings and artists in Italy at the time. Although he lived until 1492, Piero appears to have stopped painting in the 1470s which was probably due to an overriding interest in perspective and mathematics on which he wrote two treatises.

The fifteenth century artists, Perugino and Signorelli, were probably both pupils of Piero's; and his influence was to be felt not only by them, but also by many other artists particularly in the areas in which he worked, for example Ferrara and Umbria. This reflects the important communication of ideas and techniques which obviously promoted the growth and development of Renaissance art.

Piero worked both in egg tempera, as in *The Baptism*, and in oil. He was working at the time when the emphasis in painting was shifting from tempera to oil. However, there is a growing body of evidence which indicates that this transition took place gradually rather than suddenly as was traditionally thought. Many artists at the time of Piero used both tempera and oil, even combining the two in one painting.

For this reason, it is generally dangerous to assume that all works in tempera by a particular artist must be from an early period and those executed in oil from a later one. Nevertheless, with further research and improving methods of scientific analysis, it may one day be possible to prove that Piero was as important and innovative an artist in fifteenth century Italian painting techniques as he was in other fields.

Piero's reputation languished for many years, and his work was only 'rediscovered' towards the end of the nineteenth century. *The Baptism* was bought by the National Gallery, London in 1860, at a time when Piero's works were beginning to attract more widespread attention in the art world.

1. Two poplar wood planks with vertical grain were covered with white gesso. A final coat of glue was perhaps added.

2. The underdrawing was done in black, simply defining the main outlines and features, which were drawn in with fine lines without hatching or shading.

3. The more complicated details were most likely transferred on to the gesso by 'pouncing', a technique popular at the time.

4. The pale blue sky was probably then added and the wreath blocked in without details. Drapery was completed but not decorated. The wings were blocked in without gold highlighting and the hair without details.

5. The flesh was completed allowing some of the green underpainting to show through. Leaves were put in the background and gold was added.

Pouncing
Pouncing was a technique used for transferring complicated details on to the painting surface. The lines of a drawing were punctured to create a series of small perforations. The paper was then laid over the gesso ground or, in fresco, over the plaster, and dusted with charcoal powder. This penetrated the holes leaving small dots on the ground from which the artist outlined the picture.

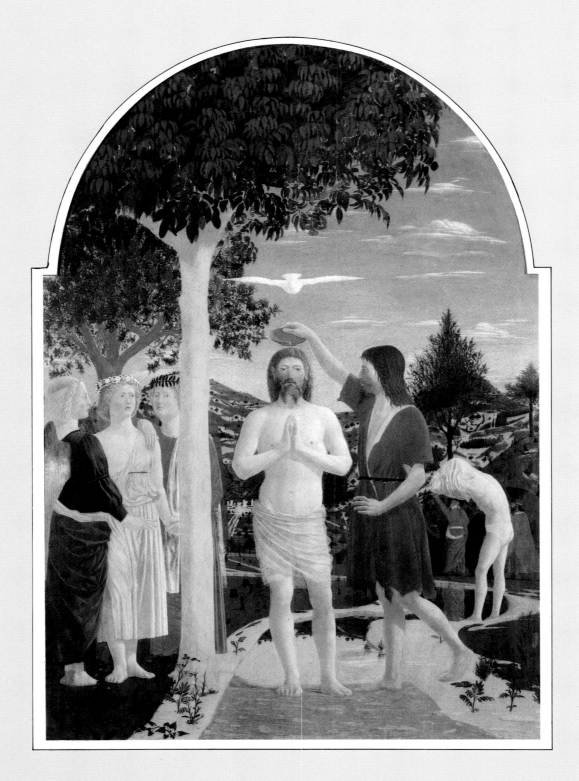

The Baptism is painted on a panel constructed of two wide poplar planks with a vertical grain. The panel has been prepared with a thick and unusually hard ground which suggests a high proportion of glue in the gesso. The preliminary drawing is simple; however, Piero probably made full-sized cartoons for some of the more complicated details, although none of these have survived. The pigments used are standard for the period. For example, the robe of the angel on the left was painted with ultramarine, the foliage is verdigris and the flesh areas have been underpainted in the traditional green earth. That a number of forms have been painted on top of one another indicates Piero's unusual tendency to complete forms even when they were to be later covered over.

The details of the landscape are painted over in a flat under-colour. The angel's robe and wing have been extended over the landscape which is now visible due to the increase in transparency of the paint with age. Small black dots from the pounced transfer can be seen along the folds of the red fabric. The drapery has been modelled with long, hatched, unblended strokes using a system whereby the pigment is at its purest and most saturated in the fabric folds. There is some gold decoration in the angels wings but this has been rubbed and unfor-tunately damaged. The green underpainting of the flesh is also now visible.

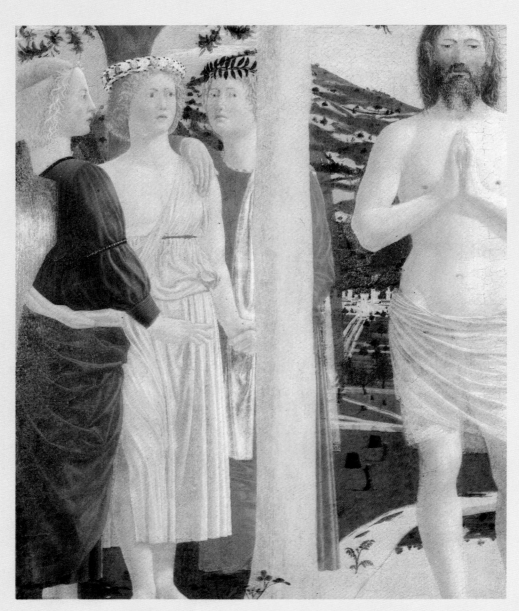

In the head of John the Baptist, the flesh is underpainted with the green earth of traditional Italian tempera painting and then completed with a natural flesh colour. The beard has been stippled over the completed flesh paint and sleeve.

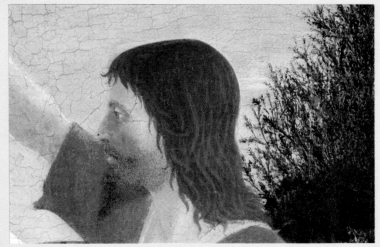

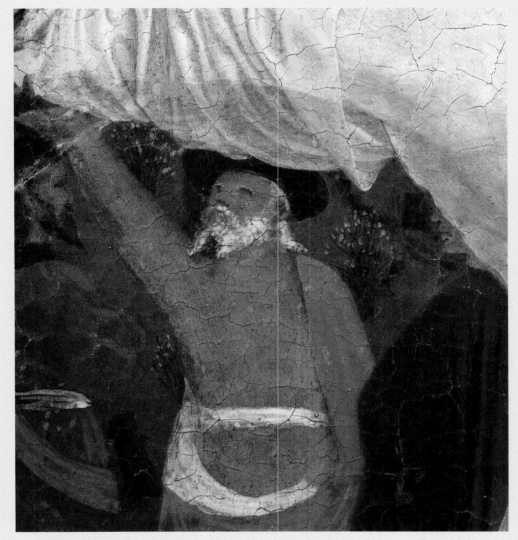

In the heads and shoulders of the two figures in the righthand background, the upper half of the figure on the left has been painted over the landscape. In these figures the paint was applied as a fairly flat wash with little hatched modelling.

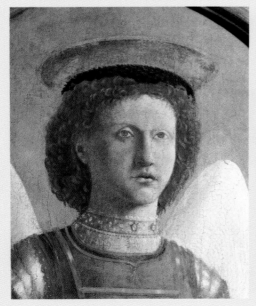

The paint medium for *St Michael* has been identified as walnut oil. The flesh has been underpainted with a brownish under-modelling, as opposed to the green earth of *The Baptism*, although a little green has been added to the upper layers of the flesh paint to give a slightly green tinge.

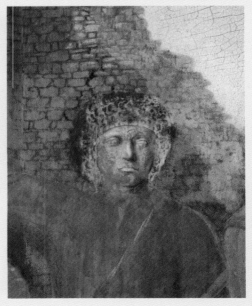

In *St Michael* the head of the shepherd has been badly damaged in the past probably by over-cleaning. so that now little more than the brown undermodelling is left. The firm. confident underdrawing outlining the main features is typical of Piero's technique.

Leonardo da Vinci

(born 1452, died 1519, Italian Renaissance artist)
The Virgin of the Rocks
painted c.1508, oil on wood, $74\frac{5}{8} \times 47\frac{1}{4}$in ($189 \cdot 5 \times 120$cm)

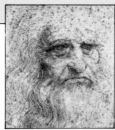

Leonardo da Vinci, one of the major figures of the Italian Renaissance, was born in 1452 and trained under the Florentine artist Verrocchio. Due to the understandable reluctance of art gallery curators to allow samples to be taken from their paintings by Leonardo, and the fact that his notebooks tend to be obscure and difficult to interpret, there is little information on the artist's techniques.

There are two versions of *The Virgin of the Rocks* – one in the National Gallery in London and the other in the Louvre in Paris. The National Gallery version is better documented and definitely came from the church of St Francesco Grande in Milan, for which it was commissioned in 1483. However, the picture has not always received the same critical acceptance as the Louvre version and it has been suggested there was a degree of studio participation. It is possible that, for some reason, the National Gallery picture was begun as a replacement for the earlier version towards the end of the century, but was never completed. Although the London version may have lost some of the immediate appeal and Florentine 'prettiness' of the Paris picture, it has gained a monumentality, depth of mood, and unity of light and colour not fully attained in the first version which the artist painted. The basic medium for *The Virgin of the Rocks* was almost certainly a drying oil as stipulated in the original contract for the work. Walnut and linseed oils are listed among the expenses for another of Leonardo's paintings and, judging from his notebooks, Leonardo was particularly concerned that his painting oils should be as clear and colourless as possible to which end he may have prepared them himself. Unfortunately, faults in the preparation of the colours may be partly responsible for the drying defects in the paint film now visible on some works, including *The Virgin of the Rocks*.

While Leonardo would have had access to most pigments of his day, he often seems to have used a muted palette with colour playing a secondary role to the modelling of forms and the organization of light and shade.

Although *The Virgin of the Rocks* has been fairly recently cleaned, many of Leonardo's other works are distorted by accumulated layers of dirt, varnish, and overpainting; and so the artist's techniques remain a mystery.

1. It is not possible to say exactly how Leonardo painted his works, however, a possible sequence can be worked out. First a panel would have been covered with a layer of gesso.

2. It seems that Leonardo may have first roughed in the figures on the panel.

3. The major forms may have been modelled in a brownish tone, defining shadows and highlights.

4. Leonardo used his fingers and palms as well as a brush, particularly for the undermodelling. This was not an unusual practice at the time.

5. Intricate details were then put in with great precision and delicacy using fine minever brushes, similar to modern day sable brushes.

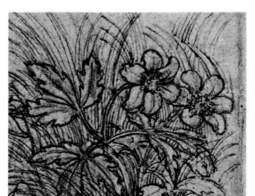

Leonardo's interest in botany was given expression in several media. There is a marked similarity between the flowers in this drawing and those in *The Virgin of the Rocks*. The detail was drawn in pen and ink over a background sketch in red chalk.

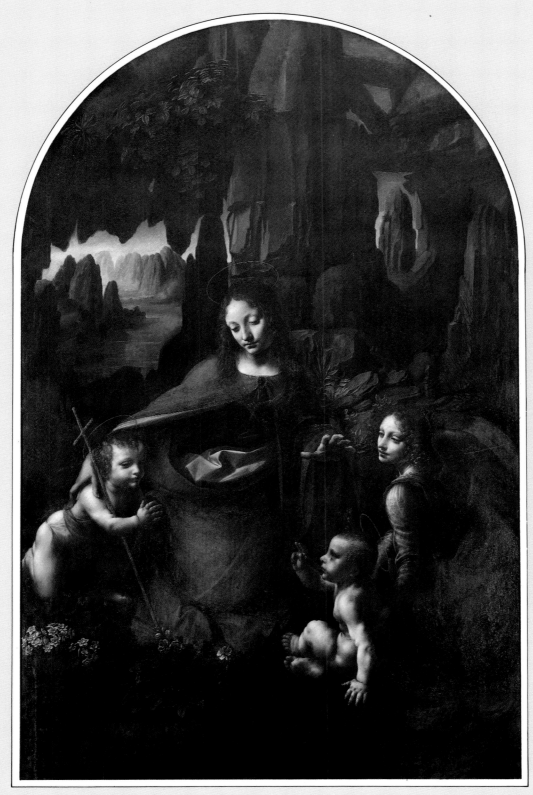

Leonardo's preoccupation with light and shade is illustrated by his use of a brownish monochrome under-modelling visible in some of the incomplete areas of the painting. While each painting involved a number of preliminary drawings and studies, it is unlikely that Leonardo did any detailed underdrawing on the panel itself. It is possible that some of the colours in the painting have altered with time: the green foliage may have darkened and become brown, the blue robes stained and dulled by dirt and varnishes. Changes may have occurred in the flesh colours accounting for its cold and marble-like appearance. It has been suggested that Leonardo finished or intended to finish the flesh areas with very thin glazes of lake pigments, the dyes of which may have since faded.

This unfinished work, *The Adoration of the Magi*, illustrates that Leonardo did his undermodelling mainly in brown, using several different tones.

This X-radiograph (**right**) shows that Christ's head was originally inclined more towards the spectator in a position similar to that of his counterpart in the Louvre. Both images can be seen because the white lead used in the flesh paint is opaque to X-rays, absorbing them and preventing them from reaching and blackening the film.

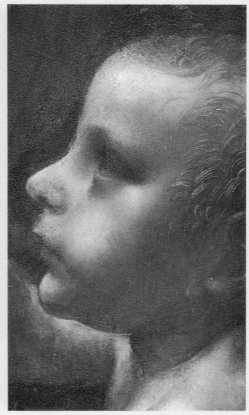

This detail from Leonardo's painting *Virgin and Child with Carnation* shows marked wrinkling of the paint surface on the Virgin's flesh. This is caused by poor technique – Leonardo seems to have added too much oil to the paint mixture.

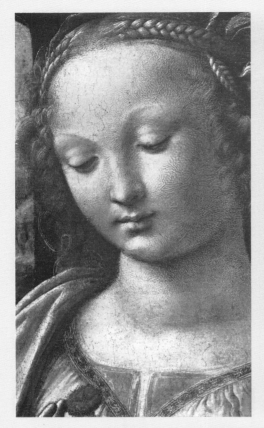

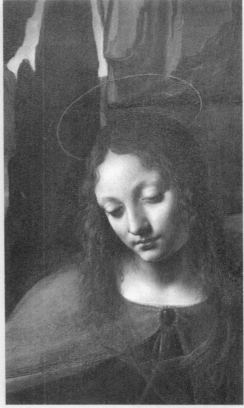

The Virgin's head was painted using the same technique for the flesh areas as in Christ's head. In the darker shadow areas, fingerprints are clearly visible. A cross section of the robe shows that it has a complicated layer structure. An initial layer of grey was painted over with azurite before the final layer of ultramarine was applied. The use of ultramarine was stipulated in Leonardo's contract for this work; this was common practice because of the expensiveness of the pigment. The yellow in the lining of the Virgin's robe is lead tin yellow. Cracks in the robe were probably caused by drying defects. It is not known whether the gold halo is original.

Actual size detail
This detail shows that the plants have probably been painted over the rocks. The delicate brushwork and detail in the depiction of the flowers reflect Leonardo's keen interest in and study of botany.

Hieronymous Bosch

(born 1450, died 1516, Netherlandish painter)

The Carrying of the Cross

painted c.1510–1516, oil on oak, 30 × 33in (76·7 × 83·5cm)

While contemporaries were fascinated by Bosch as 'an inventor of monsters and chimeras', they were also impressed by the originality of his technique. Karel van Mander, the first historian of Northern painting, wrote in 1604 that Bosch 'had established a very rapid, characteristic way of working, setting many of his things down at first, which nevertheless remained very beautiful without alteration. He also had, like other masters, the method of drawing and tracing out on the white of the panels and laying over this a flesh-coloured priming, and he often let the ground play a part too.

The techniques which Bosch employed in his paintings were both traditional and original. Most of his works were executed on panels covered with a thin chalk ground and an oil film laid over to reduce absorbency. However, an innovatory second chalk ground was applied which added brilliance to the paint. The underdrawing was done with a brush and thin black paint. Bosch was not concerned with an objective description of detail, light, or perspective, but an expression of form. His style was rapid, sketchy, linear and often limited to single broken lines that search out the main contours of shapes in the painting. Bosch's expressive, simplified style of drawing is matched by his painting technique. He generally applied only one thin coat of paint, and it is only in the cases of red and green glazes over opaque substrates that more layers have been found in this painting. This differs dramatically from the complicated, stratified construction of earlier Netherlandish paintings.

Bosch's use of white also illustrates his original technique. Firstly, white is used much more abundantly and to achieve colour effects in a single application rather than relying on the traditional method of repeated, transparent modulations of underpainting. This is linked to a diminished interest in surface textures and detail and an unusual choice of unsaturated colours. In addition, white is often used graphically and expressively in a mass of accented, loaded brushstrokes. The texture of these strokes marks the surface of the painting in a highly individualized way that contrasts with the smooth finishes of van Eyck and marks a departure in Northern painting. This is one of the major technical characteristics of Bosch's work.

1. The panel is composed of three planks of oak, the grain running vertically. The centre plank is narrower than the outer two.

2. The panel was sized and a thin chalk and animal glue ground applied which just covered the grain of the wood.

3. The ground was then covered by an insulating coat of drying oil.

4. A second, exceedingly thin layer of chalk and animal skin glue was then brushed on smoothly.

5. The underdrawing was sketched on the white ground using a fine brush and black pigment in an aqueous medium.

In contrast to those of his predecessors, many rapid pen sketches by Bosch have survived. It is not clear what role these played in the creation of the painting, and preliminary studies are difficult to find. The drawings are probably an independent form of expression, but in this case there are comparisons between the underdrawing of the judge and the sketch of the fantastic toad man (**above**).

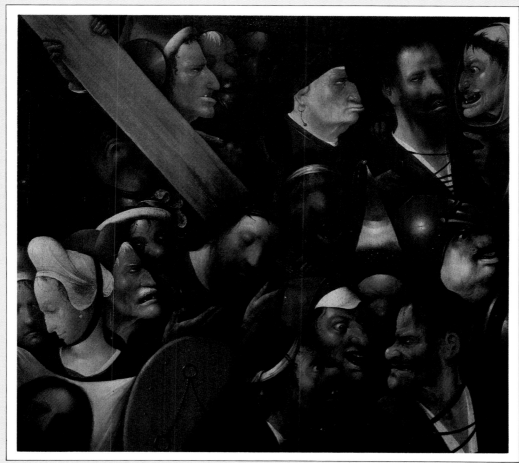

In this picture, the paint was still applied in thin flat layers in the traditional manner, but the visibility and expressive purpose of the brushwork, the detached white highlights and the simplification of the modelling were all innovatory.

There was very extensive underdrawing – usually single curving strokes without crosshatching which describe the main forms.

In places, the underdrawing has become visible to the naked eye. Despite the dexterity with which the underdrawing was done, it is unlikely to have been transferred from a cartoon.

There is a general tendency for the paint to exceed the lines of the drawing, but there are no major alterations.

Ochres and black

Lead tin yellow and lead white

Azurite and lead white

Vermilion and lead white

Underdrawing visible

Azurite and red lake with lead white

Copper resinate glaze over malachite and lead white

Bosch was not generally interested in textures with the exception of metals. Instead of using abbreviated strokes of white, the highlight is surrounded by a luminous halo. This is created by opaque white paint applied over the basic grey-brown and does not rely on the effect of the ground.

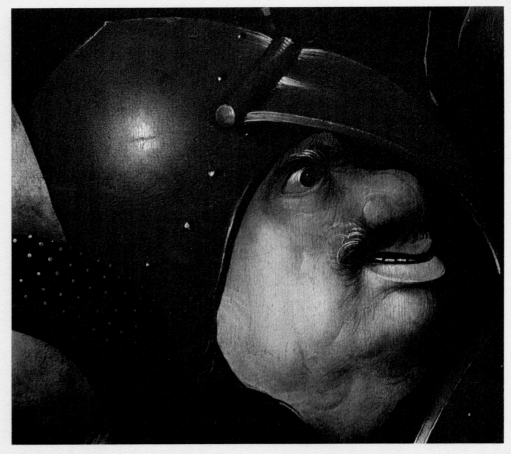

The technique of the flesh painting is traditional. Very little white pigment was used except in the accented highlights. The lights were obtained by relying on the effect of the whiteness of the ground to shine through the thinly applied transparent flesh tones. By contrast, the lead white was freely mixed with blue and yellow pigments for the headdress.

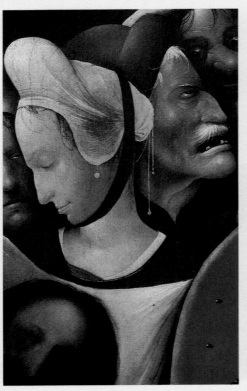

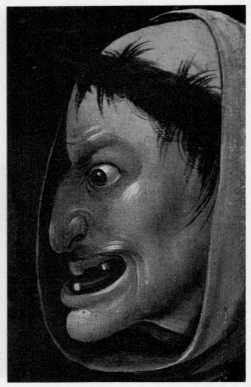

The painting of the face is a dramatic example of the use of expressionistic brushwork and highlights.

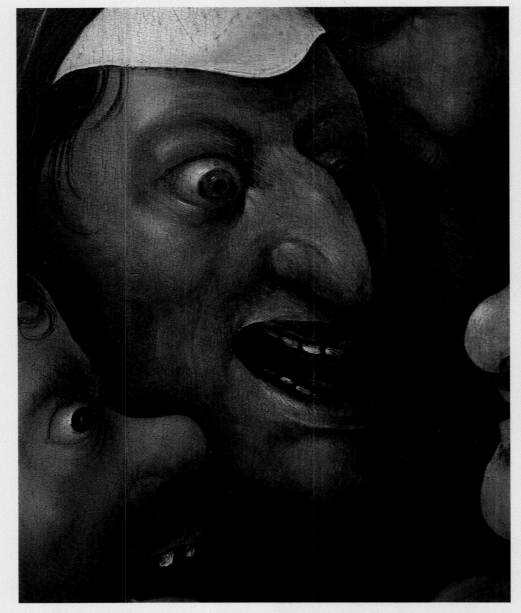

Actual size detail
Four paintings of
related religious themes
are known to have been
painted by Bosch but in
this final version, the
maelstrom of evil that
surges around the
impassive Christ and
Veronica reaches a
climax.
Bosch's direct and
simplified painting
technique is shown in
this actual size detail. It
was perfectly suited to
his intention of
impressing the spectator
with the immediacy
of the emotional impact
of the scene rather than
describing in detail a
tangible experience of
the objective world.
With great economy of
means and a free, rapid
handling of paint he
achieves a richness of
expression and a variety
of pictorial handwriting
that is entirely new in
Northern art.

The headdress and its
ribbons are entirely
described in terms of
drawing. There is no
illusionistic, blended,
tonal modelling.

Titian

(born 1487, died 1576, artist of the Venetian School)
The Death of Acteon
painted 1560s, oil on canvas, $70\frac{3}{8} \times 78$in (178×198cm)

The Death of Acteon is probably one of the last of a series that Titian painted for Philip II of Spain. They were referred to as 'poesie' by the artist and exemplify the freedom of subject matter and treatment which characterized Venetian art from the time of Giorgione, and formed the context in which Titian's own highly individual technique evolved. Vasari visited Venice in 1566 and, like other contemporaries, was struck by the phenomenal contrast between the delicate technique of Titian's early works, which invited close scrutiny, and the vigorous brushwork of the later ones, which had to be seen from a distance for maximum effect.

In Titian's work, the separation between the drawing and painting processes has entirely disappeared. X-radiographs show how the composition was worked directly in paint. The description of Titian's working method by one of his pupils, Palma Giovene, corroborates this: 'He laid in his pictures with a mass of colour, which served as the groundwork for what he wanted to express. I myself have seen such vigorous underpainting in plain red earth for the halftones or in white lead. With the same brush dipped in red, black or yellow, he worked up the light parts and in four strokes, he could create a remarkably fine figure. . . . Then he turned the picture to the wall and left it for months without looking at it, until he returned to it and stared critically at it, as if it were a mortal enemy. If he found something that displeased him he went to work like a surgeon, in the last stages, he used his fingers more than his brush.' Venice, a commercial centre and port, gave artists access to a wider range of high-grade pigments than elsewhere in Italy, and they were used lavishly. Titian's early works display the whole range of the palette in large juxtaposed, colour blocks. In this later work, Titian broke up local colour and focused on the flickering effect of light on surfaces. Complex pigment mixtures, however, were still not used, colour modulations being achieved by brushwork and glazing only. The paint varied from thin washes to thick impasto, and it was applied by brushing, dabbing, scraping, smoothing and working very freely. Contemporaries commented on Titian's dramatically individual and expressive handling of the oil painting medium. Titian had a profound influence on later oil painters.

1. Two pieces of fairly coarse twill weave canvas were stitched together. The average loom width was about 1 metre, the distance the shuttle could be thrown easily by hand.

2. The canvas was stretched and sized. The size reduces the absorbency of the fibres and prevents the oil making them brittle. Size, made from kid, pigskin or glove cuttings, was especially popular because it remained soft and flexible.

This painting was executed on a moderately rough canvas. Large scale works of religious as well as secular subjects painted on canvas appeared early in Venice partly because the wet and salty atmosphere was so unsuitable for wooden altarpieces and frescoes. Contemporaries also commented that canvases could be rolled up and transported more easily. Titian used a wide variety of canvas weights and weaves during his long painting career and there was a general shift in his preference from a fine to a coarser weave.

3. Next a gesso ground made from gypsum and animal skin glue, was applied thinly and smoothly. It just filled the gaps between the weave.

4. The composition was laid in using paint — mainly earth pigments and white.

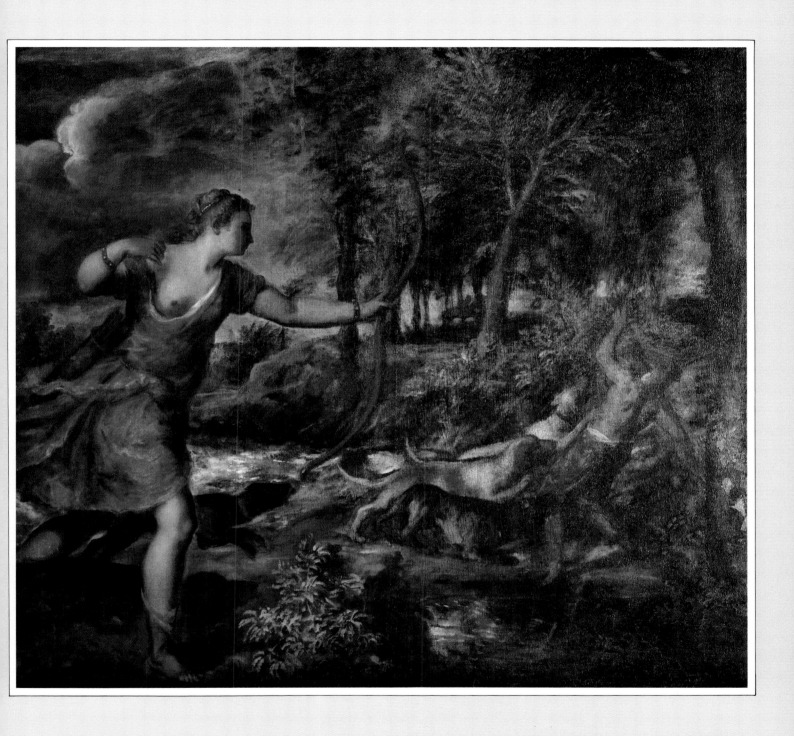

The impression of a change towards a more restricted palette in Titian's later work is misleading. Titian used ultramarine in the sky, orpiment (yellow) and realgar (orange-red) in Acteon's tunic, crimson lakes on Diana's robe, malachite and bright green copper resinate in the foliage, as well as vermilion and lead tin yellow. The picture's present dark overall tone is the result of deterioration and dis-coloured varnish. Until recently it was thought that Titian used a dark oil ground, which be-came popular during the sixteenth century; but examination has shown that it is white gesso which the heavy impregnation of lining paste has rendered translucent and caused the tone of the exposed canvas fibres to predominate.

35

The careful flesh modelling contrasts with the impressionistic treatment of the foliage. The lights are painted in thick opaque paint which contains a large proportion of lead white pigment, while the darks rely on a series of thin transparent glazes.

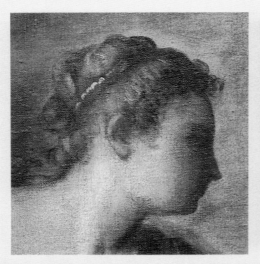

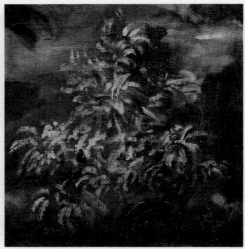

In the foliage, form is suggested rather than naturalistically described. Contemporary critics attributed Titian's late style to poor eyesight or a shaky hand. It has also been argued that the painting was unfinished.

The innumerable glazes which have been brushed, smeared or dabbed on the robe are typical of Titian's technique. They are broken up rather than applied as a smooth, continuous layer. The treatment contrasts with the flesh modelling.

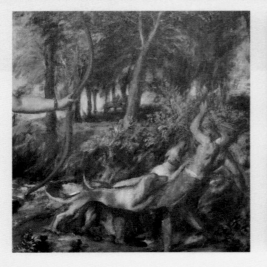

This X-radiograph (left) juxtaposed with the detail from the final picture (far left) shows alterations made during the painting. The position of Diana's arms and the bow, finally shown without an arrow or string, changed several times. The swirling mass on the right was finally resolved into three dogs attacking Acteon.

Actual size detail
The final surface is neither even nor smooth; both the paint and surface texture are striking. Subjectively, thin paint in shadows and thick paint in light areas appears more realistic because it corresponds with an apprehension of reality, and the eye is less aware of the picture plane. There are no hard outlines, but the contours are precise and often defined by light background paint. In spite of the freedom of his technique, Titian's flesh modelling always remained careful, as Palma Giovene wrote 'He never painted a figure *alla prima* and used to say that he who improvises can never make a perfect line of poetry.'

The notion that the special quality of Titian's painting lay in a secret medium has been disproved by analysis, which has shown that he used linseed and walnut oil. Documents indicate that varnish was added to paint to increase the transparency and drying qualities of dark pigments, such as lakes and verdigris. This was traditional practice. Varnishes were made from resins either melted in hot oil or dissolved in a volatile liquid such as spirits of wine, naptha or turpentine. The drying process of oil ensures that the surface is preserved with every expressive touch the artist makes. Contemporaries commented on the way Titian fully exploited this variable as a means of expression.

Nicholas Hilliard

(active 1547–1619, English court miniaturist)

A Youth Leaning Against a Tree Among Roses

painted c.1588, water-based medium on wood, $5\frac{3}{8} \times 2\frac{3}{4}$in ($12 \cdot 8 \times 7$cm)

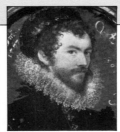

Nicholas Hilliard was originally trained as a goldsmith and this is evident in his exquisite miniatures. After spending time in France in the service of the Duke of Anjou, he emerged as a mature painter in the late 1570s in London as the Royal miniaturist to Elizabeth I and later James I. Hilliard was a declared follower of Holbein and French court portraiture, and his known *oeuvre* consists entirely of portrait miniatures which he developed with an intimacy and subtlety peculiar to the art. His linear style, incorporating naturalistic observation and modelling, found particular favour with Elizabeth I who was painted by Hilliard in 1572.

Hilliard's *Treatise on the Art of Limning* was a textbook on miniature painting based on his own methods and experience. 'Limning' was a contemporary term for this art and involved painting on vellum (calfskin). The technique was closely related to the tradition of illuminated manuscript artists.

Hilliard painted on prepared vellum, stretched over a playing card and fixed with thin paste. His brushes were made of squirrel hair fitted into a quill or handle. He cautioned against the use of too small a brush as an uneven surface would result with visible brush strokes, while too fine a tip would not take enough colour. He never used a magnifying glass as this caused distortion and over-emphasis and would always work from life rather than doing preparatory drawings of his subject. Hilliard's colours were made from natural ingredients ground on a crystal block which were then mixed with distilled water and gum arabic. To give plasticity to the lakes and umbers, he would add a little sugar candy. He advised against using muddy tones and lists as his preference black, white, red, blue, green, yellow and murrey (reddish-purple). He used three types of white — 'whitlead' for body colour, one for painting linen and satin, and another for faces. He also used three types of black, his preference being burnt ivory, especially for painting the eyes.

To create tones, Hilliard built up successive coats of fluid colour applied in short strokes and light dabs. He did not use underdrawing as the delicate surface of the vellum made correcting difficult and advised the use of pencil dipped in a flesh tint to emphasize lines.

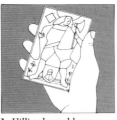

1. Hilliard would use a playing card cut into an oval shape, covered with sized vellum and primed with a pale flesh tint. He would work from life rather than preparatory sketches.

2. With no preparatory drawing, Hilliard would then lay in a light ground.

3. Using a series of coats of fluid colour to build up tone, the colours would be illuminated by the pale vellum beneath.

4. As the delicate surface of the vellum made correction difficult, Hilliard would use a pencil dipped in a flesh tint to indicate lines for further development.

5. To test whether there was enough gum arabic in the medium, Hilliard would expose it to sunlight to check for crumbling and peeling.

6. Hilliard would add the final details with minute dabs and strokes, freely applied.

Hilliard used a limited palette and tried to avoid muddy colours. He preferred to use ultramarine from Venice (**1**), red (**2**), green (**3**), yellow (**4**) and murrey, a reddish purple colour (**5**). He used three types of white (**6**) — one for faces, another for linen and satin and a third, which was called 'whitlead' for body colour. He also used three types of black (**7**), preferring burned ivory for the eyes. Hilliard would have ground his pigments on a crystal block and mixed them with distilled water and gum arabic.

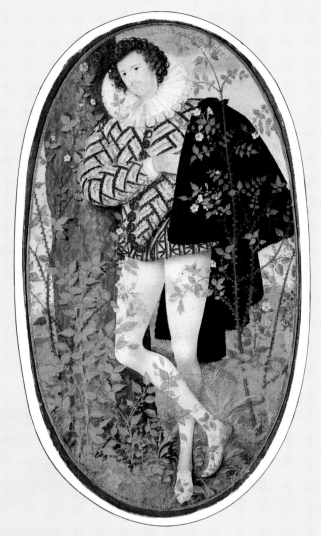

Actual size

The majority of Hilliard's portraits show only the sitter's head and shoulders and this is one of his few full-length portraits. The sitter is thought to be Robert Devereux, the ill-fated Earl of Essex, favourite of Queen Elizabeth I who was executed for treason in 1601. Hilliard primed the vellum with a pale flesh tint. As the colours dried, light penetrated the translucent paint and was reflected back from the vellum giving a glowing purity of colour. The support not only affected the colour of the pigments used, but was used as a colour in itself.

The scale of Hilliard's work — always a primary consideration — meant that clarity of detail rather than full *chiaroscuro* modelling was essential and Hilliard used a minimum of shading and modelling, as if his subjects were illuminated in full sunlight. Hilliard's use of line and pattern enlivens and counteracts the flatness created by this lack of modelling, emphasizing the ornamental function of his work.

Hilliard used wild roses to create a rich, lace-like design to break up the flatness of the sitter's dark cloak. For the face and ruff, the priming coat has been modelled with flesh tints to create the features. Hilliard attached great importance to capturing the complexion of his sitters.

The hair is created by using a wash over which a series of minute strokes define the curls.

To create an elaborate ruff, Hilliard squeezed thick paint on to trace its line. When dry, this gave a raised line which cast a shadow.

For the buttons of the cloak, Hilliard would create a *trompe l'oeil* effect by applying silver leaf overlaid with blobs of wax and paint.

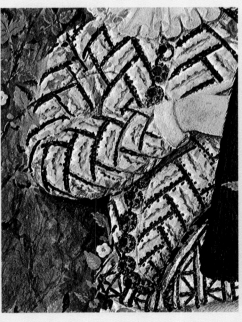

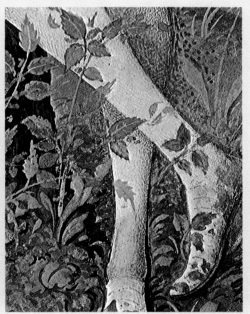

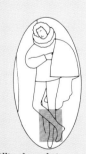

Hilliard used tiny hatching strokes to create the shading which can be seen in the legs.

Light green has been used to give detail in the leaves and grasses. Green was a notoriously impermanent colour as seen in the patch of blue which has faded behind the sitter's raised foot.

Caravaggio

(born 1573, died 1610, naturalistic religious painter)
The Supper at Emmaus
painted 1596–1603, oil on canvas, $55 \times 77\frac{1}{2}$in (139×195cm)

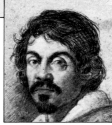

Michelangelo Merisi, called Caravaggio after his birthplace near Milan, worked chiefly in Rome. Having murdered a man, he fled in 1506, and in the last four years of his life painted in Naples, Malta, and Sicily. His violent and stormy life attracted as much attention as his controversial pictures. His vividly realistic pictures were bitterly attacked for their total rejection of idealization, which had been the chief aim of Renaissance art, and for their dramatic use of light and shadow. His style was followed by many artists, in particular those from the Netherlands, and Caravaggio had a profound influence on Rembrandt. For many conservative critics in the seventeenth century French and Italian Academies, however, his art marked 'the downfall of painting'.

Caravaggio's *The Supper at Emmaus* is generally thought to have been painted between 1596 and 1603, and is in very good condition, having been cleaned and relined in 1960. The artist's unidealized portrait of his sitters and the dark aspect of his later paintings were criticized by many of his seventeenth century biographers.

Little is known about the way Caravaggio thought out the early stages of his compositions. He sometimes rethought his approach drastically on the canvas, although this does not appear to have been the case with this work. While the enormous care with which the positions, angles and relationships of the figures have been worked out indicates that Caravaggio made painstaking preliminary studies on paper for his composition, there is no evidence that this was his practice and no drawings have ever been attributed to him. Nevertheless, it is hard to give credence to one seventeenth century critic who described Caravaggio's technique as 'impetuous and without preparation'. X-rays have revealed that the only alteration Caravaggio made in this particular painting was a slight change in the innkeeper's cap and profile, so he must have visualized the final composition clearly, before starting work on the canvas. The smooth, unbroken paint surface of the picture suggests Caravaggio used soft hair brushes and a fluid oil medium — probably linseed oil. Linseed tends to yellow, but this would not have adversely affected the warm earth colours of Caravaggio's works.

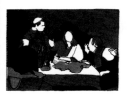

1. Having sketched in the outlines of the composition, Caravaggio would have blocked in the main areas of colour with a large bristle brush.

2. Subsequent layers of paint would have been applied with softer brushes. The contrasts of light and shadow would have been blended with a soft, broad brush.

3. Detailed work would have been added last using fine, soft brushes with a delicate point.

4. Oil glazes would have been used to modify the colours of the drapery. Christ's robe would probably have been covered with a red lake oil glaze.

Caravaggio could have used this type of brush for softly blending the top layer of paint and for modifying harsh contrasts.

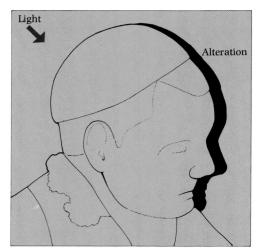

Light falls on the figures from a steep angle. The source of light in the studio might have been an oil lamp or a small high north-facing window. The window would have been fitted not with glass but with a sheet of paper, made transparent by soaking it either in oil or animal fat. This would provide a warm, constant light ideal for artist's studios. Caravaggio's only alteration in the composition was a small change in the outline of the inn-keeper's cap and profile.

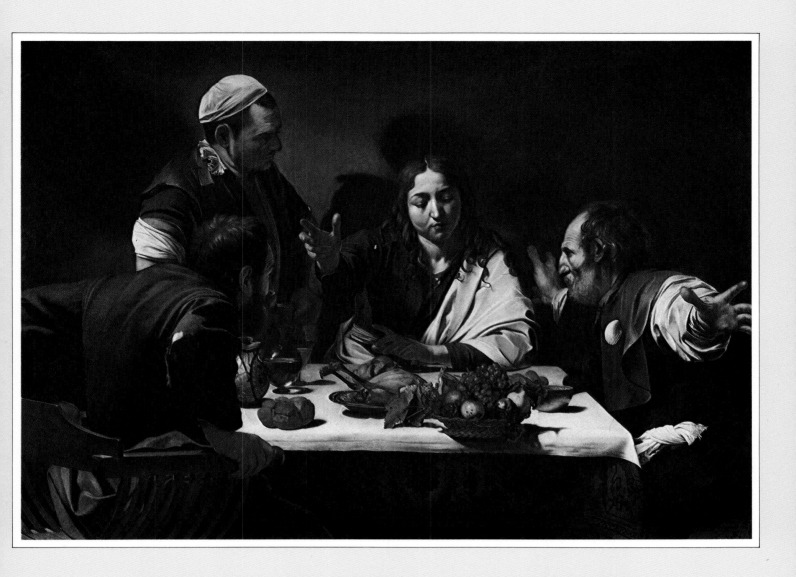

This detail of the head of Christ shows the modelling of the face and the dramatic use of light and shade to emphasize the features. The shadow cast by the servant can be seen on the wall.

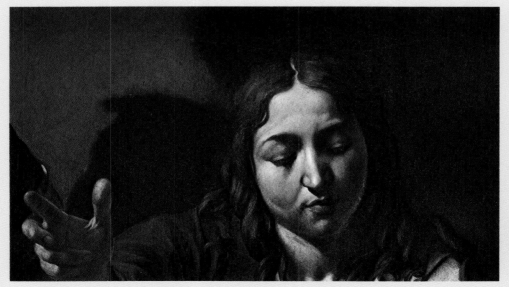

The Supper at Emmaus was painted on smooth finely-woven canvas, probably made from flax, which Caravaggio used for many of his pictures. The ground is dark, probably a deep brown.

This is one of Caravaggio's most important works and shows his complete mastery and use of extreme light and shadow, arrangement of figures, and dramatic gestures to focus attention on the figure of Christ. The rich, glowing tones, which indicate a preference for warm ochres, vermilion and lead tin yellow, are characteristic of Caravaggio's colour scheme.

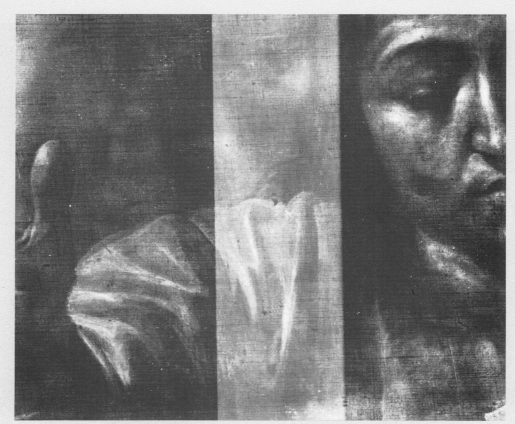

The X-ray (**left**) shows that Caravaggio blocked in the highlights of the face on the dark ground using an oil paint containing predominantly lead white. Comparison with the colour detail (**below**) shows how the oval from the face was accentuated later. It also reveals that the harsh contrasts between light and shadow and the traces of brush-marks evident in the X-ray were modified later by softer brushes, and perhaps also by a badger-hair softener.

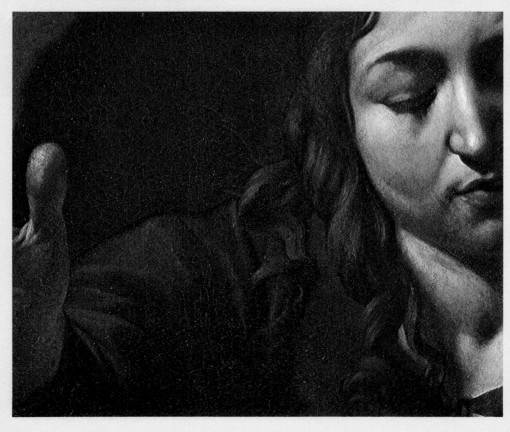

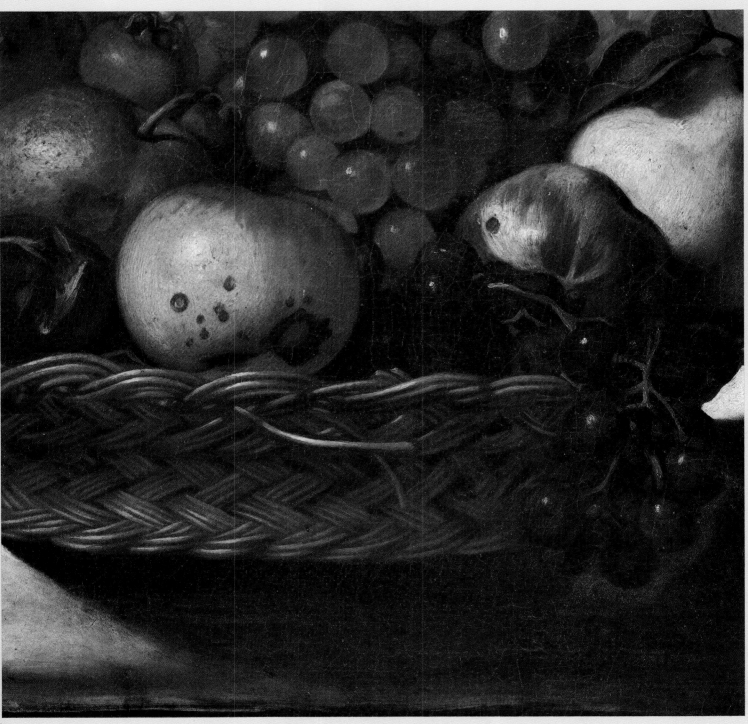

Actual size detail
The enormous attention which Caravaggio took over every part of the painting is well illustrated in this detail. A basket of fruit appears in many of his paintings and this detail shows Caravaggio's fascination with bruised, slightly rotten fruit.

It is interesting to note that Caravaggio purposely drew attention to the fruit by placing it in a very precarious position on the edge of the table.

Soft, fine brushes and a fluid oil medium would have been necessary to achieve this smooth, unbroken surface and detail such as the wicker basket and highlights on the grapes.

Caravaggio never seems to have used coarse bristle brushes or a thick oil medium to produce impasto effects, and, in this way, his technique differed considerably from that of El Greco. The smooth, unbroken paint surface suggests that he used soft hair brushes and tempered his pigments with an easily workable, quite fluid oil medium, possibly thinned with turpentine spirit. It is likely that Caravaggio used linseed oil which dried more quickly than the alternative, walnut variety.

El Greco

(born 1541, died 1614, Greek-born painter active in Spanish School)
Christ Driving the Traders from the Temple
painted 1600, oil on canvas, 41 × 51in (106 × 130cm)

Domenikos Theotokopoulos, commonly known as El Greco, was born in Crete where he probably began to paint in the style of Byzantine icon art. He received some artistic training in Venice, but his early work shows a debt to a wide range of artists including Michelangelo. By 1577 he had settled in Toledo, Spain, where he remained until his death. El Greco failed to find lasting favour with his patron, Philip II of Spain. His distorted, elongated figures and acid, brilliant, unconventional colours made his paintings unacceptable to many, and he consequently had few followers. However, a wider appreciation of El Greco's art grew with the development of modern art during this century.

While in Venice, El Greco most certainly came under the influence of Mannerist painters, the Italian Francesco Mazola Parmigianino in particular. The elongated and elegant figures, the stress on the flowing form and pale colours all indicate that El Greco, along with most Italian artists of that time, was making the transition from the Mannerist to the Baroque period of art.

It is possible that El Greco made preparatory drawings for all of his works, but not many are known. He certainly used small clay models to work out the arrangement of figures in his compositions. This may have been a practice which El Greco learned in Venice, since Tintoretto, who had a great influence on El Greco's early style, is known to have used small wax models as well. El Greco had a cupboard full of clay models in his studio.

El Greco may also have made oil studies for his paintings, as some small-scale versions of his compositions painted on panels exist. However, it is generally assumed that these were small replicas made by the artist himself or by an assistant to provide a visual record of the finished painting after it had left the studio. Pacheco, El Greco's biographer, saw several such small versions of El Greco's works on his visits to the artist's studio.

In spite of his relatively straight-forward technique, Pacheco reports that El Greco was a slow worker, 'who took his paintings in hand many times and retouched them over and over again' to improve on his first brush strokes – a practice which Pacheco called 'working hard for a poor result'.

1. The stretched canvas was given a layer of animal-skin size applied thinly with a large, flexible palette knife.

2. El Greco used a ground consisting of red ochre and gesso tempered with linseed oil. This was also applied with a palette knife.

3. The outlines of the composition were sketched on the ground probably with black oil paint, possibly charcoal black tempered with linseed oil.

4. Light areas were blocked in in white or pale grey oil paint. Large areas of opaque colour, such as lead tin yellow for the yellow drapery, were applied next.

5. Areas of pale opaque underpainting were then modified with an oil glaze applied with a fairly stiff bristle brush.

El Greco is known to have used both a coarse hog's hair brush and an early kind of palette knife. Hog's hair brushes were first popularized in Venice because it was unsatisfactory to use softer brushes on the coarse canvas which was a common painting support in that area. The knife would have had a flexible wooden blade and a wooden handle.

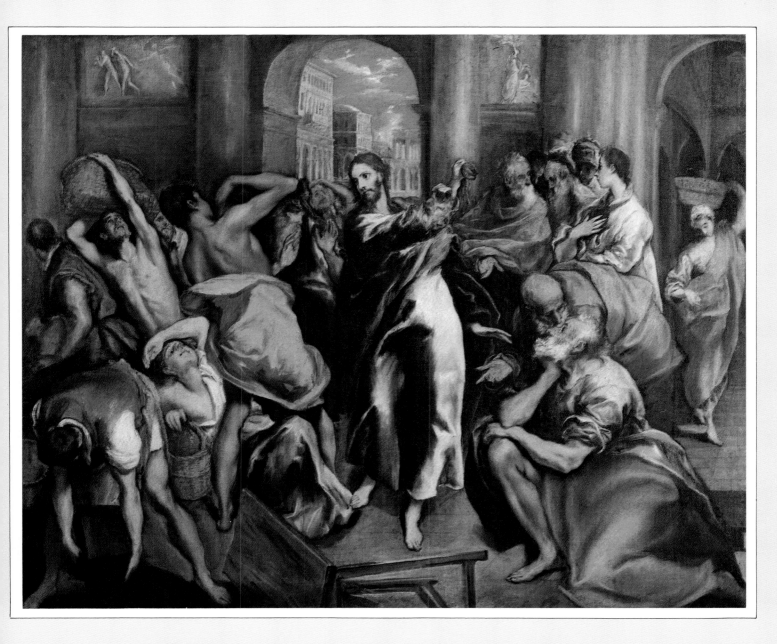

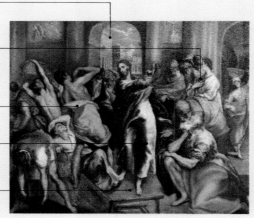

Venetian architectural
background influenced
by Italian Renaissance
stage design

Small clay models
probably used to work
out the design, perhaps
suspended from pieces
of string.

Lead tin yellow

Lead white mixed with
red lake overlayed with
red glaze

Warm brownish ground

Many of El Greco's
works are painted on
relatively fine canvas,
covered with a warm,
reddish-brown ground.
This preference may
have been a result of
his training in Venice,
where the use of such
grounds became
common in the second
half of the sixteenth
century. When temper-
ing his pigments, El
Greco used a thick oil
medium of the consist-
ency of honey, which
he applied in broken
strokes with a coarse
hog's hair brush. His

brushwork, which was
considered crude by
some contemporary
critics, may have been
developed from Titian's
relatively free later
style of painting.
The characteristic
brilliance of El Greco's
drapery was achieved
by applying a rich,
translucent oil glaze
directly onto the light
opaque underpainting.
This was a radical
simplification of the
Venetian method of
building up a complex
series of paint layers
and glazes.

The architecture in the background was probably based on contemporary Italian stage design which made use of perspective. The blue pigment is unlikely to have been ultramarine because of its high price; it may have been azurite.

El Greco's characteristic method of building up flesh tones with lead white and bluish charcoal black is well illustrated in the head of the boy with the basket, where the greyish tone of the shadow is well marked. The face was painted quite sketchily with the type of stiff hog's hair brush which El Greco frequently used.

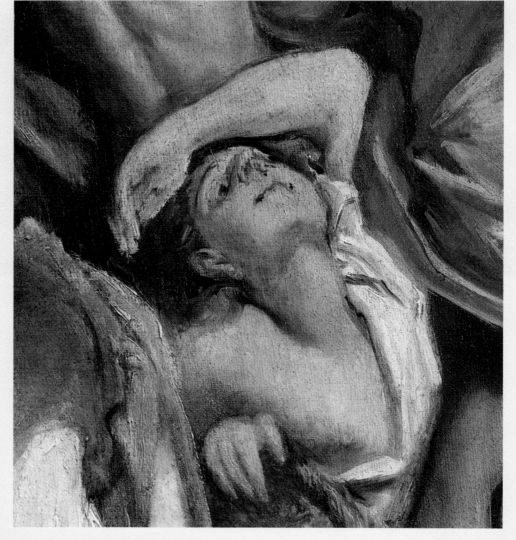

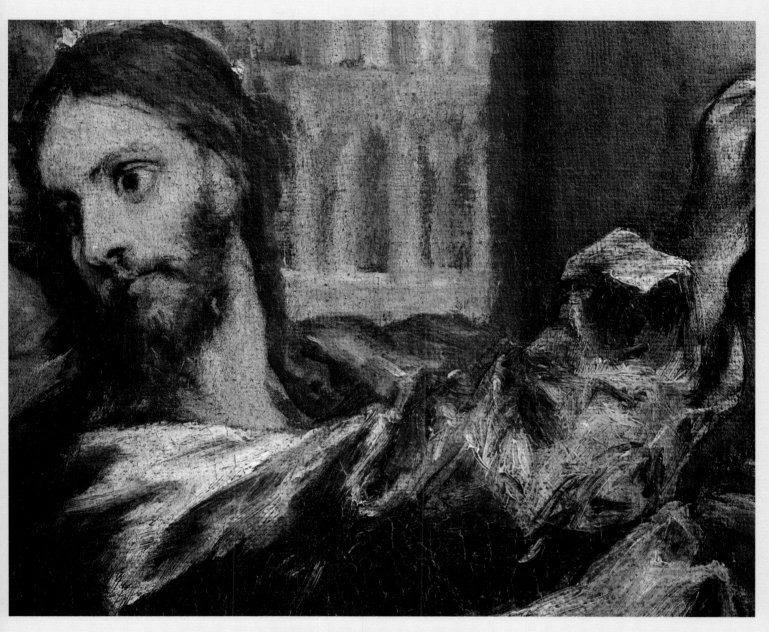

This detail shows the way in which El Greco built up forms using broken, short strokes and dabs of thick oil paint, applied in an almost impressionistic manner with a coarse, bristle brush. No attempt was made to achieve a smooth surface by gently blending one stroke into another; indeed the marks of the individual bristles which made up the brush are clearly evident.

Actual size detail
El Greco's method of building up flesh tones with lead white and bluish charcoal black is well illustrated in the head of Christ. The sleeve of the robe is an excellent example of El Greco's technique for painting drapery. The thick, opaque light

layer was painted with a stiff bristle brush worked in different directions, on top of which a transparent lake was applied. The red lake was also tempered with a thick medium and applied using hatching strokes. El Greco's method differed from the common technique of the period. Most painters tempered a lake pigment with a more fluid oil medium which was applied in smooth strokes with a soft brush to achieve an unbroken glaze.

Diego Velazquez

(born 1599, died 1660, artist of the Spanish School)
The Water Seller of Seville
painted c.1620, oil on canvas, 42 × 31⅛in (107 × 81cm)

Diego Rodriquez de Silva Velazquez was born in 1599 in Seville where he lived and worked until 1623 when he was offered a post at the court of Philip IV in Madrid. Velazquez remained attached to the court until his death, but made several trips to Italy where he paid particular attention to the works of Venetian painters.

Velazquez has been a source of influence and inspiration to many artists, including his fellow countryman, Goya, more than one hundred years later, and, later still, the French Impressionist Edouard Manet in the nineteenth century. The earlier paintings of Velazquez are reminiscent of Caravaggio in their treatment of light and shade, handling of paint and attention to realistic detail. Velazquez always leaned towards a dark and dramatic style of painting. Even in his early genre paintings however, Velazquez also showed the dispassionate and objective vision which was characteristic of him.

Although few preparatory drawings of Velazquez's paintings exist, it is probable that some were made. Preliminary studies in oil were often done. This is seen in the care and detail with which many of Velazquez's paint-ings are executed. Many of Velazquez's canvases show that he frequently made minor alterations during painting. As he painted, he frequently wiped his brush clean on the canvas, which he later covered over as can be seen in some of his early pictures.

Velazquez probably tempered his pigments with linseed oil of a reasonably fluid consistency, only using a thicker medium for dabs of highlight. The smooth, blended brushwork in many of Velazquez's paintings indicate that, like Caravaggio, Velazquez preferred to use soft hair brushes rather than coarse bristle ones.

Velazquez's technique changed considerably during his career. By the time he was painting portraits of Philip IV of Spain in Madrid in the 1630s, his palette had become somewhat cooler in tone and his handling of paint freer, as he developed a technique of using light, feathery strokes of paint.

The Water Seller of Seville was painted in Seville around 1620. It was one of a series of works featuring ordinary people, eating and drinking in dark interiors. Such scenes, known as 'bodegones', were popular in seventeenth century Spain.

2. The main composition and areas of light and dark would be blocked in using a fairly large bristle brush.

3. Using softer brushes, Velazquez would develop the somewhat roughly applied large areas of colour.

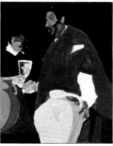

4. The softness of the water seller's tunic suggests that Velazquez went over the area with a blending brush.

1. Velazquez often chose fine, regular weave canvas which he covered with a dark brown ground using a palette knife.

5. Small details, like the ridges on the pitchers, would be added with a fine pointed brush probably made of ermine or stoat.

Velazquez made only a few alterations in the painting of this picture, mainly to the figure of the water seller.

Alteration to collar

Alteration to sleeve

Alteration to left hand

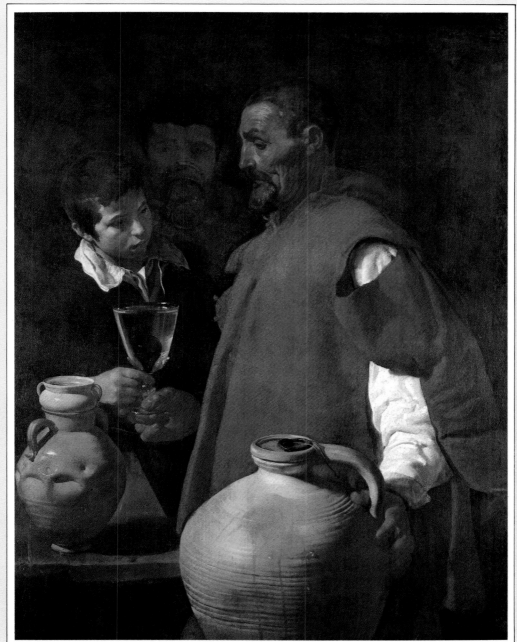

The depiction of ordinary people eating and drinking was popular in seventeenth century Spain and Velazquez did many genre paintings of this type.

The composition, with its rich ochres, earth tones, and careful attention to detail are all reminiscent of Caravaggio and show his influence on Velazquez.

While no preparatory drawings for this painting survive, it is probable that they did exist. Velazquez's biographer wrote that he did many chalk sketches, probably of both the water seller and the boy. The pitchers, which occur frequently in Velazquez's works at this time, were almost certainly studio props, and the careful rendering suggests that oil studies may have been made first in the studio.

In *The Water Seller of Seville* a striking, yet serene composition is achieved by the choice of warm, harmonious earth colours and the careful arrangement of large, simple shapes to form a triangle, of which the water seller's head is the apex.

Velazquez may have applied a spirit varnish to protect the painting some months after it had been completed. A slightly yellowing varnish would not seriously spoil the warm colours used in this painting.

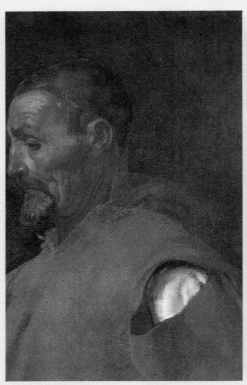

This detail is a good example of Velazquez's study of the play of light on the weathered skin of the water seller. The whole face was painted quite thickly, but the highlights on the nose and forehead were picked out with thicker oil paint than the rest of the face. The upper paint layer of the collar of the tunic has become transparent with time, to reveal the smaller, first collar underneath.

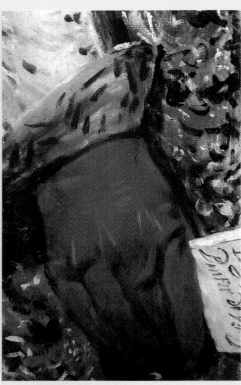

The comparison between the hand of the water seller and the gloved hand of Philip IV in the portrait by Velazquez, painted in the 1630's, shows how far Velazquez's technique developed in over 10 years. Although the paint was still quite thickly applied, the handling had become freer, lighter and more sketchy. It was such brushwork which had a marked effect on the French Impressionist Manet.

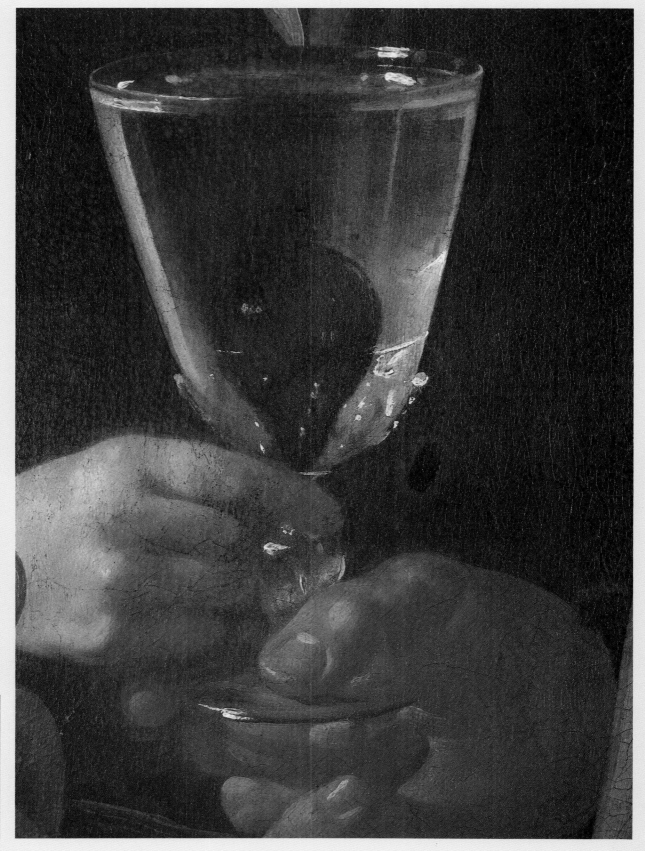

Actual size detail
Unlike the water seller's
head, his hands are
painted quite thinly,
with little lead white.
The X-ray (**left**) reveals
horizontal marks left by
the artist's brush, when
he wiped it clean on the
canvas, which was later
painted over. The
interest in the effect of
light on the glass is
reminiscent of
Caravaggio, and the
delicate way it is painted
points towards the finer,
lighter technique
developed by Velazquez
later in his career.

Peter Paul Rubens

(born 1577, died 1640, master of the Flemish School)
Portrait of Susanna Lunden née Fourment
painted c.1620–5, oil on canvas, $31\frac{1}{16} \times 21\frac{1}{2}$in (79 × 55cm)

Rubens set up his studio workshop in Antwerp in 1609 and by 1611 was turning down pupils on the grounds that he already had over a hundred applicants. Even during his absences abroad, production continued uninterrupted. However, this intimate portrait of his second wife's sister has never been questioned as an entirely autograph work. Rubens worked on both wood panels and canvas, using a variety of different grounds; his general preference for panels with smooth chalk grounds may be related to the fluency of his technique. The ground on this panel is traditional – chalk bound with animal glue and impregnated with oil – but the priming is an innovation. It is brownish, and applied with long, streaked, irregular brushstrokes. Rubens probably used a lean oil medium. The effect was less monotonous than the uniform dark grounds, popularized under Italian influences, and it had the advantage, by its translucency and striped application, of allowing the white chalk ground to shine through as well.

There are no detailed preparatory underdrawings as in earlier Netherlandish painting because the composition is sketched directly in thin, fluid paint. The priming plays a crucial part in the colour effects especially the flesh, where traditional procedure was reversed. The lights are painted thickly and opaquely to cover the ground priming whereas the shadows are scumbled thinly and translucently over it. The optical effect is cool and pearlized in the shadow, warm in the lights. This warm-cool modulation, the modelling, is achieved entirely by controlling the thickness of the flesh paint.

These effects required great virtuosity of brushwork. Rubens is described as painting with a pot of turpentine beside him, frequently dipping his brush into it in order to thin or work the paint. This is the first documented reference to turpentine as a diluent for oil paint and helps explain the variety of Rubens' brushwork. Rubens and his contemporaries were obsessively concerned with the colour and purity of their oil media. Linseed oil was most commonly used, but walnut oil, which yellowed less, was employed for delicate tints. Resin-oil varnishes were considered to be more suitable for harsher Northern climates than those made from spirits.

1. The original panel was made of two oak planks with vertical grain.

2. The wood was sized, and a chalk and animal skin glue ground applied and scraped smooth.

3. The ground was then impregnated with oil and a brown priming brushed on with long, irregular strokes.

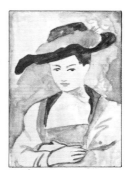

4. The composition was sketched in using very thin fluid paint and tones of yellow ochre and umber.

5. The paint was applied in a continuous process. Shadows were achieved by exposing the priming or scumbling lighter shades over dark.

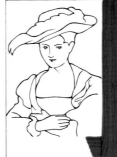

6. Two extra oak planks were attached. The additional strips do not have a dark priming.

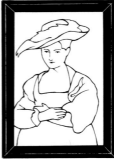

7. The edges of the additional planks only were unpainted. This indicates that the portrait was framed before the painting was finished.

This diagram shows the construction of the finished work.

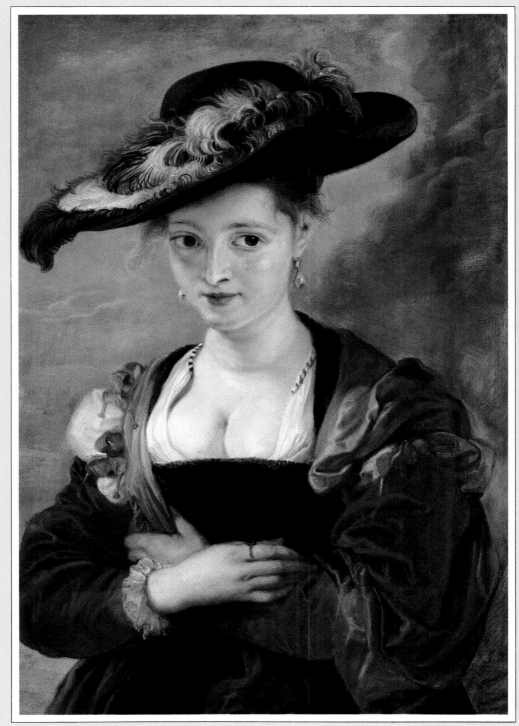

This picture was painted on four planks of oak prepared outside the studio by a well-known panel-maker whose monogram is branded on the back. It is particularly character-istic of Rubens that the composition has apparently expanded spontaneously from a relatively unchanged central core. A strip of wood was added on the right expanding the sky and reducing the formality of the composition, while another at the bottom gives the figure more substance. Rubens' technique contrasts with earlier Netherlandish methods in the use of a dark ground, the abandonment of detailed underdrawing, and the reversal of painting procedure, working from thin darks to thickly applied lights. His preference for a thin, fluid oil medium, prepared so as to remain as colourless as possible, is typical and he fully exploits its potential variety of handling.

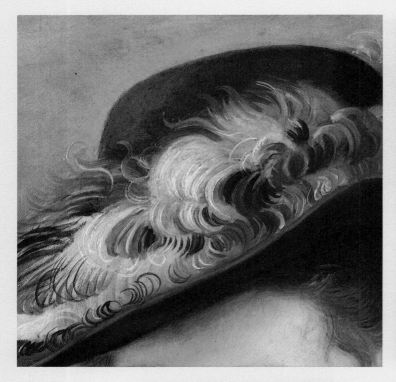

Actual size detail
Rubens' contemporary
biographer, Descamps,
includes among the
artist's maxims that in
flesh painting the strokes
of colour should be
placed side by side, and
only lightly blended.
Rubens painted
the lights yellow-white,
the complexion pink-red
and the shadows optical
blue-grey. In this actual
size detail there are
separate red accents
around the eye, while
blue pigment is mixed
into the whites and the
blue background paint
dragged into the
shadows on the right.

Top left
The hat is of a type
frequently worn by
both men and women
in the 1620s. In painting
the feathers, each
plume was described
with a single, confident
stroke.

Top right
The X-radiograph
reveals clear variations
in the handling of the
paint. The combinations
of long, fluid strokes
and shorter, blunt
strokes are highly
characteristic of
Rubens' working
methods. The flesh
highlights appear light
because of Rubens'
reliance on lead white
pigment to cover over
the dark ground.

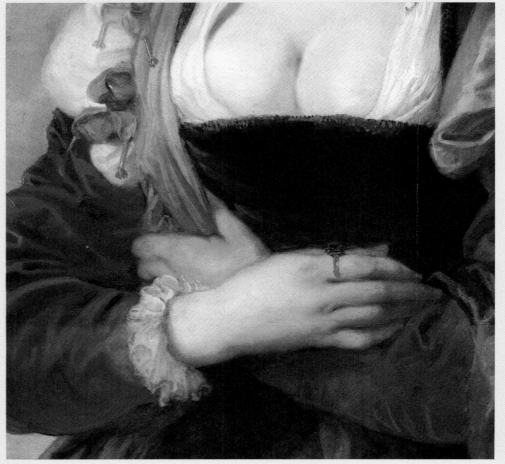

Left
The join between the
planks is clearly visible
in the area of the hands.
There were several
alterations — only the
thumb and forefinger of
the left hand were
originally shown; the
right thumb was
higher at first and the
sleeves have been
altered. The use of red
to light up the shadows
and separate colours is
characteristic of Rubens.
In the seventeenth
century, Holland was
the centre for the
manufacture of high-
quality, dry process
vermilion. In the sleeve,
vermilion and crimson
lakes are mixed together,
juxtaposed and super-
imposed.

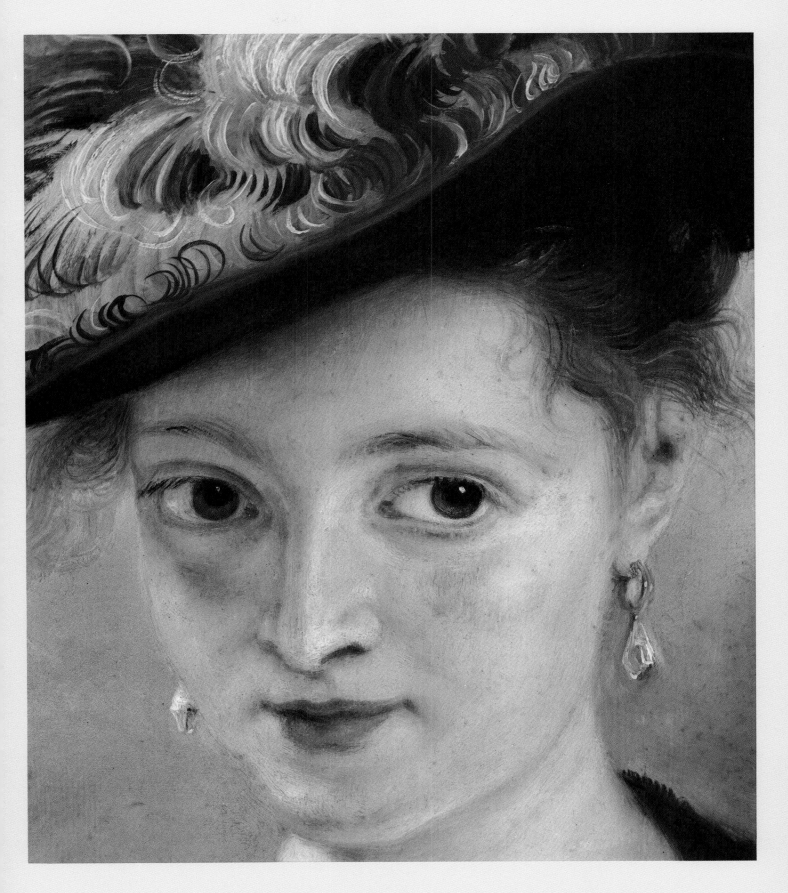

Rembrandt van Rijn

(born 1606, died 1669, master of the Dutch School)

The Feast of Belshazzar: The Writing on the Wall

painted c.1635, oil on canvas, 66 × 82⅓in (167 × 209cm)

Rembrandt never visited Italy but by the time he left his native Leyden to settle in Amsterdam in 1631, he had already been exposed to the latest developments in Baroque painting. The Dutch followers of Caravaggio had ensured that the thunderous use of light and shade and dramatic figures filling the picture surface had become familiar, as had the fluid, vigorous brushwork of Rubens and the thirst for grand, painterly illusions. Like Rubens, Rembrandt would have noted that Titian in his late work had gone in search of more reflective moods and discovered a new and glorious freedom in his brushstrokes.

Of all the Baroque masters, it was Rembrandt who evolved the most revolutionary technique and who seemed to grow into Titian's spiritual heir. By the middle of the 1630s he had long since abandoned conventional Dutch smoothness and his surfaces were already caked with more paint than was strictly necessary to present an illusion. He was weighing his sitters with jewellery solid enough to steal, vigorously modelled with a heavily loaded brush. Where others needed five touches he was using one, and so the brushstrokes had begun to separate and could sometimes only be properly read from a distance. The exact imitation of form was being replaced by the suggestion of it; to some of his contemporaries, therefore, his paintings began to look unfinished. It was from the Venetians that he had learned to use a brown ground so that his paintings emerged from dark to light, physically as well as spiritually. Yet, despite a palette that was limited even by seventeenth century standards, he was renowned as a colourist for he managed to maintain a precarious balance between painting tonally, with light and shade, and painting in colour. Just as form was suggested rather than delineated, so the impression of rich colour was deceptive.

He worked in complex layers, building up a picture from the back to the front with delicate glazes that allowed light actually to permeate his backgrounds and reflect off the white underpainting, and generously applied body-colours which mimicked the effect of solid bodies in space. Never before had a painter taken such a purely sensuous interest and delight in the physical qualities of his medium, nor granted it a greater measure of independence from the image.

1. The canvas was sized with animal glue to seal it against the binding medium of the ground, which would have otherwise have been absorbed and could have damaged the canvas.

2. A medium-brown ground was laid on consisting of ochre bound with resin and animal glue. Introduced by Titian, the use of a brown rather than white ground ensured that the artist had to work from dark to light.

3. Rembrandt left no sketches or preliminary studies. Composition and distribution of light and shade are mapped out in a monochrome underpainting. The completed image is not so much a sketch as a dead-colour painting ready to be worked up.

4. With the dead-colour painting as his guide, Rembrandt then applied the body colours working from background to foreground, leaving the figures at the front monochrome silhouettes until their turn came.

5. Rembrandt relied on body colour. Where glazes are applied, they build up the rich blackness of the velvet worn by the figure on the extreme left and soften the contour of Belshazzar's body so that it recedes into the darkness under his outstretched left arm.

6. With the ground work completed, Rembrandt would set about applying the finishing touches to the painting as a whole. Working in stiff impasto, he dabbed in highlights so the twinkle of jewellery and shiny metal drew the composition together.

In this work, Rembrandt used the following colours: lead white (sometimes mixed with 25% chalk) (**1**), black (**2**), brown (**3**), red ochre (**4**), unidentifiable transparent browns, probably Cologne earth and bistre (**5**), vermilion and organic red lakes (**6**), lead tin yellow (**7**) usually mixed with lead white, azurite (**8**) and smalt (**9**). Greens (**10**) were made by mixing lead-tin yellow with azurite or smalt.

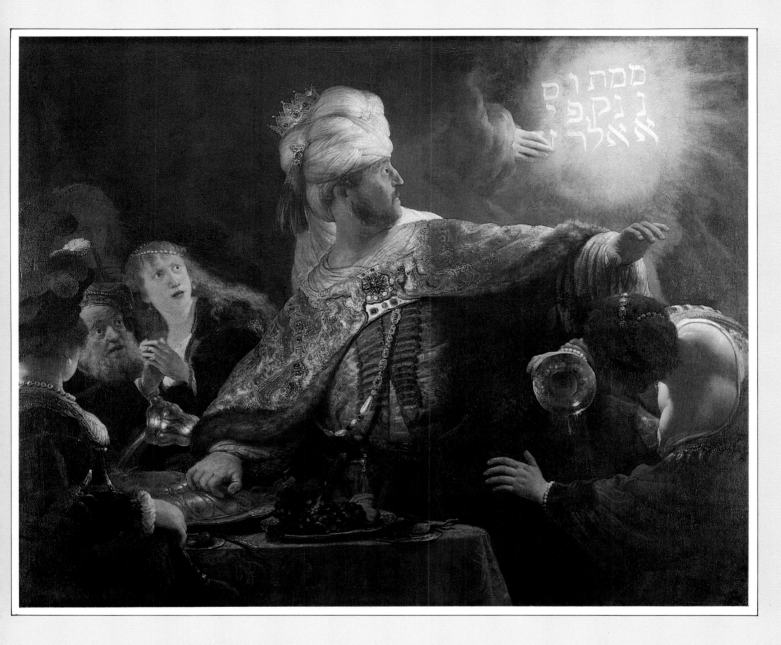

Underpainting providing
basic colour

Stiff impasto for
highlights

Smooth glazed black
for dress

Cuff made from
alternating dark and
light strokes

Single brushstrokes for
white edging of dress

Glazes built up

This is the most overtly
theatrical of Rembrandt's
biblical scenes. Not one,
but two goblets of wine
are spilling their contents
and the great jewelled
clasp on Belshazzar's
cloak is the artist's most
extravagant attempt at
recreating jewellery in
thick, wet impasto. The
picture's predominantly
green-grey coloration is
dictated by the
underpainting, the most
crucial component of a
Rembrandt painting. It
takes the place of a
preliminary sketch and
also plays an important
role in the appearance
of the finished painting,
providing the bulk of his
intermediate tones.
Underpainting provides
the basic colour for
Belshazzar's tunic, the
tablecloth, the clouds of
smoke in the background
and the shadowy figure
of the musician.

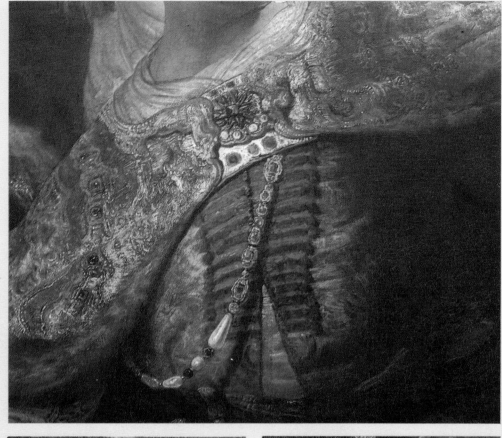

Recent restorations have shown that Rembrandt was not as compulsive a glazer as has been suggested in the past. These flesh tones have been achieved with accurately mixed body paint (usually lead white, ochre, a small amount of black, a transparent brown pigment and vermilion) rather than thin glazes. The translucence is heightened by the yellow-white highlights under the woman's neck and along her bosom. The shadow at the back of her neck does blend into an area of glazed flesh colour but the modelling underneath is inexact and results in an unusually formless back. The white edging of her dress consists of single brushstrokes allowed to break up at their ends; and the drapery on her arm prefigures Rembrandt's late work in the breadth of its execution. The single red brushstroke which joins the top of her elbow to her left shoulder has been enlivened — a slash of yellow has been worked into its edge so that a glowing orange is achieved not by mixing the pigments on the canvas but by allowing them to mix in the spectator's eye.

The richly decorated cloak and the jewelled clasp show Rembrandt at his most vigorous in his painting of accessories. Working with two basic brushes — one thick, blunt and rounded, and the other fine, and pointed — he first moulded the jewellery with the blunt brush into ridges, which reflect actual light, and shadowy troughs, sometimes using the handle of the brush to scrape textures into the paint surface. With the thin brush he then deposited wet yellow and white paint along the ridges so that real and painted light combine in the highlight. From very close up the clasp is a mass of illegible marks which only begin to take shape from a distance. Rembrandt worked in layers, overlapping his paint surfaces, so that Belshazzar's clothes would actually have been painted in the order in which he put them on. The grey tunic consists mostly of underpainting on which the artist has scumbled a design in very dry white paint, which has caught in the ridges of the underpainting. The brocade at the front of the tunic is loosely painted in much wetter impasto and mostly single brushstrokes; the alternating light and dark stripes are allowed to blur together. The thickest impasto of all is saved for the sumptuous cloak and the exquisite gold chain which shows Rembrandt again dealing almost exclusively in yellow and white highlights. The left side of Belshazzar's body would originally have been a deep red but the artist has applied brown glazes to push it gently back into the shadows without completely smothering its colour.

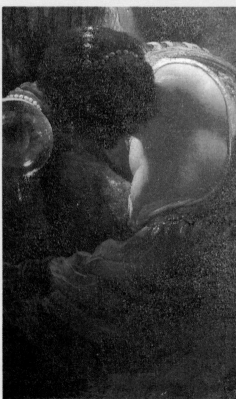

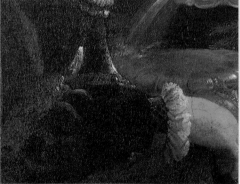

Rembrandt and Frans Hals were the first great masters of directional brushstrokes. The strokes which make up the cuff consist of alternating dark and light strokes, turned up abruptly at the ends to suggest the pleats and rounded off along the ruffled edge of the cuff with white highlights. A similar technique is less successfully used in the rather shapeless white bodice. The dress is made up of smooth, glazed black recreating the rich textures of velvet

and receding deeply into the shadow under the woman's arm. The lace trimmings again consist almost entirely of highlights which stay firmly on the surface of the dress to suggest the texture of filigree decoration.

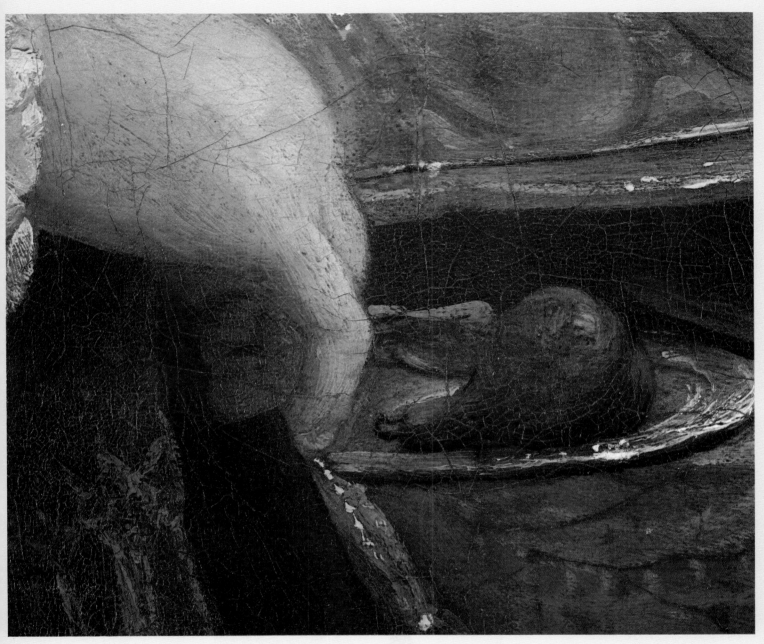

All the figures in the painting would at one time have looked like the shadowy silhouette of the musician in the background. Rembrandt's underpainting was remarkably exact and he needed only to highlight a string of pearls in the hair to bring this figure to life. Its colouring ensures that it remains firmly in the background in complete contrast to the feathers belonging to the figure on the left, which emerge from the foreground. Rembrandt often used ceruse (white lead mixed with chalk) in both his underpainting and in some highlights.

Actual size detail
Rembrandt was the most economic of painters. The plate is no more than a white highlight, the wet paint swept along its edge catches in the grooves of the underpainting to give the plate its shape. A single, fluid black brushstroke under the rim lifts it up off the top of the tablecloth. The pear is basically a silhouette which interrupts the sparse outline of the plate. The shadow at the front edge

of the tablecloth has been effortlessly achieved by going over the underpainting, on which a pattern has already been suggested in white with a darker glaze.

Jan Vermeer

(born 1632, died 1675, Dutch genre painter)
The Guitar Player
painted 1660s, oil on canvas, $20\frac{7}{8} \times 18\frac{1}{4}$in (53 × 46·3cm)

The celebrated scenes of everyday life by Vermeer mark the high point of seventeenth century Dutch genre painting. Vermeer was an art dealer and occasional committee member of the Delft painters' guild and, despite the enigmatic reputation he and his paintings have acquired, may be seen as part of a flourishing artistic generation. Together with such contemporary genre painters as Gerard Ter Borch, Gabriel Metsu and Pieter de Hoogh, Vermeer was working in a tradition influenced by Caravaggio through the Utrecht school and the painters of Rembrandt's circle.

Although early documentary sources have no recorded details of Vermeer's working methods, modern scientific investigation has revealed much about the 30 or so paintings reliably attributed to him. Before painting *The Guitar Player*, Vermeer sized the canvas and then applied several coats of a grey-brown ground consisting of chalk mixed with lead white, umber, and charcoal black pigments suspended in an oil and glue emulsion. There are no known preliminary drawings by Vermeer and infra-red photography does not reveal any black underdrawing on the ground layer beneath the paint surface. There is, however, convincing stylistic and circumstantial evidence that Vermeer frequently made use of a *camera obscura* – an instrument made up of lenses and mirrors in a box or chamber. A reduced image of the subject is reflected or traced from the mirrors onto the painting surface which the artist used as a 'drawing' to work from. Vermeer may have either laid preliminary colours directly on the projected image or traced the outline in white lead paint.

Vermeer painted light as it fell on the subject using a variety of techniques ranging from thin layers of glazes or flat underpainting to thick opaque *alla prima* paint. Visible brushwork and texture are minimal except for the impasto and some areas of drapery, and the stippled dots of light-coloured paint were a characteristic light-reflecting device.

Smalt, a deep blue pigment made from powdered cobalt glass, or azurite were commonly used by painters of this period, but Vermeer made extensive use of the costly pigment ultramarine which is extracted from the semi-precious stone lapis lazuli. Vermeer's signature can be seen below the curtain.

1. The canvas was first fixed onto the stretcher with small, square-headed wooden pegs at about 3–4 in intervals.

2. The canvas was then sized. Several coats of grey-brown ground consisting of chalk mixed with lead white, umber and charcoal in an oil and glue emulsion were then applied.

3. Vermeer probably used the *camera obscura* at this stage and worked from the image reflected onto the surface.

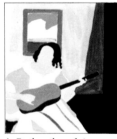

4. Rather than doing a detailed underdrawing, Vermeer may have laid down broad areas of flat colour.

5. Modelling was achieved with the *alla prima* method or by building up layers of thin glazes; usually both were used together.

6. Small points of highlight were then put in with lead white or lead tin yellow.

The *camera obscura* was a sixteenth century invention which consisted of a darkened box or chamber containing an arrangement of lenses and mirrors. These would project a reduced image, similar to that of a modern reflex camera, onto a flat surface from which an artist could trace a precise and detailed drawing. Depending on the type of instrument used, this drawing in turn may have been transferred onto the surface which was to be painted.

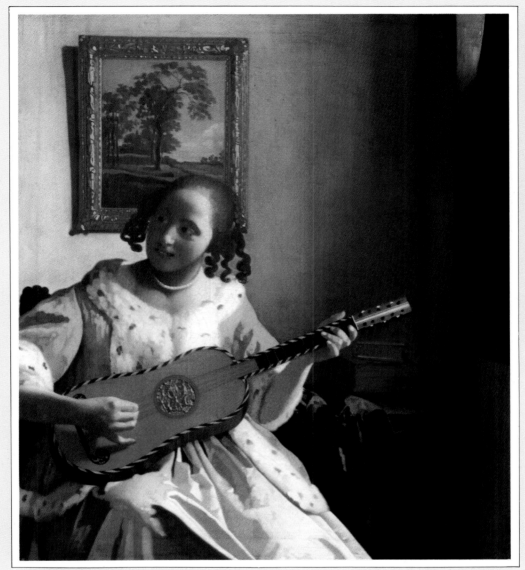

The Guitar Player is a late work by Vermeer and this relaxed everyday scene in a domestic setting is typical of his subject matter. The subdued colours increase the optical realism which results from Vermeer's technique of painting form and detail as they appear rather than as they are known to be — the arms and hands, for instance, are not painted with anatomical precision but in terms of light and shadow. The painting is in excellent condition with minimal restoration and is one of the few seventeenth century paintings which has not been lined. The hand-spun and hand-woven canvas has never been removed from its stretcher, to which it still remains attached by the original small, square-headed wooden pegs.

This detail from *The Artist's Studio* by Vermeer shows an artist sitting at his easel painting the portrait of a girl. His hand rests on a mahl stick. On the easel is a stretched canvas with a light grey ground showing an outline sketch in white. Only the wreath on the model's head has actually been painted, and there is no sign of any preliminary drawing.

Grey underpainting forms the basis of the skirt, over which broad, flat areas of white paint and dark grey-green glazes create the modelled effect of folds in the fabric. There is minimal texture or brushwork and interest lies in Vermeer's handling of tone to describe areas of light and shadow. The position of the guitar along the lower contour was altered, and the changed line can be seen.

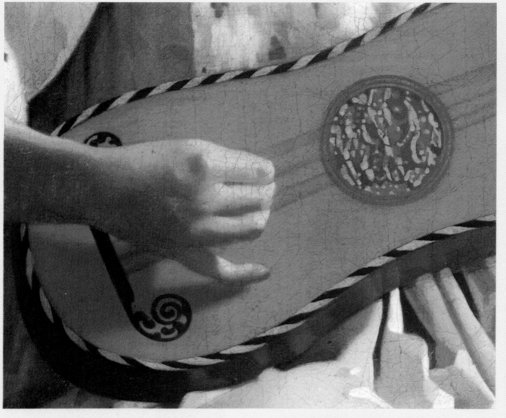

Actual size detail
This detail is a fine example of the striking variations in Vermeer's paint texture and brushwork. Thin dark glazes barely cover the grey-green underpainting of the shadowed right side of the face and throat. This contrasts vividly with the white lead dots of paint on the pearls and the impasto of the gilded frame and guitar 'rose'. The textured paint of the impasto creates an abstract light-reflecting pattern rather than a meticulous record of the objects. X-ray photographs show an emphasis of white lead on the knuckles of the right hand, which is held above the blurred lines of the vibrating guitar strings.

The fingers of the left hand are painted with three or four flat, broken dabs of flesh-coloured paint emphasizing the intensity of light falling on the model. The pegs on the guitar head are an abstract pattern of brilliant white, grey and black which stand out vividly against the featureless architecture of the wall and window. Ultramarine was used for painting both the curtain and the draped cloth.

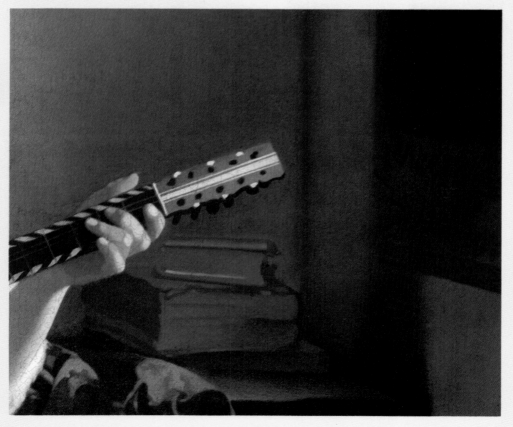

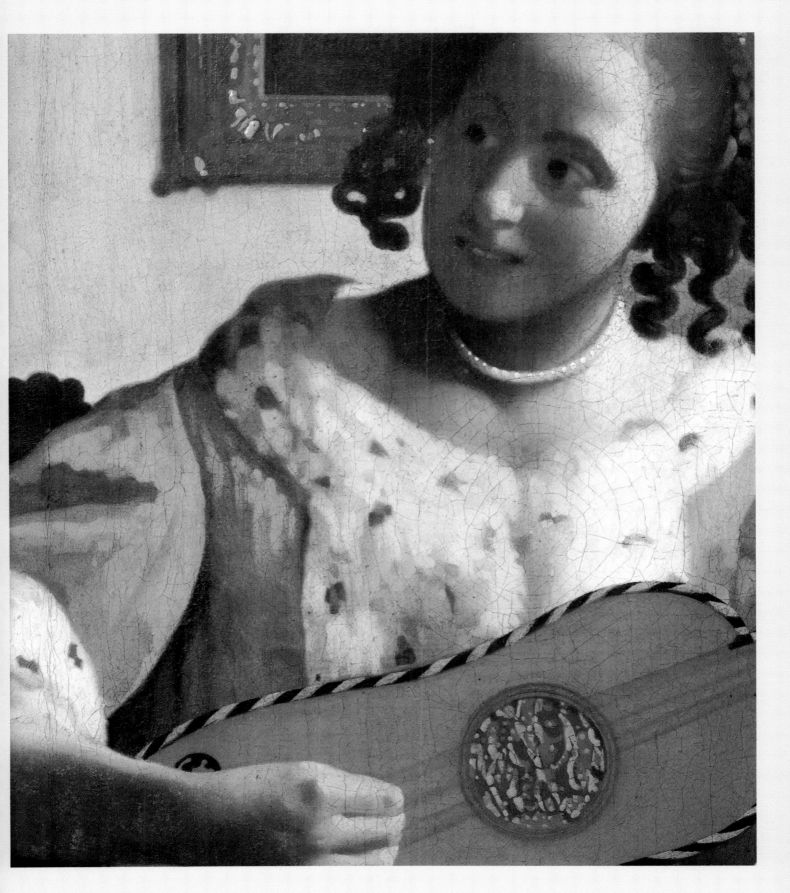

Antoine Watteau

(born 1684, died 1721, French artist)

Fêtes Vénitiennes

painted c.1718–1719, oil on canvas, 22 × 18in (55·9 × 45·7cm)

In Watteau's work there is a reconciliation of the opposing Flemish and Venetian influences which divided the artistic world of eighteenth century France. Watteau's paintings also capture the elegant, capricious and superficially charming qualities of Rococo, a fashion which suited the early skills Watteau acquired as a painter of decorative interiors. Themes from the *commedia dell'arte* were a frequent source of inspiration to him.

Watteau was remembered by his contemporaries as a fast, messy and impulsive painter. His palette was rarely cleaned, his brushes were dirty and, as he painted, they dripped with oil from a pot full of debris, dust and paint particles. Speed was of the essence and much comment was made on Watteau's excessive use of oil which has left some of his paintings in poor condition. Watteau's contemporaries claimed to notice tonal discoloration and deterioration in the paint only a short time after Watteau had completed it.

Watteau frequently made corrections and adjustments to his paintings which he often only thinly disguised. In the case of *Fêtes Vénitiennes*, most of these changes can be seen as easily with the naked eye as with infra-red photography or X-ray. Although Watteau was a prolific draughtsman, there is almost a total absence of preliminary drawings or outline plans for his works. However, Watteau kept hundreds of figure studies and landscape sketches in bound volumes. The models were often dressed in fancy or theatrical costumes and these supplied Watteau with motifs from which he developed many of his paintings. He arranged the figures in groups which were usually dictated by a landscape background. Sometimes such figure studies were used for more than one painting, and it is known that a few were portraits of friends. In *Fêtes Vénitiennes* the male dancer is known to be a portrait of a painter and friend, Nicholas Vleugels, and it is thought that the melancholy figure of the bag-piper may be a self-portrait.

Despite the relatively poor condition of many of Watteau's paintings, *Fêtes Vénitiennes* is in exceptionally good condition and has only been minimally restored. In this instance, the artist's use of the excessively oily medium can be seen as a characteristic of Watteau's technique rather than a problem.

1. After the canvas was sized, a warm grey ground was applied.

2. If there was no preliminary drawing, Watteau would apply paint directly to the canvas. Watteau worked quickly.

3. Alterations and changes were made and painted over during the painting process.

4. Final glazes and shadows were painted with the same speed as the rest of the painting.

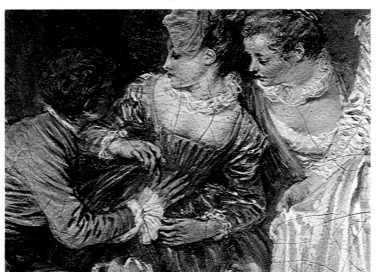

Actual size detail
The brushwork is quick and free, the paint perceptibly modelled and Watteau has interspersed the pigments to produce streaky effects. The glazed blue stripes are a quick finishing touch. The outlines are emphasized by dark, shadow-like glazes.

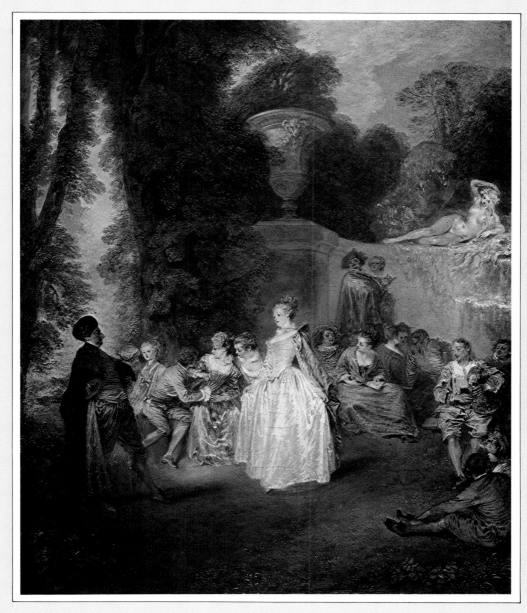

Fêtes Vénitiennes is a typical later work. The idealized garden shows beautifully costumed people dancing and making music.

The painting is on a plain-weave linen canvas which, when sized, was prepared with a grey ground containing white lead. Watteau made little use of the ground colour or the canvas texture but applied his paint *alla prima*. Its texture is most pronounced in the clouds, drapery and flesh-painting, and the brushwork is free and varied. The figures were painted more precisely and the portrait of Vleughels, the dancer, contrasts with the sketchy execution of the sculpted naiad. The tall trees were thickly painted, and the dark colours built up in semi-transparent layers with more restrained brushwork. Watteau's excessive use of oil as the paint medium has caused the fine wrinkling in the paint layer and the pronounced pattern of cracks in the dark green foliage.

The profile of this figure, the artist's friend Vleughels, was altered.

The legs of the figure were repositioned.

The profile on the wall was thinly covered.

The position of the woman's dress was altered at the hem.

Watteau often made changes to his paintings and in *Fêtes Vénetiennes* many of these can be seen with the naked eye.

Joshua Reynolds

(born 1723, died 1792, English painter)
Mrs Hartley as a Nymph with Young Bacchus
painted 1772, oil on canvas, 35 × 27in (89 × 68·5cm)

The two main periods of Reynolds's life which influenced his painting technique were his apprenticeship with the portrait painter Thomas Hudson from 1740 to 1743 and his trip to Italy from 1749 to 1752. The latter profoundly affected the artist and, for most of his career, Reynolds used poses borrowed from Classical sculpture, Michelangelo, Correggio and Van Dyck, amongst others.

Unfortunately, Reynolds was neither a careful nor systematic painter and because of his consuming passion for experimentation with various pigments and media, few of his later works have survived in anything like their original condition. Within his lifetime, several pictures were returned to his studio for repair and many have clearly suffered from later unsuccessful attempts at restoration.

Reynolds's broad aim was to duplicate the effects of the Old Masters in the shortest possible time and, as conventional media were thought to dry too slowly in the damp British climate, he would add quantities of driers. From the notes he made in muddled Italian, we find that Reynolds, like Turner, was interested in the effects of wax as a medium. He would probably melt the wax and add spirits of turpentine to produce a paste which could be mixed with colours ground in oil. This relatively quick-setting paste would enable him to produce effects ranging from the boldest impasto to the thinnest glazes, depending on the quantity of diluent added. As well, he experimented with various media and varnishes often recklessly super-imposing several media, each with a different drying rate within the same picture.

Reynolds was no less rash in his choice of pigments and would mix incompatible colours like orpiment and white lead or make use of recently invented but untested colours and 'fugitive' lakes and carmines.

His brushes were nineteen inches long, and his palette an outmoded type with a handle. Information regarding his choice of colours is contradictory and he himself wrote that 'four [colours] are sufficient to make every combination required'. One source says he preferred carmine, ultramarine, Naples yellow and black. Another says that he chose white, Naples yellow, yellow ochre, vermilion, light red, lake, black and Prussian blue. In his notes, Reynolds called Prussian blue 'Turchino'.

 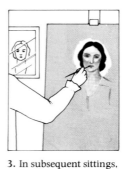 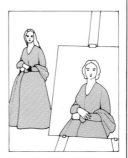

1. For one of his standard portraits Reynolds would choose a light coloured canvas with an off-white or pale grey priming. Without a preliminary drawing, he would apply a rough patch of white paint where the head was to be.

2. Using lake, black, and white, he would block in the main features, working wet-in-wet to produce a pallid likeness. An assistant said the face would resemble 'a beautiful cloud; everything was in its right place, but as soft as possible'.

3. In subsequent sittings, Reynolds would create warm flesh tones sometimes using opaque colours, like Naples yellow, but more often using thin, fugitive glazes which would not obscure the under-painting. He would sometimes paint from his sitter's image reflected in a mirror.

4. Once the head was finished, Reynolds would then pass the picture on to an assist-ant who would fill in the drapery from a life-size figure dressed in the sitter's clothes. Another assistant would often fill in the landscape, and Reynolds would probably add the final touches.

Reynold's brushes were up to 19in (47cm) long so that he could work standing well away from the canvas. He used an outmoded type of palette with a handle. Although Reynolds himself wrote that 'four colours are sufficient to make every combination required', one of his biographers states that he used the following colours which he would place on his palette in this order: white, Naples yellow, yellow ochre, vermilion, light red, black and Prussian blue (which he called 'Turchino').

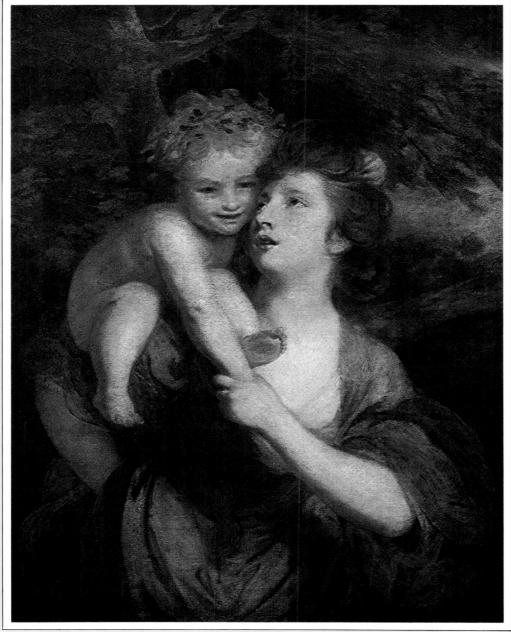

The head in this picture suffers from serious craquelure perhaps due to Reynolds's use of 'white virgin wax' (bleached beeswax) which 'caused his colours to scale off from the canvas in flakes'. It seems that he melted the wax and then added colours ground in oil. He reportedly told one connoisseur 'Mix a little wax with your colours, and don't tell anybody.' A cross-section of the various layers of this picture indicate that Mrs. Hartley's drapery was originally violet achieved by super-imposing a lake glaze on top of blue, but apparently Reynolds changed his mind and applied a very thick layer of white to obliterate it. A thin layer of blue served as the shadow of a fold line, followed by a layer of of orange-brown.

Cross-sections of most of Reynolds's paintings reveal a complex layering of pigment and media. Shown here, working from the bottom-most layers up, are: traces of a layer of size (1); thin whitish ground, perhaps in two layers (2); Prussian blue with black particles (3); lake pigment (4); thick opaque white (5); pale blue painted wet-in-wet to the previous layer (6); yellow with some vermilion and large white lumps (7); discoloured yellow-brown varnish (8); surface dirt and dust (9). This complex layer structure indicates that Mrs Hartley's drapery was originally violet in hue, made by super-imposing a lake glaze (4) on top of blue (3). However, Reynolds changed his mind and applied a thick layer of white to obliterate it. He then painted on a very thin layer of pale blue (6), perhaps to serve as the shadow of a fold line, followed by a layer of brown-orange paint.

Reynolds used assistants to complete the backgrounds of many of his pictures. However, *Mrs Hartley* is an experimental work and it is almost certain that Reynolds painted it completely himself.

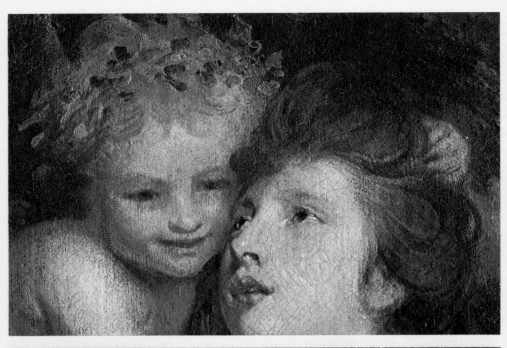

Actual size detail
Despite a heavy layer of varnish and extensive retouching, this detail shows how the head of Bacchus has been painted in a radically different way from that of Mrs. Hartley. With the latter, the traces of blue-black undermodelling near the temple creates shadows, and the added blue pigment in the white of the eye lends brilliance and liveliness to the entire face. Note that the white highlights and brushwork have been flattened during the lining process which is likely to happen if the paint contains a large amount of wax.
In Bacchus, the warm flesh colours have been applied thinly and the plain weave of the canvas and white ground are visible throughout. This, however, may be due to attempts to clean the picture, as many of Reynolds's experimental media are soluble in the mildest of solvents.

Beneath the layers of discoloured varnish, it is likely that Reynolds built up the foliage in this area with a series of thin glazes which may have discoloured. Marchi, one of Reynolds's biographers, noted that he would sometimes apply just a layer of megilp (a solution of mastic resin in a mixture of turpentine and linseed oil). Marchi commented that Reynolds used this to 'serve as a tint. This did not answer, for in a few months it was sure to become yellow and was obliged to be taken off.'

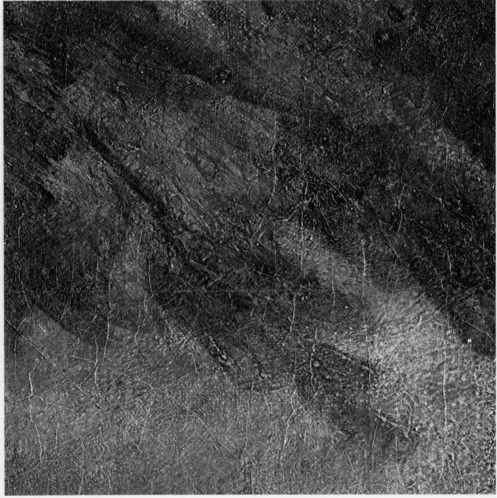

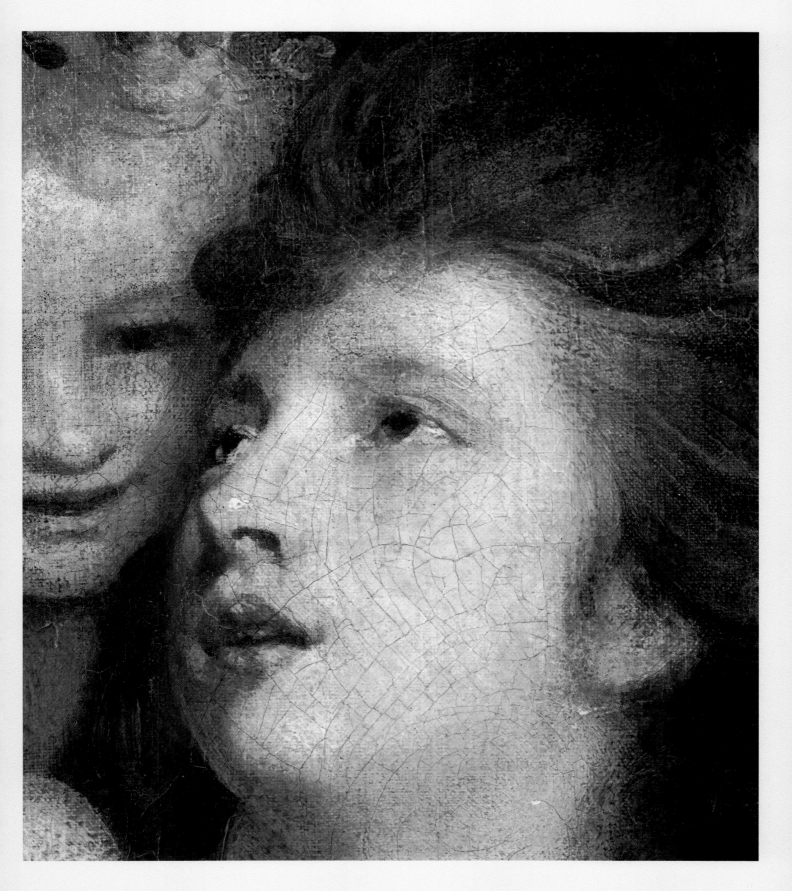

Thomas Gainsborough

(born 1727, died 1788, English portrait and landscape painter)

Portrait of the Artist's Wife

painted c.1778, oil on lined canvas, $30\frac{1}{4} \times 25\frac{1}{4}$in (77 × 64·5cm)

Gainsborough was apprenticed around 1740 to a French engraver, and this training is reflected in his style. His main introduction to painting came through the copying and restoration of seventeenth century Dutch paintings. Besides being a prolific artist, he became a founder member of the Royal Academy in London in 1768.

Unlike Reynolds, Gainsborough confined his experiments with technique largely to paper. The majority of his easel paintings, however, testify to the wisdom of painting 'fat over lean' and to this day, many of the portraits done in his later years remain in sound condition and are almost free of craquelure and surface deterioration.

Our knowledge of the artist's materials is scant and unreliable, but his letters indicate a fastidiousness in the choice of pigments and varnishes. Gainsborough normally favoured varieties of a warm, red-brown colour for a ground described in contemporary texts as resembling 'tanned leather' and particularly recommended for landscapes.

Contemporaries of Gainsborough describe how he would begin work in a very subdued light, 'a kind of darkened twilight', which enabled him to assess his subject in terms of basic shapes and broad tonal areas, free from distracting detail. Probably over a preliminary cursory chalk drawing, he would set to work on the canvas with rapid strokes of black, umber, lake or white paint, followed by washes of thinned colour to 'block out' the form. These transparent washes, often so thin that they resembled watercolour, were to serve as a tonal underlay for further development.

The thin underlayers and half tones would begin to dry quickly, enabling Gainsborough to apply translucent, opaque, and glazing colours very rapidly in a largely wet-in-wet technique, either working into the washes or over them with translucent layers.

The drapery and background would be completed last by the artist applying colour in a welter of glazes and loose, dazzling, scumbled strokes – 'odd scratches and marks' – which, as Reynolds observed, only assumed form when viewed from a distance. Very often alterations can be seen with the naked eye, and X-rays reveal that changes were often undertaken when the painting was close to completion.

1. Gainsborough would place his model in a subdued light so as to better to assess the overall composition.

2. According to a contemporary, the artist would place himself and his canvas at a right angle to the sitter so that he stood still and touched the features of the picture at exactly the same distance at which he viewed the sitter.

3. Gainsborough would initially mark the position of the sitter's head in chalk often held in a pair of tongs to allow him to stand back from the canvas. When the painting was near completion, he would again use the chalk to mark alterations.

4. He would then block in the painting in thin paint. His daughter claimed that his 'colours were very liquid, and if he did not hold the palette right, would run over.'

5. Having blocked in most of the composition in thin paint, Gainsborough would concentrate on the head and the area around it, before returning to complete the drapery and background.

During the seventeenth and eighteenth centuries, artists kept their paints tied in small bladders. To extract some paint, the artist would prick the side with a sharp tack which had to be replaced to seal the hole.

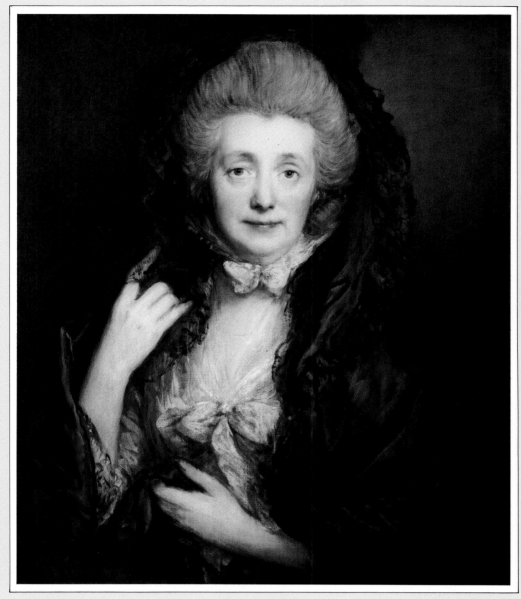

Gainsborough would first work from the model in a dim light allowing him to lay in the general tones of the larger areas, working quickly in rough washes of very thin oil which served as an under-painting for the subsequent development of flesh and drapery. Allowing more light on the subject, he would complete the head of the model. In this case, the eyes, nose and mouth appear to have been put in using a wet-in-wet technique, while the overall smoothness of the surface suggests the artist may have used a blender before applying the last touches as seen in the highlights in the eye, the strokes of red-brown in the curve of the eyelid, the line of the mouth and the dabs of colour for the nostrils.

Right
Gainsborough's use of a pale ground in this picture perhaps relates to his interest in transparencies lit from behind. As well as constructing an illuminated box, he and other artists painted some larger-than-life figures for a theatre in 1775 and one contemporary noted that 'these pictures are all transparent and are lighted behind'.

Actual size detail
In a technique resembling that of the watercolourist, Gainsborough has achieved enhanced luminosity in his flesh tones by painting thinly and allowing the pale colour of the ground to shine through. He is believed to have used a particularly pure white pigment, Cremona white, which he may have bound in poppy oil, as this was noted for its transparency and non-yellowing qualities. In view of Gainsborough's interest in creating a luminous effect, it is significant that, only a year or so after painting this picture, he constructed an ingenious illuminated box to show transparencies which were painted in oil and varnish on glass and lit from behind by candles.
In this detail, a single, fine line in grey paint is perceptible down the shadowed side of the nose, whilst the nostrils have been completed with two dabs of the dark pigment which is also to be found in the mantle on the left. On the right, below Mrs Gainsborough's ear, a stroke of thin flesh colour has been applied over black to soften the illuminated edge of her cheek.

This detail encapsulates much of the astonishing variety of Gainsborough's impulsive brushwork. It ranges from the brown washes of the bodice to the bravura scumbles and thick impasto of the bow to the bold zig-zag of the orange sleeve, which was applied with a hog's hair brush. In addition, the limpid flesh tones of the hand were painted *alla prima* with a bold stroke of red paint, outlining the thumb; and touches of black paint, rich in medium were applied over the scumbled strokes of the white ribbon. Traces of blue paint can be seen in the bow. The pigment is probably Prussian blue, although earlier in his career, Gainsborough is known to have used indigo, which often behaves unsatisfactorily in oil.

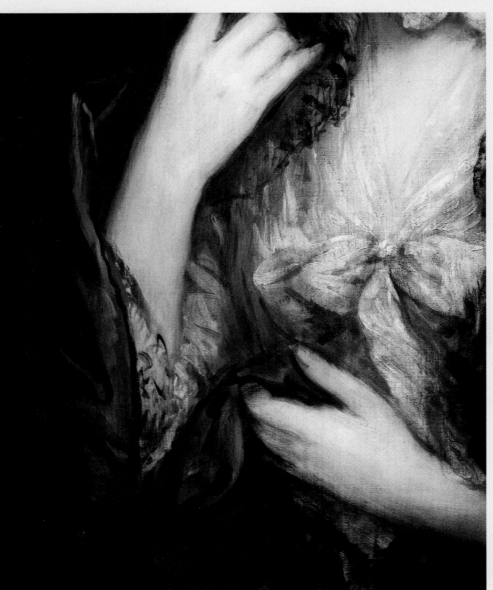

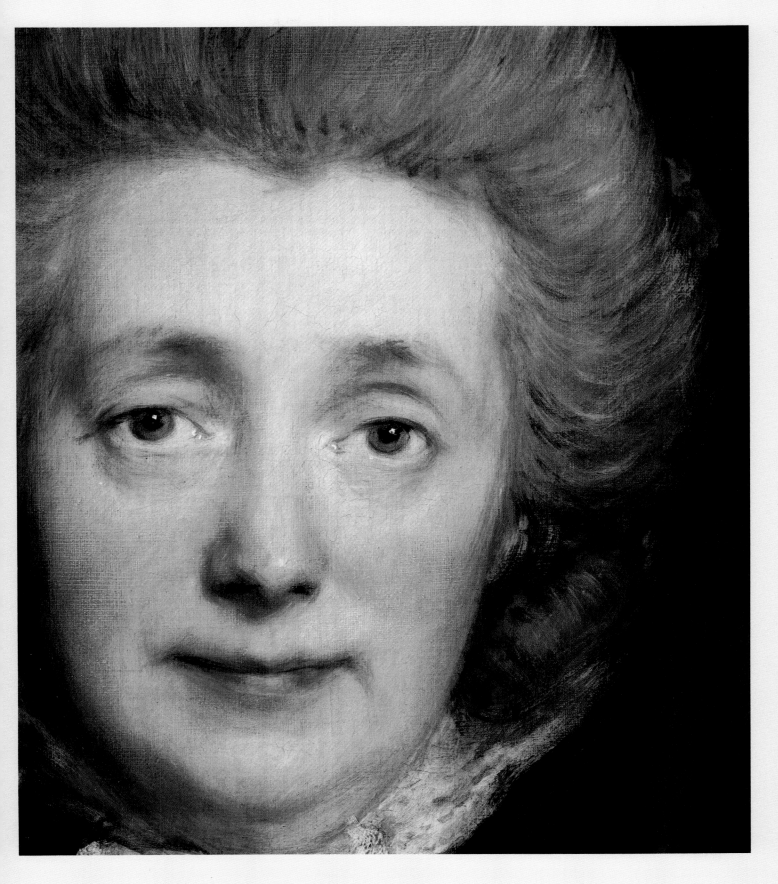

William Blake

(born 1757, died 1827, English artist, philosopher and poet)
The Body of Abel Found by Adam and Eve
painted c.1825, watercolour on wood, $12\frac{3}{4} \times 17$in (32×43cm)

William Blake was one of the most intensely individualistic of British artists. His works combine poetic visions and dramatic religious allegory in a sinuous drawing style. Blake, who trained as an engraver, is well known for his book engravings, watercolours, and for his poems. It is significant that he chose not to paint in oils at a time when this was the most acceptable medium, rejecting it in favour of a technique which he, inaccurately, described as 'fresco'. The words 'fresco W. Blake' are incised in the priming at the bottom right of this picture but this is not what is generally accepted as fresco. It is painted in a water-based medium more properly called tempera or distemper. Unlike egg tempera where egg is the medium, or gouache and watercolour where gum is used as the medium, Blake's medium was probably rabbit-skin or carpenter's glue. The glue would have to be applied very diluted or warmed.

Blake tried to produce the maximum brilliance and purity of colour in his works. It is important to remember that in Blake's formative years the artist's palette was still limited. Only later, with the development of new colours, could the artists experiment more.

Blake's tempera style, which was closely related to that of his engravings, watercolours and illustrations, relied heavily on line drawing. So Blake used a method which allowed the underdrawing to show through. He also avoided the heavy, opaque forms which characterized the work of most contemporary oil painters. Because of the brittleness of the glue medium when it dried, the final paint film was thin and Blake was unable to use impasto or to leave any thick, flowing brushmarks. The lightness of the ground which formed the highlights and emphasized the ground was crucial to Blake's technique.

Although Blake had read Cennini's work on tempera techniques, his understanding of the Old Masters' techniques was suspect. This caused him to make many mistakes before he found a satisfactory method, and, for this reason, most of his works have deteriorated. Movement of the support, ageing of the varnish and drying out of the glue have led to fine surface cracks and many small losses of paint. Nevertheless, Blake, over the years, evolved a method which allowed him to preserve the subtlety of his drawing and to use his skills as a colourist to achieve the effects he desired.

1. For this 'fresco', Blake used a mahogany panel. Good cuts of mahogany were readily available, and the wood usually made an excellent and stable support. However, this piece has since developed a marked convex warp.

2. Blake applied several layers of glue and whiting to the panel to cover the wood grain with an even, warm white, gesso ground. He probably rubbed the surface down and sealed it with more glue, as the surface is smooth and non-absorbent.

3. Next Blake drew a rough sketch probably with graphite pencil, working it up to a more precise drawing in heavier pencil, and black colour applied with a fine brush. A fine reed pen or quill may also have been used. There are no major alterations, and the drawing is clearly visible in the finished picture.

4. Blake then ground his pigments by hand in a dilute solution of the glue. The range of pigments was quite small and relied on traditional watercolour materials. The pigments seem to have been ultramarine, ochres, madder, black, Prussian blue, gamboge, vermilion and gold.

5. The painting was built up by applying paint in small strokes, each little more than a stain on the white ground. The white highlights of exposed ground have been left, like the unpainted paper in a watercolour.

6. When the painting had almost been completed, a few details were re-worked and strengthened.

7. On drying, the paint would lose much of its shine, so Blake applied further layers of glue and then a spirit varnish. The varnish was probably mastic in turpentine which would give the painting a glossy surface and saturate all the colours.

In this work, Blake used the following pigments: ultramarine (**1**), ochres (**2**), madder (**3**), black (**4**), Prussian blue (**5**), gamboge (**6**), vermilion (**7**), and gold (**8**).

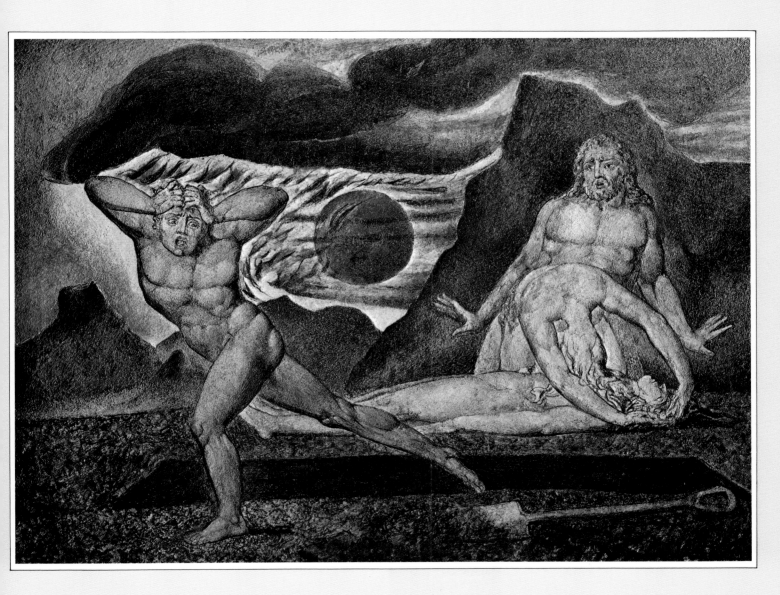

Actual size detail
The detail shows the finished ink drawing of the figure of Cain. The rough underdrawing can be seen. Most noticeably, minor changes have been made to the hands; the original positions show through quite clearly. The light area to the left of Cain shows the exposed gesso ground. The mountain has been painted slightly thicker, but the colours are still transparent. The blue-green shadows and thinly scumbled flesh tints on the figure were applied with a small brush. The flames around Cain's head, originally painted in vermilion and blacks, have, in many places, flaked away. The dark cloud is virtually opaque with shell gold highlights applied on top.

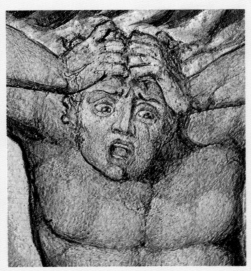

On the finished painting the paint film is thin and even, and there is virtually no impasto The brittleness of the dried glue limited the thickness of the paint and Blake could not rework without first rubbing down to the ground. The light ground is basic to Blake's technique, acting both to form the highlights and also to bring out the colours. The blue-green shadows on the flesh may be derived from the Italian true fresco paintings which Cennini had described. Blake has also used a fine powdered gold, called shell gold, which would have been applied in the same glue medium. The foreground green is made by applying a yellowish green glaze over the blue modelling. The colour probably includes a yellow lake or gamboge.

Blake was not totally consistent in using the transparency of colour which his method created. For example, the gold painted over the black and the vermilion in the sky are both opaque pigments whose colour is not dependent on the white ground.

John Constable

(born 1776, died 1837, English landscape painter)
Chain Pier, Brighton
painted 1827, oil on canvas, 50 × 72in (127 × 183cm)

The child of a prosperous Suffolk miller, Constable's youth had a profound influence upon his art and, long after he had moved, the landscape of his childhood continued to inspire his paintings. Many of his mature works were created from memory and also from many drawings and sketches of his early environment.

Constable was greatly influenced by the landscapes of Rubens and Claude and, although he had a formal art education, he found the copying of Old Masters the surest means to gain technical expertise in a period when traditional, practical knowledge was all but extinct. A contemporary recalled Constable's dual preoccupation with nature and the Old Masters: 'No one perhaps has given a greater look of studying Nature alone . . . than John Constable, but he told me he seldom painted a picture without considering how Rembrandt or Claude would have treated it.'

The degree to which Constable worked out of doors is debatable, as the practical problems of working on large, finished canvases outside would have been great. Constable painted only in daylight and a contemporary recorded his working methods, which involved working on the whole together . . . beginning with a faint dead colour in which the masses only are laid in, and proceeding with the details gradually, and without suffering one part to advance much beyond the rest, until the whole is finished . . . Indeed, in landscape, it seems impossible that those almost imperceptible gradations of colour and light should be obtained by any other process.'

For Constable, *chiaroscuro* was an effect to be obtained at all costs; and, in the pursuit of this, he evolved an expressive and unfinished execution, including the impasted flecks of white which offended many of his contemporaries.

This was particularly true of Constable's work after the 1820s when his subjects moved away from the logic of external reality. Delacroix commented that 'Constable says that the superiority of the greens in his meadows is due to the fact that they are made up of a large number of different greens. What gives a lack of intensity and life to the verdure of the ordinary run of landscape painters is that they do it with a uniform tint.' This is one of Constable's major technical achievements.

1. Preliminary sketches and oil studies were first done.

2. The stretcher with linen support and pink oil ground were probably made to order for the artist.

3. A pencil underdrawing was first made and then the masses established with washes of subdued colour.

4. A thin but opaque building-up of the surface commenced with details added.

5. Glazings of burnt red lakes and transparent earths were used to add depth and richness to shadows and foreground.

6. Freely knifed and brushed touches of off-white were used to give the quality of reflective light and sparkling of waves.

This drawing, executed in pencil and strengthened with lines in pen and ink on two sheets of paper watermarked 1824, was made by Constable when he visited Brighton in 1825 or 1826, in preparation for his painting. The elongated format captures the panorama of the Pier and the Parade, which recedes in a wedge shape into the distance.

Concentrating upon the complex central motif, the drawing serves to record accurately the salient features and perspective, which could then be transferred to the larger canvas. In the finished painting, the areas of both sky and foreground were greatly extended, while additional buildings, boats and figures gave compositional strength and unity.

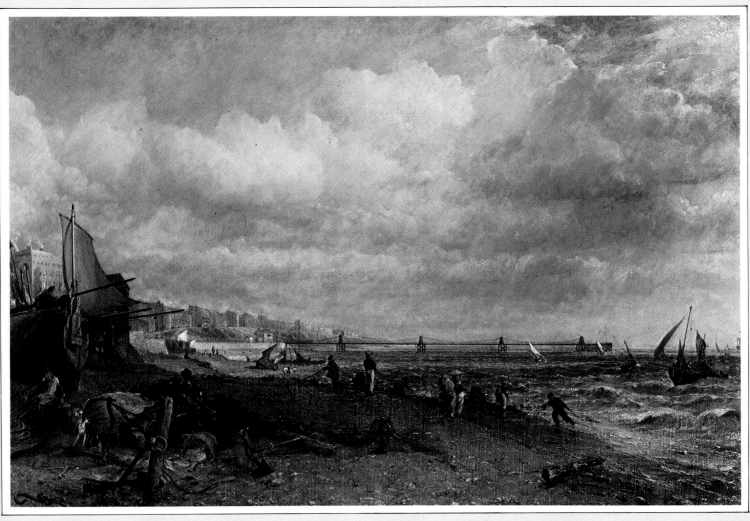

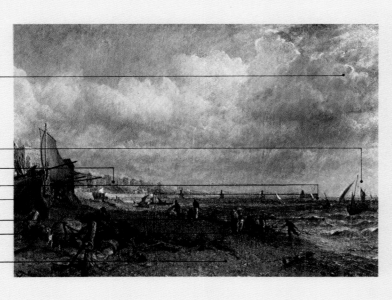

Thin scumbled layers

Fine graphic brushwork

Thin dry opaques

Overpainted sail

Glazed darks

Brushed impastos

Knife-flecks of white

Dragged knifework

Many changes were made in this painting during the course of its execution, with the overall format being reduced by about one-eighth of its original length. The length of the pier was extended by the artist, which necessitated painting out a sail boat which cut across the new position. Other adjustments included the addition of high-lights along the horizon which have obliterated part of a small boat; the shape of the upturned hull in the left foreground has been softened and rounded, and some of the incidental figures superimposed on the completed picture. A plain canvas with pink oil ground has been used and irregu-

larities in the weave appear where paint has been dragged across the surface. Very fine sable brushwork is contrasted · with delicate and free, but controlled, flicks and dashes of colour laid on with a knife to enliven the foreground and water. The flecks of off-white were used to create atmosphere, and Constable was heavily criticized for this. The dry paint consistency, used for distant, hazy buildings, contrasts with the richness of the foreground and varied scumbles and thin impasto of the sky. The palette is dominated by earth colours with touches of bright red.

The sky was of great importance to Constable who stated that 'It will be difficult to name a class of landscape in which the sky is not the key note, standard of scale, and chief organ of sentiment.' Constable devoted the larger proportion of his composition to sky which, through delicately scumbled veils of whites and blue-greys, captures the sullen moody light which pervades the scene.

Unlike the smaller incidental figures, most of the active foreground figures were anticipated in Constable's compositional layout. This dark figure was integrated amongst the sparkling lights reflected off the turbulent waves by the superimposition of flecks of off-white. Dark transparent greens give the deep sea effects, while scattered touches of knifework and blended strokes of stiff white depict the waves.

Finely controlled overlaid films of knife-applied earth colours create the broken colour and texture of the beach. The handling is boldest in the foreground to suggest its proximity to the viewer and to contrast with the subtler work which is intended to evoke distance. The accessories were freely executed with brush and knife.

Actual size detail
This detail illustrates Constable's varied and expressive handling which evokes a natural atmosphere. Delicate brushwork can be seen in the pier and outlines of the buildings and bathing machines which contrasts with the rich, dark paint in the foreground and thin impasto of the sky. Umber glazes were added to give the darkest shadows depth, and thin knifed layers of opaque earth colours were punctuated with flecks and dragged strokes of creamy off-white, giving atmospheric accents of light. Delicate, free touches of greens enliven the bank and add awnings to the hotel windows. They appear loose when viewed close-up but come into focus when seen from a distance. Superimposed tiny figures animate the scene.

Layers of reworking characterize the skyline, where tiny sailing boats added for interest have themselves been partially over-painted when the highlights on the horizon were strengthened.

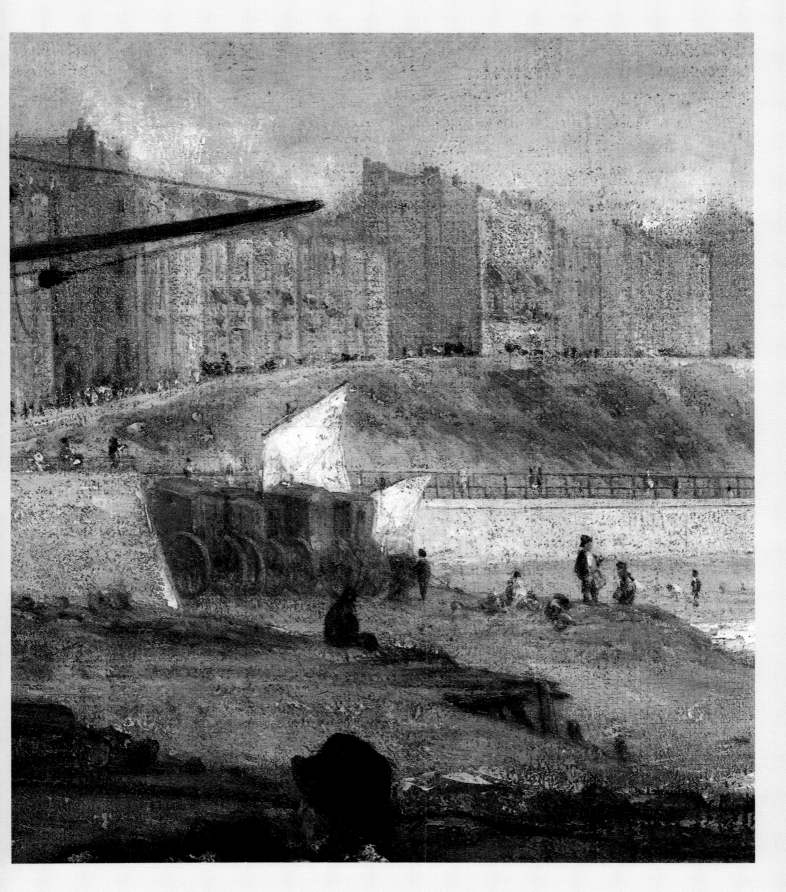

Jean-Auguste-Dominique Ingres

(born 1780, died 1867, Neoclassical French painter)
Oedipus and the Sphinx
painted 1828, oil on canvas $6\frac{7}{8} \times 5\frac{3}{8}$in (17·8 × 13·7cm)

Ingres, the first great radical of the nineteenth century, created a personal, sensual style that moved away from the grand manner of the late eighteenth century Neoclassicists and evolved a new, individual idealization of form through an expressive use of line. Thus, despite a formal and academic training, Ingres' technique was unconventional and brought an intuitive and intimate grace to the stoic Neoclassical ideal.

Reacting against the sombre brown and red earth grounds of Rococo art, the Neoclassicists used pale preparations which ensured luminosity and durability. As oil paint tends to become transparent with age, pictures done on dark grounds appear to 'sink' as the ground becomes increasingly visible. Thus, on dark grounds, much of the subtlety of transparent shadows and delicate half-tones disappears with time. Artists had long been aware of this problem and felt that paler grounds had obvious advantages. However, they were more difficult to work on as they made the calculation of tones difficult unless the entire surface was covered. Dark grounds also expedited the artists' work by acting as a middle tone when left exposed between opaque highlights and any dark, transparent shadows. Ingres had a preference for strong, fairly coarse canvas, a rarity among Neoclassical painters who had followed the common rule that figure painting should be executed only on finely woven canvas the weave of which was invisible at the viewing distance.

In addition to his use of pale grounds and rough canvas, Ingres also broke with tradition by using white in his shadows. *Chiarascuro* painters had felt that transparency was essential for producing depth, and Ingres' innovative use of white created a new low-relief flatness. As well, Ingres' opaque shadows reflect his preference for soft, full-faced lighting which differed from the dramatic cross-light found in the work of earlier Neoclassicists.

Ingres' paint was thin and fluid, his touch, lively and descriptive, only blended in the figures. Although he was often considered a 'monochrome' painter who used colour as an afterthought, Ingres' flat areas of bright colour have a powerfully emotive and visually seductive effect not yet seen in painting of that century which influenced many later artists.

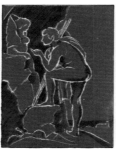

1. A medium weight, irregular weave canvas was primed with a thin darkish red ground.

2. Ingres began with a graphite or chalk drawing to establish contours.

3. These were reinforced and thin shadows executed in a dark brown, probably raw umber. Also with this fluid wash the main features, such as the hair, were drawn in with a fine soft brush and fluid wash.

4. Modelling was built up in carefully gradated tones of light and shade. Flesh areas were smoothed and tones blended with a fan brush while the paint was still wet.

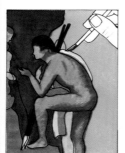

5. Highlights and individual accents of thick paint were added last.

Actual size detail
Backgrounds, such as the sky and rocks, were created with thin unevenly brushed opaques which allowed the red ground to show through.

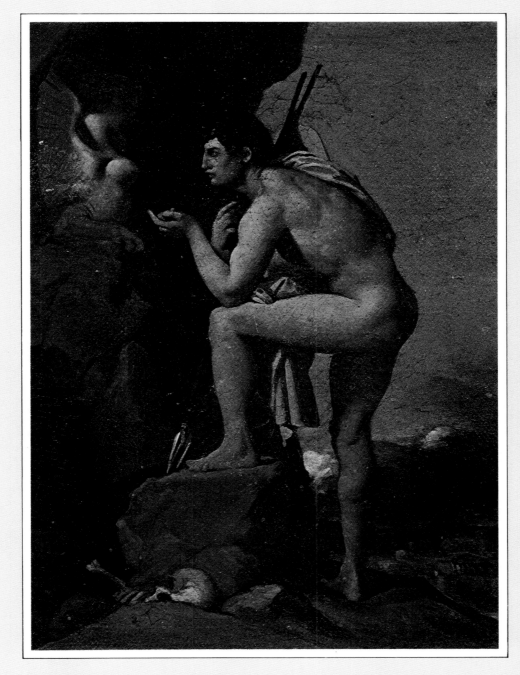

The exposed canvas texture in this painting was unconventional for Neoclassical painting in which smoothness of finish was advocated. The weave is consistently visible in the painting and must have made the delicate handling of the paint difficult. Unusual for Ingres is the use of a dark red ground. The paint layer is thin and opaque. The ground is actively used to create an atmosphere of dark foreboding and warms the flesh tones. It is not, however, used as a middle tone as was common in *chiarascuro* painting. The paint quality is generally fluid and rich, and the background thinner and leaner. Ingres has used a sombre palette dominated by browns and earth colours, occasionally punctuated with brighter colours. Ingres rejected the then commonplace use of bitumen as a brown, because he recognized the dangers of using this transparent dark brown which never dried thoroughly and caused serious cracking and bubbling on numerous paintings of the period.

Eugène Delacroix

(born 1798, died 1863, French Romantic artist)

Taking of Constantinople by the Crusaders

painted 1840, oil on canvas, $161\frac{1}{2} \times 196$in ($410 \times 498$cm)

Delacroix, the great Romantic artist of nineteenth century France, received a Neoclassical training and, while his first major work reflected this in its frieze-like composition and sculpted modelling, the passionate, melancholic themes and colouristic genius that were to characterize the artist's mature work were already visible. Delacroix's handling of colour in this early work was influenced both by Rubens and observations of nature, and was the starting point for his experiments in the juxtaposition of complementary colours, so influential to later painters like the Pointillists.

Delacroix's use of colour combines the results of observing nature with a personal abstract quality. Thus, while the overall harmony created may owe little to recorded nature, the touches of complementary colours in the shadows and the rendering of reflected colour show the artist's careful observation of natural effects. Despite his awareness of natural light, however, Delacroix never entirely abandoned the cool, studio light with its warm shadows.

Delacroix understood the importance of colour in bringing a natural appearance to a picture and this, linked with the luminosity of shadows, which he observed in the work of Veronese, led him to replace the darks of traditional *chiaroscuro* with a more natural representation of outdoor shadows and reflected colour. Delacroix made numerous watercolour studies and annotated drawings out of doors, was familiar with colour theory, and experimented with absorbent grounds in the Venetian tradition. As well, he experimented with various media, and some of his recipes for working in oils over washes of water-based paint came from friends who were known to have painted theatrical scenery.

Delacroix's brushwork, like his colour, has an existence almost independent of the forms represented, yet it is vigorously descriptive in evoking texture and building solidity. The paint is often thinnest where it depicts the turning of form in space, and thickest where it appears nearest the spectator. The handling of foreground and background are similarly contrasted, with immediate subjects painted thickly and boldly and distance created with a diminishing touch, thinner paint, and hazier definition.

1. Delacroix worked from many preparatory compositional sketches, oils, and studies of individual figures.

2. The canvas was made to order and may have been one of Delacroix's experiments with absorbent glue-chalk grounds in which he wished to emulate the techniques of the Venetians or Rubens.

3. Preparatory drawing is no longer visible; dark brown contours and the main lines of the composition were put in followed by thin washes to establish masses of light and shade.

4. Forms were built up working from dark to light and both fairly loaded with colour.

5. Shadows were reworked later in the painting process with additions of reflected colour.

6. Contrasting individual strokes of orange and green were then added over dry paint to enliven shadows in the flesh.

7. Contours were left thinnest with paint built up, for example on the flesh areas, to imitate the roundness of form.

8. Details of texture, like the armour and horse's hair, were added loosely and thickly. Glazes were added, and, when these were dry, the painting was varnished.

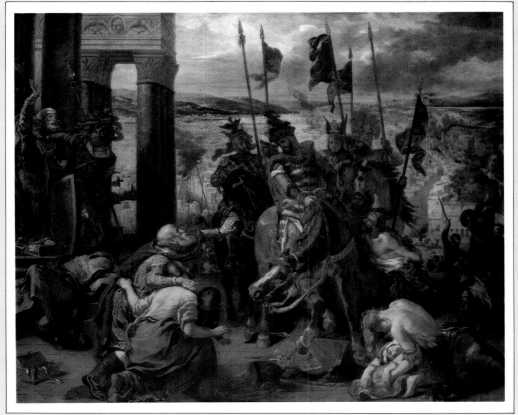

The painting was executed on a pale ground which shows through where the paint is thinnest and most transparent. Colours are built up thickly and opaquely even in the shadows. The paint is thinnest where the contours depict the turning away of form, and most thickly applied where rounded forms project towards the viewer. The composition is split into foreground and background, with little middle ground. Generally, brushwork follows form and, on flesh areas, highlights are applied in a dry, pastel-like paint. Colour contrasts are widely exploited with an extensive palette and colour mixing.

Actual size detail
Delacroix's brushwork is lively and crisp in the foreground becoming softer, and more blurred to render distance in the background. The thick, juicy texture of the foreground paint changes to a thin, dry, and scumbled passages in the background.

This study for the *Taking of Constantinople by the Crusaders* was drawn in pencil by Delacroix in 1839 or 1840. The annotated colour circle shown here as two overlapping triangles is the earliest definite proof of the artist's knowledge of the theory of complementary colour contrasts published by Chevreul in 1839. Chevreul's theories reinforced Delacroix's own intuitive handling of colour.

William Turner

(born 1775, died 1851, English landscape painter)
Snowstorm
painted 1842, oil on canvas, 36 × 48in (91·5 × 122cm)

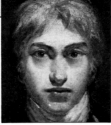

Born and bred a Londoner, Turner's precocious talent took him at the age of fifteen to the Royal Academy Schools and the Royal Academy Summer Exhibition of 1790. Nine years later, at the youngest permissible age, he was elected an Associate of the Academy which supported him through the criticism and misinterpretation which was to plague his career.

Turner was influenced by the architectural watercolourists with whom he worked as a boy, and his mature style combined a respect for the Old Masters, the ideals of eighteenth century artists, and the originality born of the individualism of the Romantic movement. He was also fascinated by the scientific ideas of his age and studied colour and light theory, particularly the importance of yellow which was felt to be the closest colour to 'the production of a white light'.

Turner's atmospheric light effects have been described as being 'invented', despite his commitment to work from nature. He preferred using pencil outdoors, as he found even watercolour time-consuming and inhibiting. In his early work, Turner exploited the dark warm grounds typical of eighteenth century landscapists; later, his grounds became paler and his mature works were generally executed on a white ground which enhanced and extended the brilliant colours which characterized Turner's palette. From the start, Turner adopted broad underpainting, using a variety of washed colours, rather than the more usual monochrome. Pinks, blues and yellows predominated in his underpainting which both established the composition and gave an emotive atmosphere to the colouring which was added subsequently.

Turner's use of colours, overlaid on the canvas rather than mixed on the palette, was described by a friend as approximating to 'the excellencies of Venetian colouring'. Turner depended as much on the use of scumbling as on glazing, but always the softness of these effects was counteracted by the tough and abrupt application of a thick, dense paint surface. This process of superimposing thick layers, toning them down and then returning to them was a source of fascination in Turner's technique which produced, in the in the words of a contemporary: 'solid and crisp lights surrounded with ethereal nothingness'.

1. A white, fairly thick oil ground was first applied on a plain linen canvas.

2. Underpainting followed using bright colours diluted with turpentine.

3. Stiff, thick layers were brushed on or applied with a knife, sometimes wet over dry to create jagged, swirling effects.

4. Thinner paint was applied with a brush to delineate outlines and details, and compositional changes made.

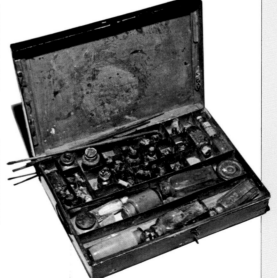

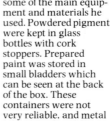

5. Scumblings and glazings were then worked over dry paint to enhance the richness of the colour and evoke an ethereal quality.

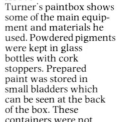

6. The painting was varnished and framed, gold being Turner's preference.

Above
Turner's paintbox shows some of the main equipment and materials he used. Powdered pigments were kept in glass bottles with cork stoppers. Prepared paint was stored in small bladders which can be seen at the back of the box. These containers were not very reliable, and metal tubes introduced from around the 1840s proved much more satisfactory. Turner seems to have used fairly large round and flat bristle brushes.

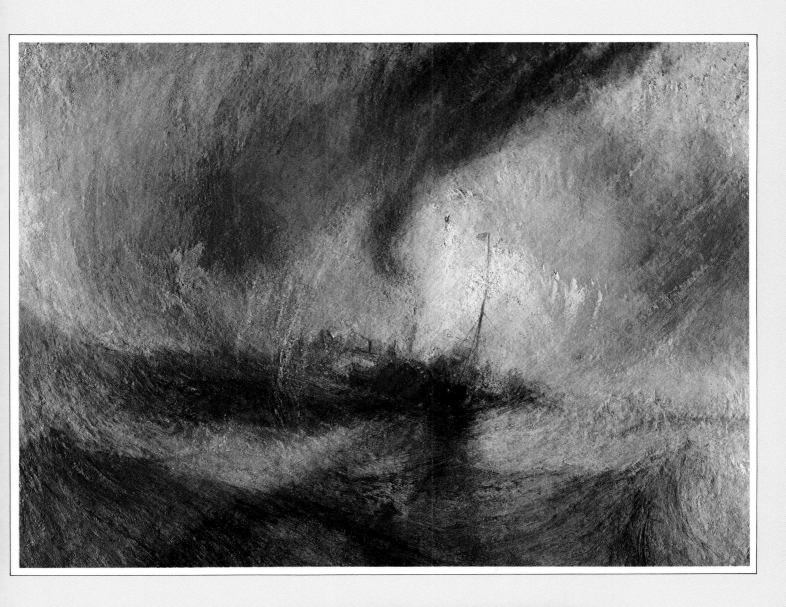

Turner often used double canvases with two layers of linen left loose. These were often primed on both sides for protection. The canvas texture was not used in the painting process due to the thick ground. Thin washes were probably used to create the chief compositional structure, although they are no longer visible. The paint surface has been built up by the over-laying of stiff, impasted colours dragged over one another to create a broken effect. The paint quality is dryish with blacks and dark glazes added in a thin consistency. The paint is concentrated mainly on the development of lights using dirty white and yellows in scumblings and impasto worked wet over dry.

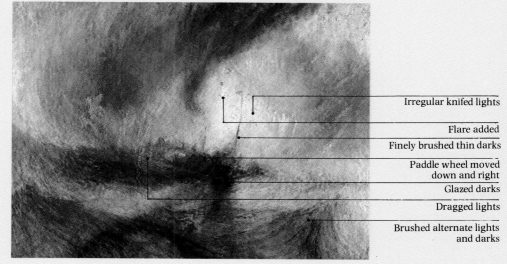

Irregular knifed lights

Flare added

Finely brushed thin darks

Paddle wheel moved down and right

Glazed darks

Dragged lights

Brushed alternate lights and darks

Right
Thick layers of stiff
impasted colour were
reworked with scrapings
of dryish off-whites and
creams, which were
dragged across the
irregular surface to
give a jagged, crusty
effect. Thin darks and
scumbled whites were
built up over dry colour
in alternate partial
layers. Both a painting
knife and stiff hog's hair
brushes were used.

Top middle
Although Turner is
considered to have
referred less frequently
to nature in his mature
and late works, he did
stress the importance
of observation in this
picture, recounting that
he had himself been
lashed to the mast of
the packet-boat Ariel
to record the scene.
However, the im-
practicability of such a
method would suggest
the record was
imprinted in his
excellent memory
rather than on canvas
on the spot.

Top right
Turner's almost feverish
striations of irregularly
applied thin and thick,
dark and light paint
evoke the swell and
movement of the stormy
sea. This builds up over
the whole canvas, where
the marks suggest a
clockwise movement
around the central pivot
of the boat. This creates
a swirling vortex which
depicts wind-whipped
sea and snow.

Actual size detail
Turner's thick,
application of paint can
be readily seen in this
detail. While the lighter
yellow areas have been
applied almost certainly
with a knife and stiff
brush, the fine details
of the mast and rigging
were done with a soft,
sable brush. Turner
built up broken whites
and yellows first with
scumbles and thinner
glazes of darks applied
after. Turner would
rework these with
thick scrapings of dryish
white paint, dragging
further layers of thick,
dryish paint across the
textured layer to create
his atmospheric, hazy
effect. The fine cracks
in the paint surface
indicate its thickness,
and perhaps Turner's
tendency to add
extenders and stiffeners
to the paint.

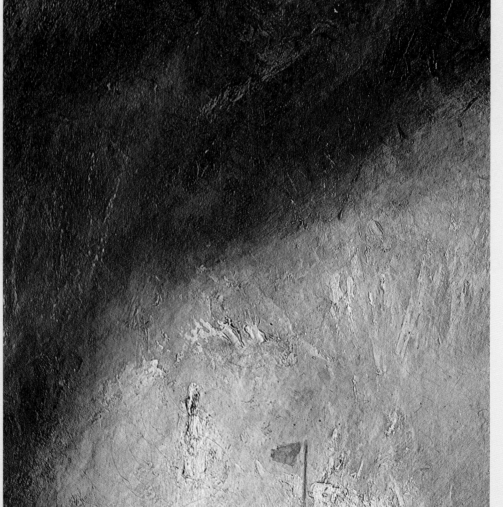

Left
The stiff, buttery
yellowish paint knifed
on here as part of the
central focus of the
composition, is a
reminder of Turner's
notion, culled
from contemporary
scientific theory, that
yellow was the colour
which most closely
approximated the
phenomenon of white
light. Using a variant
of classical landscape
compositions, he
concentrated the lightest
parts in the centre of
the picture.

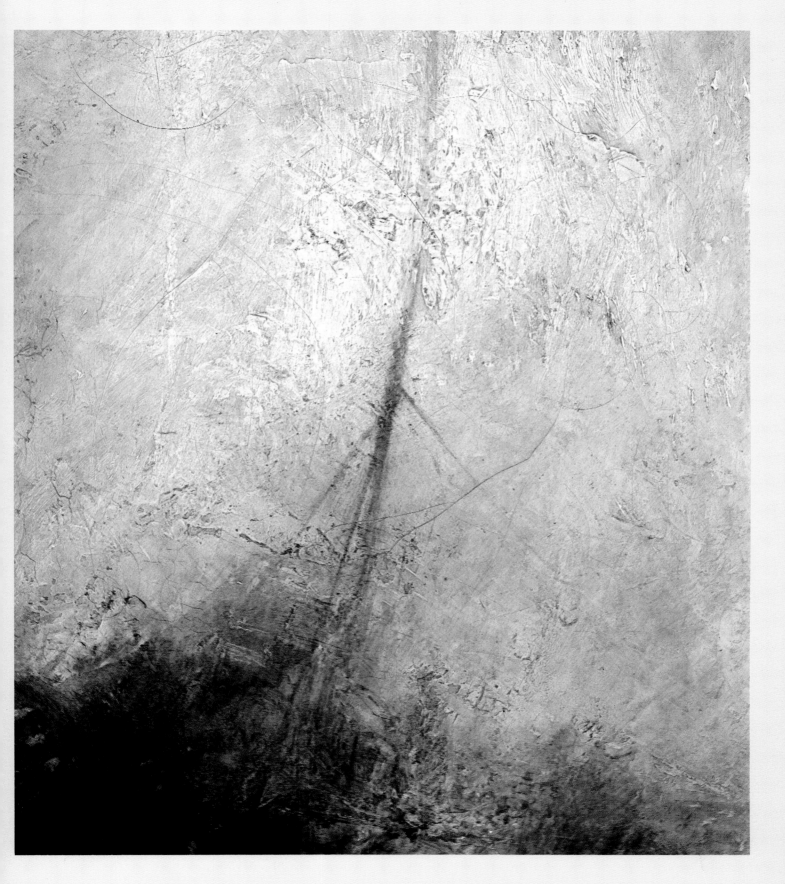

Jean Millet

(born 1814, died 1875, French genre painter)
Le Départ pour le Travail (Walk to Work)
painted 1851, oil on canvas, $21\frac{7}{8} \times 18\frac{1}{8}$in ($55{\cdot}5 \times 46$cm)

Influenced by Poussin, Michel-angelo, Dutch seventeenth century painters, and French eighteenth century art, Millet immortalized the agricultural worker brought to the fore by the Revolution in 1848. Although a well-read and educated man, Millet's Realist subject matter reflects his peasant origins. His subjects included the labours of the field, times of day and seasons and, generally, the unending toil of the labourer on the land.

Millet worked from memory, studies from life, and models posed in the studio. He was not an out-of-doors painter, and his is the cool light of the studio with its warm, contrasting shadows. Often employing the earth colours, Millet's paint surfaces echo the soil which he painted. His heavily worked shadows and lights are in the tradition typified by the eighteenth century French still-life and genre painter Chardin. Late works exploit brightly tinted grounds giving an effect of coloured light.

The paint quality is stiff and impasted in the highlights, thin and fluid in the middle tones and shadows – a traditional method, although elsewhere, Millet's shadows are unconventional in the heavy use of impasto. There is an active dialogue between the paint layer and ground in the darks and middle tones; impasted areas obliterate the ground but maintain the brilliance of pale areas which, over a dark ground, would sink with time. Modelling of flesh is handled with simple contrasts of light and shade with most of the middle tones suppressed. Millet's crusty paint surfaces were enlivened by dragging stiff, dryish colour across dry paint on textured canvas, creating a characteristic stippled, broken effect.

Millet's graphic techniques were comparable to his oil techniques in their power to evoke texture and light. His large pastels in particular were built up with a web of pale powdery colour strengthened by firm, fluent outlines of skilled draughtsman, which are also seen in his paintings.

His handling of water in oil paint exploits the transparency and opacity of the pigments to imitate natural effects. Thus, the transparency of water in the shade of dark reflections is rendered with fluid, thin, transparent browns over a pale ground, while the surface reflections of sky and light are represented by opaque, broken whites and blues.

1. A ready-primed canvas was used on which a thin ground of white or off-white had been applied.

2. Charcoal or black chalk was used to establish the main compositional lines.

3. A thin wash was used to strengthen outlines and lay in main shadows: raw umber for landscape and burnt umber for figures.

4. Highlights and deeper shadows were then added, with the initial wash showing through to create the middle tones.

5. Thick, opaque lights were applied in a dryish crusty paint consistency.

6. The landscape was worked very lightly with an opaque greenish scumble whose translucency allowed the initial wash to show through.

7. Contours were worked and strengthened with a soft-haired brush and diluted umber.

In this work, Millet used the following colours: earth colours (1), black (2), white (3), a mixed blue-green (4), iron oxide red or vermilion (5).

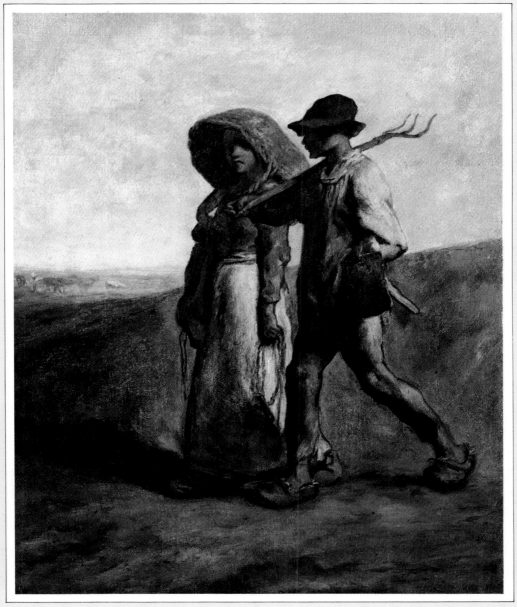

The Walk to Work is typical of Millet's treatment of light in the stiff impasto and contrasting use of thin, transparent passages which reveal the pale ground beneath. The light comes from two conflicting sources, the back and side. Millet used a *chiaroscuro* technique in the manner of Dutch and Flemish painters to create this dramatic lighting. The brushwork is graphic and descriptive, evoking forms and textures. Millet used a limited, subdued palette dominated by earth colours, black and white. A mixed blue-green recurs throughout Millet's work, and an iron oxide red is used to add warmth.

This detail shows how Millet used the initial blocking-in of forms with a thin umber wash as a middle tone. The dark paint has gathered in the interstices of the canvas weave, giving a speckled appearance where the white ground glows through the thin transparent umber to create depth in the shadows. A thin scumble of opaque green has been laid over the browns to indicate the grassy background.

The Gooseherdess is another painting in which Millet exploited contrasts between loaded impasto in the lights and thin transparent films in the shadows. The contrast is here used effectively to imitate the natural appearance of water with its transparent depths and reflected, opaque lights; it makes an interesting comparison with Monet's entirely opaque handling which also creates a remarkable illusion of water.

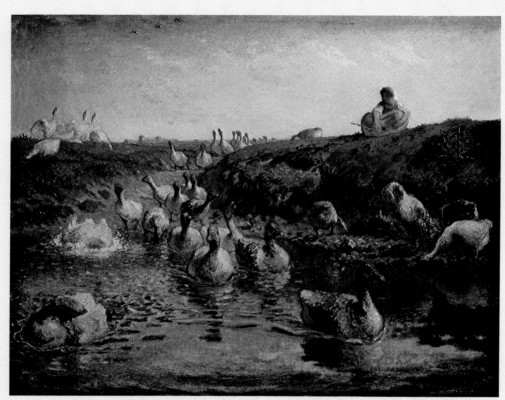

In Millet's confident, draughtsmanly execution, the brushstrokes follow the form of the clogs, while the man's legs are sculpted in strong contrasts of light and shade concentrating upon the muscular form beneath the barely indicated trousers. Further working might have built up the texture of fabric on the underlying form. Thin transparent darks reveal the white of the ground and the texture of canvas, and thin opaque scumbles separate the background from the figures.

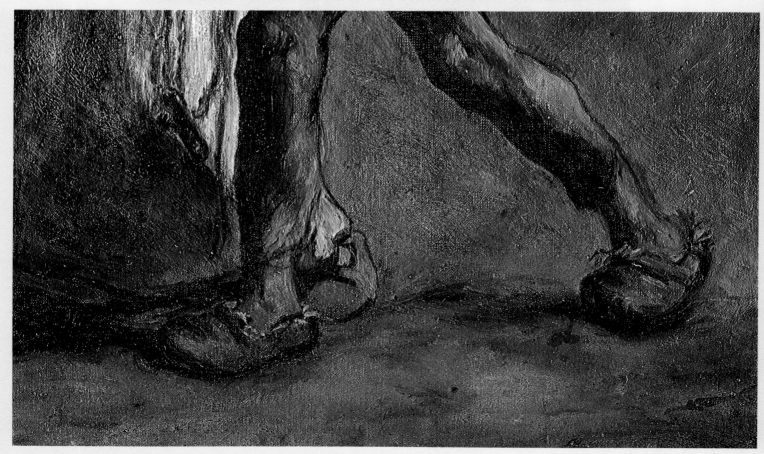

The side light catches the heads, sculpting them in simplified blocks of opposed light and shade; both are equally loaded. Stiff brushwork is clearly visible in the creamy paint of the sky, which was worked up around the outlines of the heads. A strong dark contour has been left visible following the line of the man's neck. The shape of the pronged fork has been accentuated, the original curve of which has become visible with time as the stain of raw umber has appeared through the pale paint of the sky. The power of the image is enhanced by the shadows which add weight to the figures.

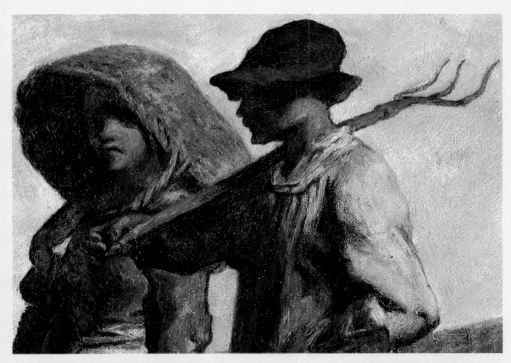

Millet's vigorous handling and simplified, statuesque forms give a timeless grandeur to the harsh reality depicted. The stiff, buttery paint consistency retains each mark of the brush, which is exploited to convey the rough texture of home-produced fabric and the coarseness of work-hardened skin. Millet's surfaces were described by a critic as of 'a paste thick like mortar, on a harsh rough-grained canvas, with a brush broader than a thumb . . . this dish-cloth canvas daubed with ochre and black.' However, this summary underestimates the subtlety and delicacy of Millet's techniques.

William Holman Hunt

(born 1827, died 1910, Pre-Raphaelite British painter)
The Awakening Conscience
painted 1853, oil on canvas, 30 × 22in (76·2 × 55·8cm)

This painting had been chosen as a relatively early example of the work of the Pre-Raphaelite Brotherhood which was founded in 1848 and of which Holman Hunt was a founder member. Other members included John Everett Millais and Dante Gabriel Rossetti. The Pre-Raphaelites, as their name suggests, tried to emulate works of the *Quattrocento*, but, to achieve their results, they used the newest possible materials. For example, Hunt used recently introduced pigments such as emerald green, which had first been prepared in 1814. The group discussed the kind of painting which they felt would revolutionize their art and also shared their experiences with materials and techniques. The members of the group later diverged, but Hunt stayed closest to their original aim of rejecting the idealization of nature associated with Raphael and his successors and returning to a more immediate and realistic representation of the world, combined with a rather romantic view of medievalism.

Technically, Hunt was both well-informed and cautious, comparing his use of materials with those of the Old Masters. Hunt placed great importance on the permanence of his support, medium and pigments, and rejected those which he knew to be faulty. For example, he avoided the mistake of using bitumen as a brown, which has caused many nineteenth century paintings to deteriorate. He followed closely the experiments of the chemist George Field, who was concerned with the permanence of colours. Hunt used a rich and relatively thick medium made of poppy oil and copal resin. Hunt found that this medium was easy to work and did not contract excessively on drying; it remained tough and flexible even when applied thickly. This indicates the quality Hunt desired in an oil painting, which is illustrated by his criticism of the thinness of Gainsborough's paint, which gave an effect 'too like that produced by a watercolour to be satisfactory in a large painting'. *The Awakening Conscience* is typical of Pre-Raphaelite work in its moral emphasis and realistically depicted detail. The lavishness of the room and of the woman's dress and jewellery reflect the material rewards of her sin in becoming the man's mistress. The gilt frame is an integral part of the effect of tonal and textural richness which Hunt wished to create.

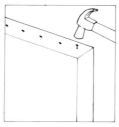

1. The original canvas was made of fine plain linen, ready primed with a thin white oil ground. It was probably ready stretched with a 'blind' stretcher, which protected the back of the canvas.

2. Although the canvas and stretcher came from a good and expensive colourman, Hunt was not satisfied with the ground. He applied at least one further layer of white pigmented oil ground. This produced a thick, smooth layer.

3. To make his medium, Hunt melted copal resin, dripping it into warmed turpentine and then added equal amounts of oil. He probably used either poppy or stand oil. He then ground the pigments into this medium.

4. He chose the medium as it is easy to work, does not contract too much on drying and stays tough and flexible even when applied thickly.

5. Hunt now drew the composition using paint thinned with rectified spirits of turpentine.

6. Hunt applied the paint to an area and worked until the finished effect was achieved before moving on to the next area. The shadows were created by applying scumbles and glazes over the priming.

7. When the painting was complete, Hunt applied mastic varnish to all the painting except the main figure. Varnishing was standard practice; it was intended to be glossy and saturate the colours.

8. The picture was placed in a carved and moulded wooden frame which had been applied with gilt. Hunt designed, and possibly made, the frame himself.

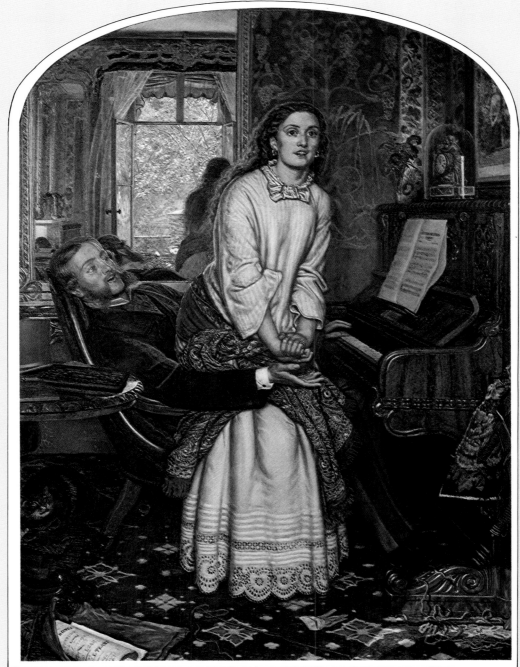

The picture illustrates a moral in a heavily emphasized way. The woman, who wears no wedding ring, is the man's mistress. She is shown at the moment of realizing her sin. Her face was originally more contorted, but Hunt was persuaded to change it as the owner of the work found it too distressing. Hunt later regretted making the change. The alteration, however, cannot be detected in the picture. The painting is realistic in detail but not in terms of proportion or perspective. All the important objects are in focus and given equal priority. The draughtsmanship appears uncomfortable when viewed from a distance. Hunt had problems in placing the man's arm, the reflections in the mirror are confusing and the folds on the woman's dress are a little contrived. At the end, a layer of mastic varnish was applied to the whole area, except the face; this led to the paint cracking. This area was later retouched. Nowhere is the ground exposed. It lends intensity to the strongly coloured areas, but the light highlights are completely opaque. This technique combines well with the versatile medium and bright pigments which Hunt used.

Actual size detail
This detail shows different styles of painting. The imprecise treatment of the picture and the wall contrasts with the precision of the clock and flowers A thick, treacly medium was applied evenly and worked patiently until the correct effect was produced. The highlight on the clock case is a thick, white brushmark, applied on top of the rest of the paint, while the flowers were painted relatively thinly with no impasto.

Gustave Courbet

(born 1819, died 1877, French artist of the Realist School)
The Meeting or Good-day Monsieur Courbet
painted 1854, oil on canvas, 51 × 58¾in (129 × 149cm)

Leader of the Realist movement in painting, Courbet brought new meaning to a style which, during the 1830s and 1840s, had given a rustic and charming view of rural life to the Parisian public. Not only was his class-conscious subject matter alien to both public and critics, but his uncompromising and vigorous painting technique, evolved specially to treat rural themes, was highly innovative. Courbet's subject matter was largely autobiographical immortalizing the common people, the middle and labouring classes of his provincial home town.

Monet recalled that Courbet 'always painted upon a sombre base, on a canvas prepared with brown'. This statement, however, is deceptive. While Courbet used earth-coloured grounds for his largest works, for smaller pictures he bought commercially available, ready-primed canvases with pale grounds and, when the ground did not suit his requirements, he simply added his own. In some of Courbet's works, especially the seascapes, where a dark ground was used under a thin paint layer, increasing transparency of the latter has allowed the ground to dominate and darken the original effect.

Courbet's robust paint surfaces echo the subject matter of his pictures and his frequent choice of shallow pictorial space was complemented by the rich plasticity of paint handling. He was renowned for his dexterity with a palette knife with which he applied thin skins of opaque colour that snagged previous layers, producing a delicately, colour-modulated surface. The application of paint with a knife draws the oil binder to the surface and, while susceptible to yellowing with age, the technique gives a smooth buttery look unobtainable by other means. Courbet contrasted knifework with textured brushwork, which he often reserved for flesh, fabric and hair. Other methods, like dabbing colour with a rag to create the texture of foliage, were also used.

Courbet's sombre, predominantly tonal handling gave his landscapes the browns of studio shadows imposing the *chiaroscuro* of interiors even on his outdoor studies. His late seascapes, however, show a move towards the cool blue shadows and diffuse light which are associated with natural atmospheric contrasts and effects.

1. A ready-primed, non-standard format canvas was used with a thin white ground, leaving the canvas texture strongly in evidence.

2. Figures and details were sketched in with thin brown paint and the background indicated with finer brushwork.

3. A thin, knife-applied skin of raw umber provided the base colour under the road; elsewhere scumbles of local colour were laid in broadly.

4. Figures are carefully and fully worked up with bold but delicate brushwork.

5. Courbet used a knife for the layered ochres of the road and fine dragged brushstrokes to evoke the distant landscape.

6. Texture of foliage was created by dabbing the picture with a crumpled rag dipped in paint. The painting was varnished upon completion.

In this work, Courbet used a fairly sombre palette of: earths (**1**), black (**2**), viridian (**3**), mixed greens (**4**), cobalt blue (**5**), iron oxide red (**6**), lead white (**7**).

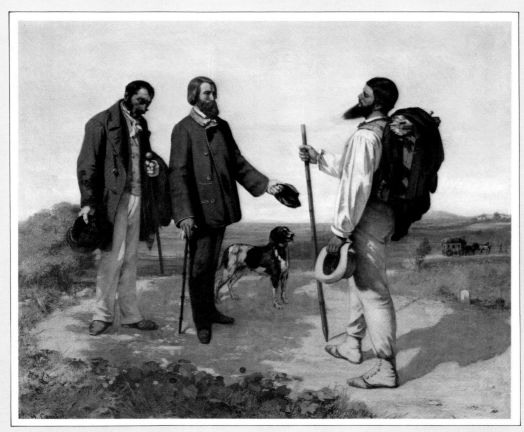

In this painting, Courbet's practice of laying in a dark ground over the pale commercial priming has been abandoned to convey the luminosity of the bright, Southern light. A variety of techniques evoke form and texture: dragged layers of knife-work, wet-in-wet, and colour dabbed on with a rag. The paint layer is varied in thickness, but uniformly opaque, with white lightening a subdued palette dominated by earths, black, viridian, mixed greens, and blue, probably cobalt. Concentrating on the figures, Courbet worked from dark to light and shadow to highlights, with constant adjustments to both.

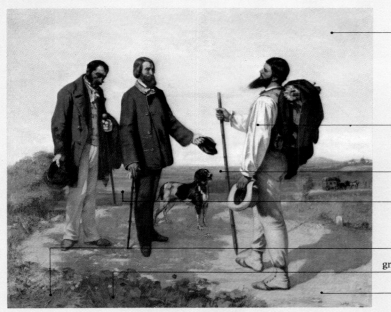

Thin opaque films and overlaid scumbles

Rich brushed impasto

Delicately brushed hazy tints

Dragged, stippled knifework

Canvas texture, white ground and green scumble

Boldly brushed details

Knife-applied paint

The light comes from front left, accentuating the central figure's strong nose and profile. Colours are opaque and broadly but deftly handled in general masses of light and shade, stark against the pale blue of the sky.

The receding carriage gives the only articulation of middle-ground in the abrupt landscape. The grass at the bottom was depicted by dabbing colour over the initial blocked-in green with a rag dipped in paint. This produces an effective, rugged texture.

The dog, executed in lively, hair-evoking brushwork, seems to have been completed after the landscape and the shadows were added around the dog. The broad, colourful handling of the foreground contrasts with the pale delicate skyline.

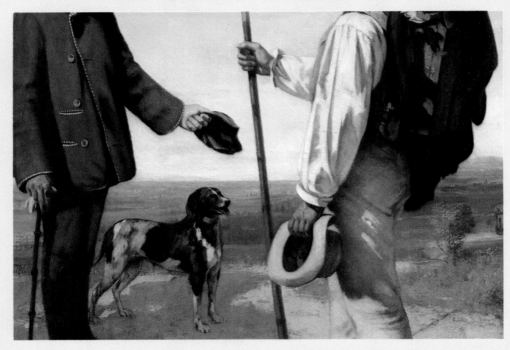

Light and shade on this figure were rendered in stark flat areas. The shadows around the feet were also a late re-working, and the shrub was rendered by dabbing paint on with a rag.

Courbet's is the only uninterrupted shadow in the painting. His spatted shoes were freely brushed on, while the creamy ochres of the road were applied in superimposed irregular films with a flexible painting knife. This area had a knife-applied underlay of brown umber.

In this detail, a stain of umber or of black mixed with umber is beginning to appear through the sky paint. This had been applied at a late stage in the painting because Courbet adjusted the length of the beard on his self-portrait. Originally it was longer and jutted out even further than it does in the final version.

Actual size detail
The loose ochres were rapidly and stiffly applied, exploiting the canvas texture and revealing patches of the luminous ground. The detailed grasses were worked on top with thicker brushed paint, and the carefully observed flowers were added. The broad but detailed handling of the foreground contrasts with the smudged soft skyline which creates the rapidly receding flat landscape.

Edouard Manet

(born 1832, died 1883, French artist)
Déjeuner sur l'herbe (*The Picnic*)
painted 1863, oil on canvas, 82 × 104in (208 × 264·5cm)

In the course of his career, Manet directed the subject matter of Realist painting away from rural life towards the modern urban life of Paris. Early in his work, Manet developed a slurred, wet-in-wet technique of mixing colours directly on the canvas. He also suppressed middle tones and boldly stressed areas of light and dark. For this, he chose a strong, full-faced light source to eliminate half-tones and create flattened planes of light and shade. Manet's early subjects show the influence of Spanish painting, particularly Velazquez, and reflect an awareness of contemporary, popular prints.

Manet exploited pale grounds, often grey or creamy off-white, for their luminosity and flatness. It is more difficult to create an illusion of depth on a pale ground than a dark one and he used this to advantage in creating a shallow pictorial space. On such a ground, thinly painted areas contrasted with the oil-rich colours in the central motif, drawing attention to the main subject and thus directing the viewer's eye to the more important areas of the painting.

A deliberate and sometimes hesitant artist, Manet sought to disguise his slowness behind an impression of immediacy. Monet said of Manet's *Olympia:* 'He had a laborious, careful method. He always wanted his paintings to have the air of being painted at a single sitting; but often . . . would scrape down what he had executed during the day, . . . he kept only the lowest layer, which had great charm and finesse, on which he would begin improvising.'

During the 1860s, Manet used diluted, subdued colours for his underpainting. However, as a result of his contact with Monet, he began to use paler colours, closer to the local colours of his subjects. Observation of outdoor light made Manet abandon his tonal palette and, like the Impressionists, add white in order to brighten his colours.

Manet's early works exhibit the cool light and warm brown shadows of the studio. He was at that time preoccupied with reworking Old Masters' compositions and themes with modern subjects. His painting technique combined traditional and innovative elements. In spite of Manet's contact with Impressionism, he continued to bridge the gap between past and present, and the revolutionary aspects of his technique influenced his successors.

1. A pale ground, apparently a creamy off-white, was used to create luminosity and flatness.

2. The lighting was full-faced to eliminate the half-tones in the modelling.

3. There is no evidence of underdrawing, and the figures may have been sketched in with a dark fluid umber.

4. Scumbles corresponding to the local colours were used to block in the figures and forms.

5. The build-up of the paint layer was concentrated on the central group of figures using a rich, oily paint.

6. The background and areas around the figures were reworked in translucent, thinly scumbled paint.

7. Curving, flowing brushstrokes were used to define the figures. The grass was painted around the figures after they were completed.

8. Manet would often scrape down the thick, impasted areas which he wished to rework. A thin, light varnish was painted over the completed work.

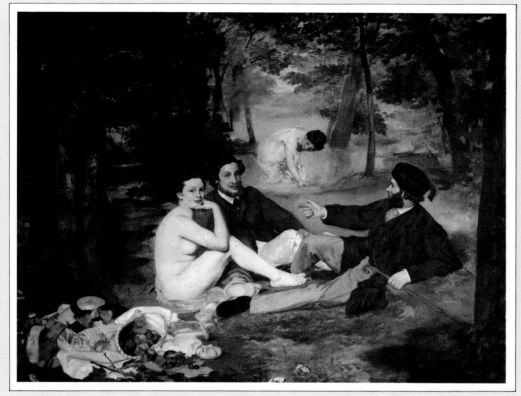

Manet's underpainting for this studio picture was done more or less according to the local colours of the subject, but darker. Focus is concentrated on the central group of figures by the use of dense and opaque paint, as contrasted with the thinly painted or roughly worked areas of the background. The strong light coming from behind the artist exaggerates contrasts of light and shade and suppresses half-tone modelling. The rich oil paint rarely exploits the smooth texture of the canvas but flows with it. The green of the grass is worked up around the finished figures, and the brushwork follows their contours rather than being descriptive of the grass it represents.

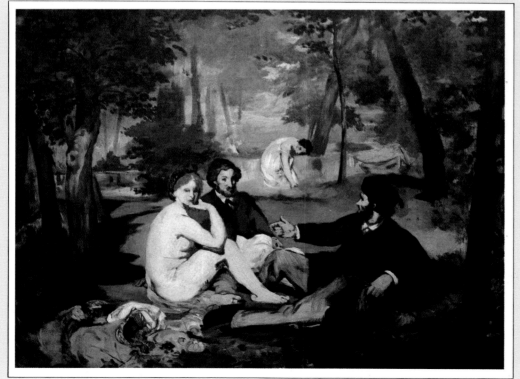

In this smaller early version of *Déjeuner sur l'herbe*, Manet's unfettered experiments with contrasts and the elimination of half-tones in the modelling are even more uncompromising than in the finished exhibition picture. The main composition is roughly blocked in, the white ground glowing through the mainly fluid transparent colours.

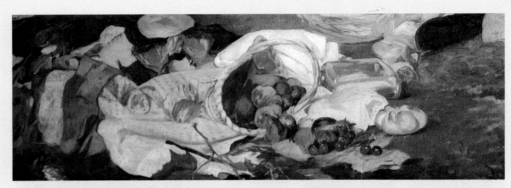

The boldly evocative handling of the still life motif in the study is here refined by a crisper finish. The picnic and the woman's discarded clothes provide keys to the picture's story.

The duller blue, thin layer in this early version contrasts sharply with rich reds, yellows and greens of the basket, fruit, leaves and bread. The lush paint of the white fabric enhances this overall effect. Although much more freely and sketchily painted, all the essential objects are already depicted, a broad brush defining the forms with remarkable ease and fluency.

The strange spatial anomalies, like the over-large bather, are typical of Manet's compositions, which often disregard the traditional pre-occupation with a coherent, three-dimensional illusion. The paint layer on the figures is rich and opaque, with freely painted contours worked wet-in-wet to summarize the forms, the twill canvas weave adding texture to the surface. Brushwork is bold, in places expressively following form to reinforce it, in others swiftly covering the white surface with zig-zag hatched strokes. Manet's varied touch describes the differing surfaces of flesh, grass, and fabric.

This area of the back-ground, where the light breaks through and softens the harsh darks of the invented scenery, is the most thinly and fluidly painted part of the picture. The paler, muted washes of colour suggesting the distance draw the eye, while dark trees frame the whole scene like theatre flats at either side.

In the study, the paint is still more dilute, the application giving the most summary hint of the shapes of trees. The initial wash is only reworked and modified in limited areas of the foliage, like the darker greens and the thicker whites. The hovering bullfinch, rapidly delineated here, is more fully detailed in the final version.

The raised arm, which was originally longer and thus closer to its position in the study, has been shortened during execution, and moved a couple of inches to the right.

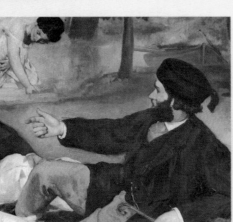

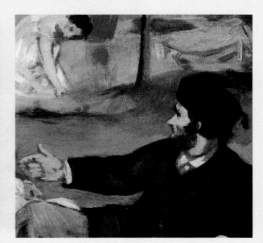

In both the study and the finished picture the buttery green paint of the grass has been worked around the painted figures, strengthening both their outlines and the flat opacity of the green. In the final version this green obliterates the original position of the hand which, in the study, increases the spatial ambiguity by appearing to touch the other man's sleeve.

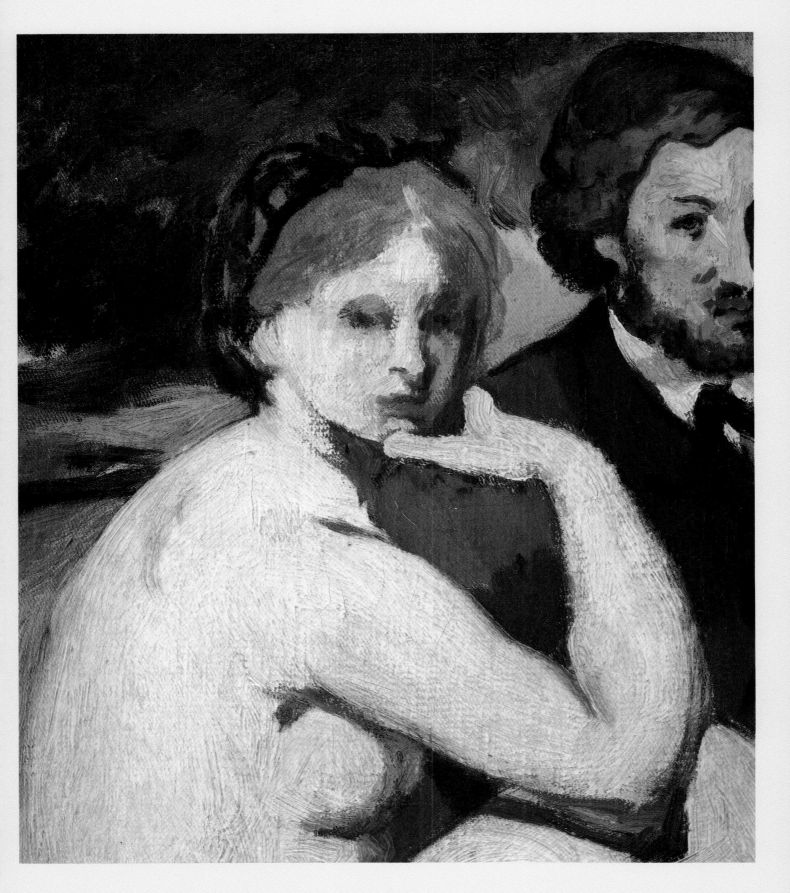

Claude Monet

(born 1840, died 1926, French Impressionist artist)
Effet d'Automne à Argenteuil (Autumn at Argenteuil)
painted 1873, oil on canvas, 22 × 29in (56 × 75cm)

Probably the most typical Impressionist painter, Monet began his career as a caricaturist, summing up his subjects with the same economy he later used in rendering the fleeting effects of light and colour in nature. Introduced to open air painting by the French artist Boudin, Monet rapidly developed as a landscape oil painter. His first major figure painting, *Déjeuner sur l'herbe*, painted 1865 to 1866, was a re-working with natural light effects of Manet's painting of the same title. Monet continued to paint figures but they never dominated his work. Monet was also influenced by and appreciated the bright colours, high viewpoint and interlocking, assymetrical compositions of Japanese prints.

Sincerity and spontaneity in the rendering of nature were crucial ideals of Impressionism and, by the late 1860s, Monet, working with Renoir, was developing the techniques and speed needed to represent fleeting outdoor effects. Few of his paintings were finished in a single sitting; often he got no further than a rough blocking-in before the scene relatively changed, the work then being completed in subsequent sittings. Monet mainly used tinted, pale grounds, particularly greys, cream and beige. He preferred a thin layer of preparation which left the canvas grain exposed. Over this he dragged dry, stiffish paint from which, like Degas, he had first soaked the oil binder, to create ragged vibrant flickerings of colour across the surface. His colours, like his ready-prepared canvases, were bought ready made, as the mechanization of paint grinding was commonplace for artists' colours from the 1830s. Collapsible tin tubes, invented in Britain in 1840, had been introduced in France but in 1855 still cost more than the traditional paint bladders. While the lack of tin tubes had not deterred earlier outdoor oil painters, their invention clearly simplified their work.

Monet's pale grounds and opaque paint layer were combined to create a scintillating representation of transient outdoor light. Until the late 1880s, he preferred to paint in full midday light, or shadowless overcast skies, thus avoiding strong shadows and tonal contrasts, so his use of light effects promoted a brilliant two-dimensionality. Monet's painting increasingly concentrated upon capturing coloured, atmospheric light and reflections.

1. A pale ground was applied to a fine-weave canvas allowing the texture to show through.

2. Broad areas of local colour were blocked in using a thin scumbled paint.

3. The irregular build-up of the opaque paint layer allowed the original blocking-in to remain visible in places.

4. Wet paint was applied into wet or over dry to blend the colours.

5. Stiff, dry paint was dragged across the surface in broad strokes of wet over dry creating a latticed web of colour.

6. Reflections and water were achieved by this same opaque layering technique rather than the more traditional opposition of opaque highlights and transparent glazes.

7. Textures were differentiated by varied brushwork. Impasto layers were lightened by scratching through using the wooden end of the brush to expose the pale ground.

Monet's palette was simple and fairly limited. The blues are ultramarine or cobalt and the cadmium yellows were consistently employed by Monet. Viridian and emerald greens were on his palette but played an unimportant role here. Vermilion and alizarin crimson were his reds and cobalt violet was added from the 1880s. It is important to note that Monet never used colours straight from the tube but all were mixed with lead white in varying degrees to create a pastel-like reflecting luminosity.

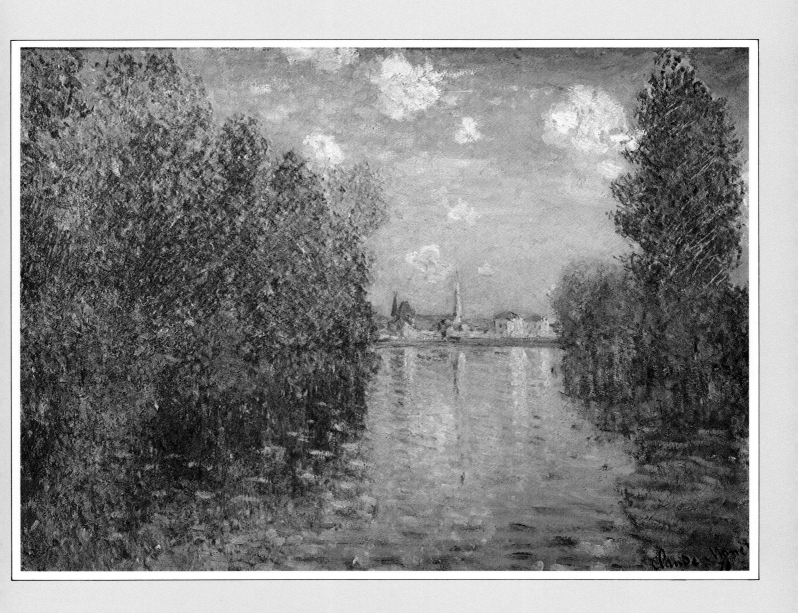

Monet used a pale grey ground whose luminosity plays a crucial role in creating the illusion of light and sun in this painting. The picture was begun with dilute opaque colours and colours broken with white applied directly to the ground. The paint was built up in increasingly impasted layers creating a web of colour through which earlier layers remain partially visible and continue to play an active role. The brushwork and paint consistency are varied to evoke textures and

forms. The paint quality is thick, buttery or stiff and often applied by dragging a stiff hog's hair brush across the surface, giving broken, vibrant effects. Unlike colours which have been mixed in the conventional manner solely on the palette, Monet's colours remain unmuddied.

Monet's brushwork is extremely varied and descriptive of the forms and textures he wished to describe. Rough, crusty strokes are used to depict foliage; longish, horizontal ones for reflections of sky on water, and the sky itself is created with thinner paint and broad strokes. Clouds are represented by churned brushwork with stiff paint used to evoke puffiness, and buildings are created with form-following strokes of thick, smooth paint. Monet's brushwork was also used to create

spatial effects as seen in the water which recedes with diminishing touches as it moves into the distance; the sky and water are rendered paler near the skyline to recreate the distant hazy natural scenery. Monet adhered to the basic rule of oil painting: fat over lean. This means that dilute layers are covered by increasingly oil-rich layers. This ensures the durability of the work by preventing inter-layer cracking resulting from placing slow-drying layers beneath faster-drying ones.

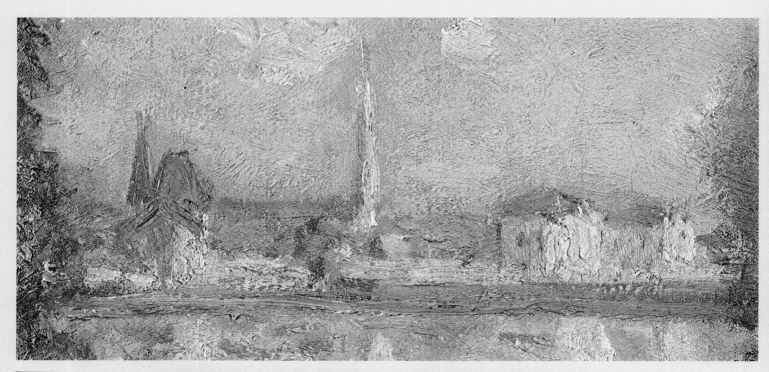

The long stroke of bright blue contradicts the recession implied by the diminishing brush-work and paler colours and stresses the horizontal axis of the picture. This horizontal, and the vertical marked by the deeper blue spire divide the composition into four equal parts, giving a structured two-dimensional design enhanced by the flat areas of contrasting colours.

The thin blocked-in paint is visible beneath the thick vertical strokes of the reflected trees. Wet-over-dry horizontal strokes of stiff blue and white depict reflections from the sky, creating an entirely opaque illusion of water.

Actual size detail
Both wet-in-wet and wet-over-dry work can be seen in the paint layer here: whitish clouds were added in stiff opaque colour, slurred over the dry paint of the foliage, upper left, adjusting the silhouette of the trees. To modify the foliage colours and extend the branches out over the sky paint, wet-in-wet colours — blue and white — were slurred together in small touches with a single brushstroke, the fine brush having picked up both colours at once. Alizarin crimson and white were applied in dabs in the same way, both these adjustments being worked over the dry orangey-greens of the foliage. Fine blobbed strokes of mixed white and viridian, and of orangey ochres were added late, over background blues in the foliage.

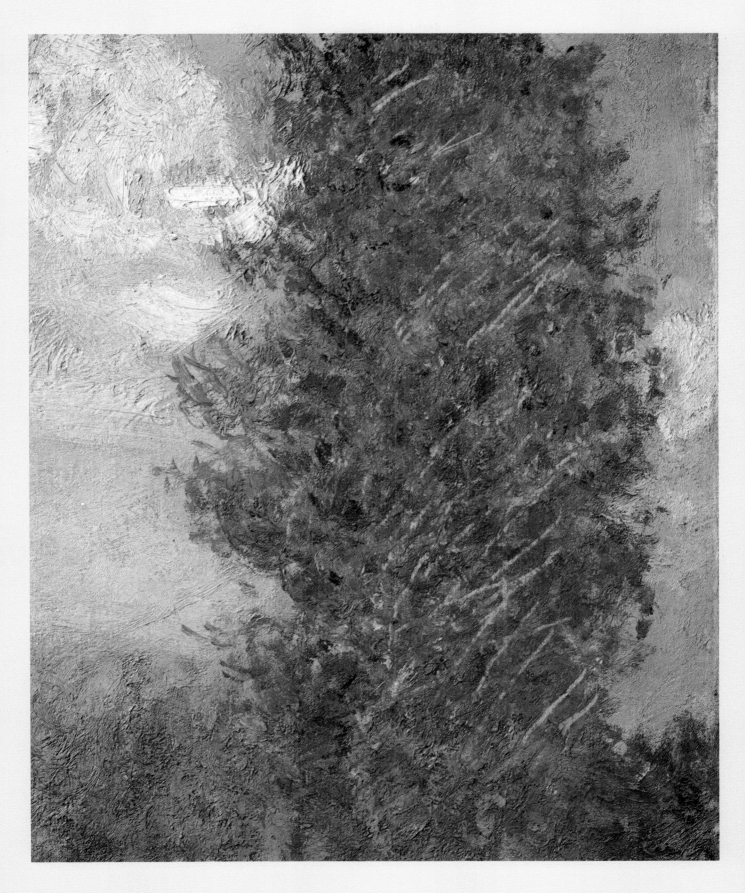

Pierre Auguste Renoir

(born 1841, died 1919, French Impressionist artist)
Torse de Femme au Soleil (*Woman's Torso in Sunlight*)
painted 1875, oil on canvas, 32 × 25½in (81 × 64·8cm)

Renoir's youthful experience as a painter on porcelain had a lasting influence on his art, contributing a love of fluid transparencies and introducing him to the eighteenth century Rococo artists. He had a great admiration for Delacroix and, during his formative years, was also influenced by Manet, Courbet, and Corot. Renoir's modern-life figure painting reflected his Parisian artisan background and, while his work with Monet in the late 1860s encouraged him to paint landscapes, he never abandoned his commitment to the human form. Renoir can thus be distinguished from such painters as Monet, Sisley or Pissarro both in the importance he placed on figure painting, particularly the female nude, and by his transparent, rich surfaces, as his fellow artists used impasted opaque paint films.

Renoir preferred pale grounds, using tinted primings in the 1870s and white thereafter. He preferred solid, heavy canvas which he considered more durable, and his paint layer was typically thin, delicate, and diluted with a medium of oil and turpentine which made even opaque colours translucent. The luminosity and brilliance of Renoir's colour is thus derived from this use of transparent and translucent colour brushed thinly over pale grounds which glow through the paint layer. Renoir would apply his colour using a wet-in-wet technique, slurring tints in order not to lose their purity by over-mixing. In addition to brushing his colours, Renoir used rubbing and staining to build up form, colour and depth.

Renoir was the first artist of his generation to exploit fully the use of warm-cool colour contrasts; in one painting of 1874 he used a cream ground in which varied brushstrokes of ultramarine blue created the form and folds of fabric. Where the blue is thin, the cream glows through and appears warm pink by contrast, creating highlights; where it is thickest, the ground is least visible and shadows are evoked by the rich, saturated colour.

During the 1880s, Renoir, turned to a more classical and rigorous style and adopted the hatched, constructive strokes of Cézanne, and a tight drawing and modelling technique. Renoir's late style represented a fusion of this with his Impressionism of the 1870s, and resulted in a juicy, succulent handling of figures, reminiscent of Fragonard and Rubens.

1. A fairly fine-weave canvas was bought ready-primed with a single layer of pale, warm grey ground.

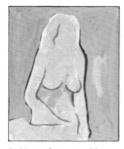

2. Next, thin scumbles were laid down in dilute local colours with warm reds for contours of flesh and the general shaded areas on the figure.

3. The background was rapidly worked wet-in-wet leaving the ground and canvas texture showing through.

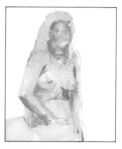

4. The figure was built up slowly working wet-in-wet and then with thin wet-over-dry layers which obscured the canvas texture.

5. Final additions to the figure and foliage such as the jewellery and red stains in the flesh area were made to enrich shadows and cool contrasting complementary colours.

In this work, Renoir used the following colours: flake white (1), Naples yellow (2), chrome yellows (3), cobalt and/or ultramarine blue (4), alizarin red (5), viridian green (6), emerald green (7), vermilion (8).

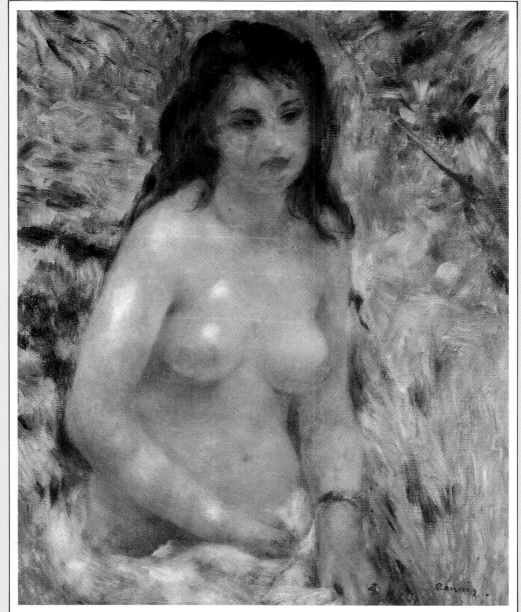

The painting's overall luminosity is derived from the pale grey ground. Despite the dappled sunlight, the figure never loses its strength of form and solidity, and the foliage is loosely and intentionally blurred to concentrate the viewer's attention on the girl. Renoir's method was traditional, but he used opaque colours for shadows in the flesh and his colours are mixed and broken. There is a superb, confident handling of the wet-in-wet technique, particularly in the foliage, hair, and drapery. Brushwork describes form and texture and is used to increase solidity. Flesh hues exploit subtle warm-cool modulations, with pastel-like blues on the chest depicting the cool reflections of sky and foliage.

Several subtle adjustments in the figure were made including obliterating a patch of drapery by extending downwards the area of exposed lower belly. The cobalt blue edging at the woman's left and right elbow stresses the form and separates it from the background. The right shoulder was enlarged and broadened by adding bluish-hued strokes above the patch of sunlight, which were applied over the wet red-yellows of the hair which, in turn, were applied over dry paint.

The woman's left breast has been enlarged during execution. The reddish lower half and a new nipple were added to change the figure's pose to a more classical position. The line of the shoulder, obscured by the fall of hair, remains level. The original, higher position of the under-breast contour is only visible as ridges of dry paint beneath the present opaque layer. The thick opacity of the flesh contrasts with the superb fluid handling of grass, the brushstrokes of which follow the contour of the arm.

Renoir's fluent handling follows and builds up the form of the flesh, on which delicate thin layers of opaque colour were worked wet into wet. The jewellery was added later when the work was dry, and also, the area of exposed stomach was extended by flesh colours painted over the original marks of drapery. A thin film of transparent blue adds reflected cool tints to the white cloth. Transparent red lakes were stained into the dry flesh paint to give richness and warmth.

Actual size detail
Colour was applied
smoothly to obliterate
the fine canvas texture
and evoke the quality of
flesh. When this was
dry, the thin opaque
highlights and contrast-
ing thin stained red
shadows were added in.
Fine hatched lines of
colour close in tone to
the reflected reds of
the shadows, were
worked over them,
following the curves of
the breast to stress its
form and weight. These
light strokes can be seen
as parallel touches on
the left underside of the
breast and, beneath it,
longer curved lines
following the form of
the torso. Similar
brushstrokes describe
the swell of flesh from
the armpit towards the
shoulder. The luminous
warmth of the shadows
contrasts with thin
scumbles of pale green-
blues indicating the cool
reflections from sky
and foliage.

The form of the face is
less strongly defined
than that of the body,
which serves to
concentrate the eye on
the woman's torso.
The unfocused quality
of the wet-in-wet
handling of the hair
links it to the free
brushwork of the
background.

Edgar Degas

(born 1834, died 1917, French Impressionist artist)
Après le Bain, Femme s'Essuyant (After the Bath, Woman Drying Herself)
drawn 1880, pastel on cardboard, $40\frac{7}{8} \times 38\frac{3}{4}$in ($104 \times 98 \cdot 5$cm)

In 1854 Degas abandoned his study of law and began training under Louis Lamothe, a pupil of Ingres. Degas subsequently met Ingres and was encouraged by the master to 'draw lines'. He proceeded to develop as a superb classical draughtsman, combining this with his strength as colourist to unite these two conflicting French traditions represented, on the one hand, by Poussin and Rubens in the seventeenth century, and, on the other, by Ingres and Delacroix in the nineteenth.

For Degas, art had a strong intellectual basis, as he himself stated 'What I do is the result of reflection and study, . . . of inspiration, spontaneity, temperament I know nothing.' Unlike most Impressionists, he worked indoors from memory and was not interested in working from nature. Degas' scientific curiosity led him to experiment with many techniques and media.

On canvas, he used a variety of grounds and experimented with raw canvas. He also painted on supports made of coloured paper laid on canvas in which the colour and absorbency of the paper played a central role. Such works demonstrate Degas' experiments employing a technique of soaking the oil binder from the colour on blotting paper prior to diluting it with turpentine to create a fluid, quick-drying, matt medium. The dry, pastel-like film thus created was similar to that of his pastel drawings, and he often combined these techniques adding gouache, drawing materials, and printing ink to his multi-media repertoire.

X-rays of Degas' oil paintings suggest that beneath the precision of his early style lay the economical and blurred studies characteristic of his later work. Unlike Monet and Renoir, Degas' paint film was built up in distinct and fairly regular layers.

Pastels gave Degas an ideal combination of colour and line which he built into a web of crossed striations of colour each reading through to previous layers. Steaming the pastel surface dissolved the pigment into films of colour, which Degas then worked as a paste with a stiff brush or his fingers or, when the mixture was more fluid, spread like a thin scumbled wash. Degas' use of pastel, which made work easier as his eyesight began to fail in the mid-1880s, gave this hitherto relatively underexploited medium a new importance.

1. A medium weight, textured cream-coloured pastel paper was used.

2. Charcoal was used for drawing in contours and the grey shadows.

3. Colours were built up over the picture simultaneously, the same hue being picked up at different points in the composition and applied with the same intensity.

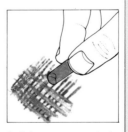

4. Colours were worked in open, webbed layers, so that earlier colours read through.

5. A variety of strokes was used; some defined the forms and others contradicted it to emphasize the shallow pictorial space.

6. Sometimes a thin mist of water was sprayed over the surface creating a paste-like consistency which Degas would then work with a stiff brush or his fingers.

7. Degas experimented with different fixatives. A recent innovation, fixatives were generally poor in quality. They tend to darken and muddy colours; artists preferred to have the picture put under glass to protect it.

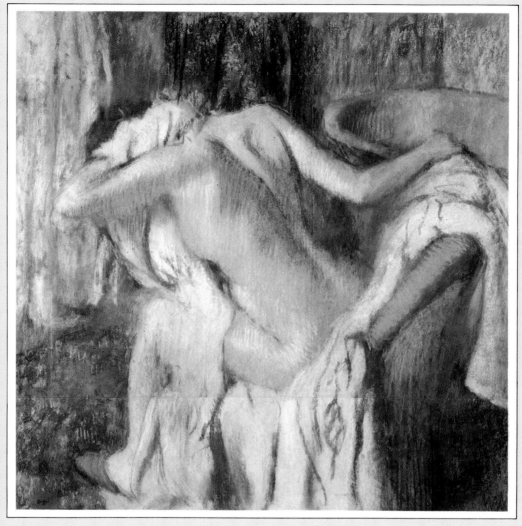

The squarish format with the figure cramped in the pictorial space is typical of Degas' style. The cream-coloured paper adds warmth and provides basic colouristic unity. While the cream colour is obliterated in the heavily worked areas of the flesh, chair, and bath, the paper texture remains to break the pastel strokes, giving a flecked surface of interwoven colour. The outlines and areas of shading in the torso and towel are established in charcoal. The marks of the pastel evoke texture varying greatly from short, pressured strokes, to longer, sweeping lines. The repetition of colour across the picture encourages the eye to move across the surface and make visual links. The woman's pose, with her back flattened parallel to the picture plane stresses the geometry of the composition.

The picture is on textured, cream, non-pressed paper. The central horizontal panel has two vertical joints, one through the outer curve of the woman's waist and one to the left of her projecting elbow. Narrow strips on the top and bottom are divided vertically down

the middle. The pieces of paper appear to abut each other and not overlap. The upper and lower strips may be overlapped by the entire central block, as pastel strokes appear to have 'skipped' the seam, and the upper and lower strips seem to be less heavily worked. Faint evidence of a pin-hole may indicate that the central panel was begun before the others.

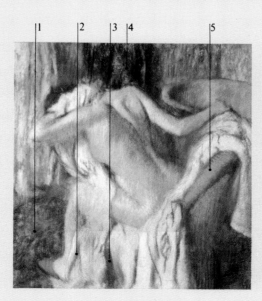

The pastel marks vary greatly in this picture and are used for both decorative and textural effects. Short, pressured strokes (1) describe the carpet with zig-zags of dark blue-green on top, and longer, sweeping lines of purple (2) give the effect of shadows on the towel; soft, slurred strokes (3) give a bluish reflection on the white fabric. Stabbed, hard touches (4) using the pastel tip give a greyish pattern above the woman's head and neck, and the bright yellow used on the slipper and chair (5) is laid over orange.

The artist's hesitation and changes in the position of the figure remain visible. The projecting elbow was shortened as was the thigh, the knee being moved to the right. Adjustments to the upper arm relate to those at the elbow, and neither the arm nor the leg was definitively completed. A late working of orange into the gap between the waist and right arm extends over the hip and may have been due to Degas' failing eyesight. However, it serves to stress the highlight catching the hip and waist to the right of the spine, thus reinforcing the pattern of diagonals and the main axis of the spine.

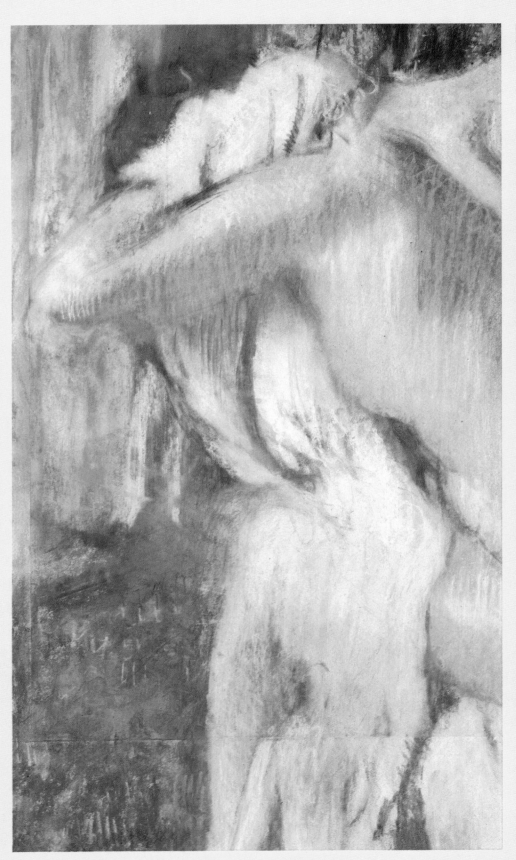

Actual size detail
The cream-coloured paper glows faintly through the smudged charcoal greys of the shoulder blade contour and shadows acting as muted flesh tints. Pale madder pinks and creamy, probably Naples yellow were used, with white on top in strong hatched striations which allow the charcoal greys to show through. Blue pastel is worked into white at the peak of the shoulder, while orange strokes add warmth to the contour of the upper arm. The soft, friable pastel pigment catches on the textured paper creating a stippled flickering effect between the layers of alternate dark and pale colour. The dusty opaque dryness typical of pastel surfaces is clearly visible here.

Degas used a wide range of pastels, with colours worked into one another on the picture surface to produce additional tints and broken colours. Ultramarine appears in a raw touch just below the breast and in the curtains above the woman's right shoulder. Purple is used on the towel, as are white and pale turquoise. The deep shadows on the towel are dark blue-green which also appears on the chair and carpet. Orange is picked up on the wall under the woman's right arm, the crook of her right elbow, on the wall at top right, and the curtains, top left. Flesh tints are dominated by a greyish yellow and warmed by a variety of pinks. Alizarin is also used in the hair and curtains, and viridian green in the carpet. White is worked into the towel and highlights on the flesh.

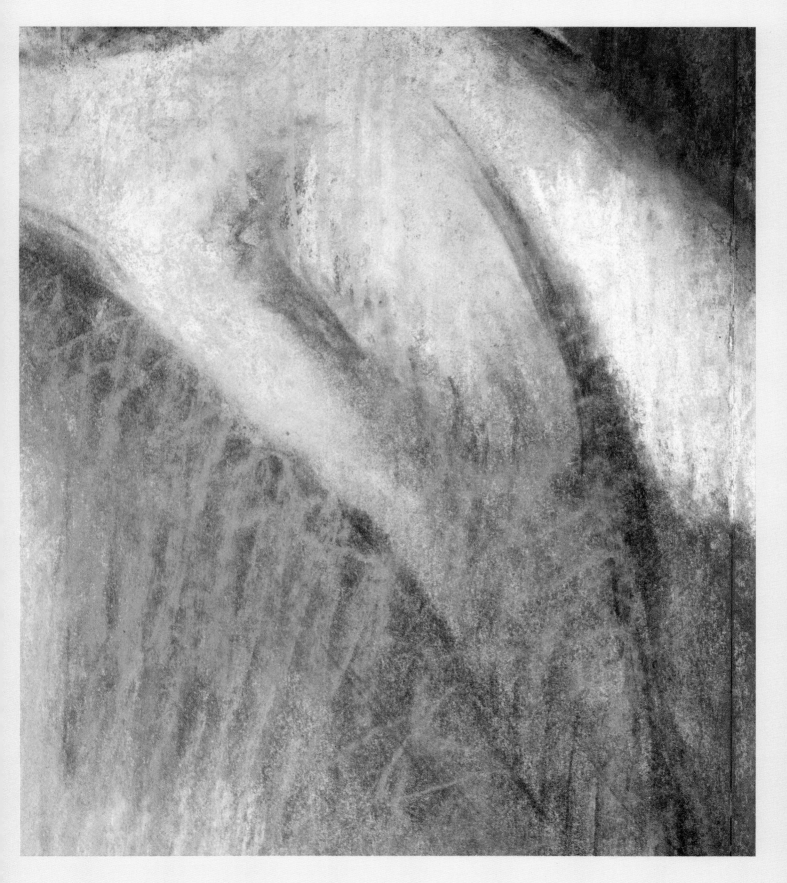

Georges Seurat

born 1859, died 1891, French Post-Impressionist painter
Une Baignade, Asnières (Bathers, Asnières)
painted 1883–1884, oil on canvas, $79\frac{1}{8} \times 118\frac{1}{8}$ in ($201 \times 301 \cdot 5$ cm)

Trained by Lehmann, a pupil of Ingres, Seurat was first and foremost a skilled classical draughtsman; and his early drawings, done in the manner of, for example, Holbein, Poussin, and Ingres were crucial in the formation of his mature style. Seurat concentrated on drawing until 1882, evolving a subtle touch and exploring tonal contrasts through the use of soft, Conté crayon on textured paper. The varied pressure and intensity of the black crayon and the fact that it caught on the tufts of the white paper created a varied tonal effect. Seurat's scientific interest in colour theory began as early as 1878 and he analyzed the work of Delacroix to understand that artist's use of the law of contrasts.

Seurat began making studies in oil out of doors in the early 1880s. While his drawings express a rigorous analysis of tonal modelling, his early oils reveal an observation of colour in nature. While Seurat had been influenced by the work of the Impressionists, his criss-cross hatching of the colour was already distinctive and individual.

From 1884 Seurat abandoned earth colours and adopted a 'prismatic' palette consisting of eleven colours chromatically arranged in the order of the spectrum. These comprised the cadmium yellows, vermilion, madder lakes, cobalt violet, ultramarine and cobalt blues, viridian green and two mixed greens. White was crucial for Seurat who, like Monet, mixed it with all his colours thus increasing their reflective powers and better evoking a feeling of natural light. Thus, opacity was important to his surfaces as was a matt finish which was intended to remain unvarnished. Glass was placed over the finished painting as a substitute for the darkening shine of varnish traditionally added for protection.

In 1885 Seurat's descriptive brushwork gave way to the use of the pointillist dot. Using this technique, palette mixtures were limited to hues adjacent on the prismatic circle. Patches of contrasting colours, like orange and blue, enhanced each other when placed side by side, but Seurat's optical mixture, where separate dots of primary colours like blue and yellow were intended to 'fuse' in the eye as green, in fact produced a dull greyish effect, because the colours fused as pigment not as light.

1. A strong, heavy canvas with a thin white or off-white ground was used to enhance the paint's luminosity.

2. Broad areas of local colour were blocked in. Figures and objects were indicated by thin outlines of paint.

3. The paint layer was built up slowly mainly in a wet-over-dry method to retain the purity of the colours.

4. Dryish paint consistency was used. Colours were mixed with white to add brilliancy.

5. The figures and garments in the foreground were heavily worked in opaque layers; the background is thinner, paler and softer.

6. Pointillist dots were added as contrast in 1887.

For this painting Seurat's palette included: mixed orange (1), raw sienna (2), alizarin red (3), ultramarine blue (4), cobalt blue (5), violet (mixed from alizarin red and blue) (6), vermilion (7), emerald green (8), viridian green (9), cadmium yellow (10), yellow ochre (11). Seurat may also have used Cerulean blue (12).

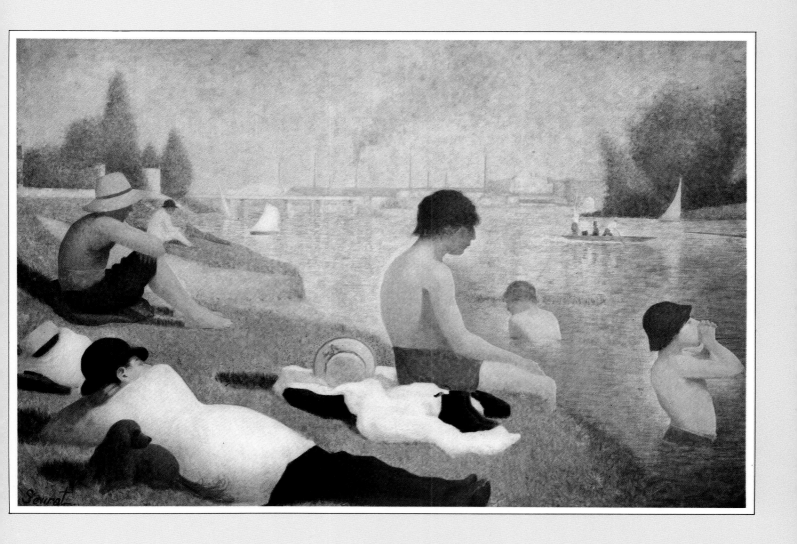

Grass is depicted with dryish, hatched strokes imitating its spiky growth. The clothes are rendered more broadly with sweeping strokes to evoke the weight and texture of fabric. The brushwork follows the folds in the fabric and the curves of the hat. The darks contain transparent colours not found elsewhere in the picture.

A strong, heavy-weight canvas with a thin, pale ground has been used and the grain exploited to create a fuzzy, hazy effect evoking the warmth of the atmosphere. The brushwork is varied, descriptively recreating surfaces and textures to help differentiate objects in space. Horizontal strokes are used to define water, and vertical for the grass. Broad, sweeping strokes follow the forms of the figures and evoke the weight and feel of fabric. The mid afternoon sun falls from right to left creating shadows of equal size to the figures and gives a calm stability to the composition. Much of the paint application is wet over dry to retain the purity of the colours. Stiff paint is built up over thin, opaque layers of local colour and complementary shades worked in.

Here it is evident that Seurat's knowledge of tonal contrasts has come into play. To separate his figures from the background, the natural effects of light and shade have been altered, exaggerating their respective lightness and darkness. This recreates in paint optical laws of tonal contrast with which Seurat was familiar. For example, the pale water is lightened behind the figure's back and the flesh darkened where the two meet, in order to separate them.

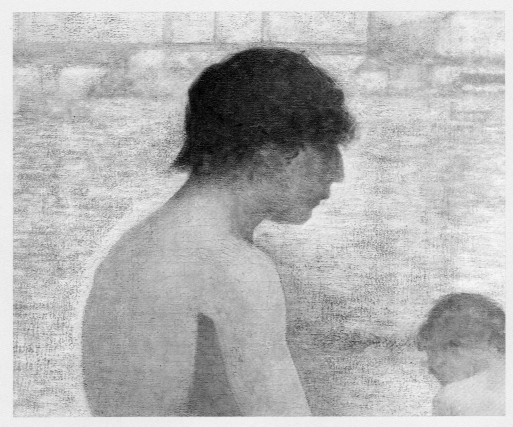

Here again tonal contrast can be seen. Beneath the figure's chin, shadow darkening the flesh colours is stressed while the water is rendered paler to distinguish the figure from its background. The later addition of pointillist dots can be seen on the hat and in the water.

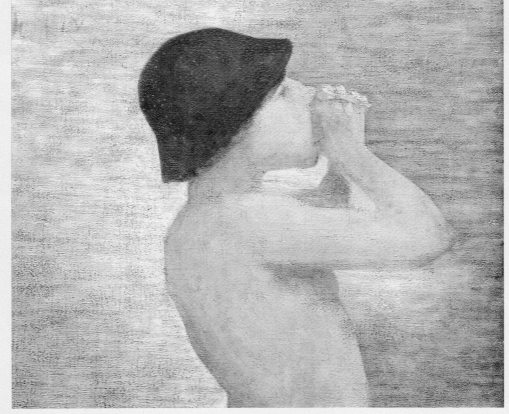

Actual size detail
This detail shows many features typical of Seurat's work. Seurat made changes during the painting process, for example the figure of the boatman was added at a late stage, as can be seen where the blue of the water and the earlier

brushstrokes show through. Similarly the reflection was a late addition. The blurred colours of the water were created using a wet-in-wet technique. Seurat may have used a mixture of cobalt blue and white for this. In the top lefthand corner

the brushstroke which added a touch of yellow can be clearly seen. This detail also shows the dirt which has accumulated in the crevices of the canvas.

Vincent van Gogh

(born 1853, died 1890, Dutch Post-Impressionist artist)
Chair with Pipe
painted 1889, oil on canvas, $36\frac{1}{8} \times 28\frac{3}{4}$in ($92 \times 73$cm)

Van Gogh came late to painting after trying his hand in the art trade, teaching, and the church. His earliest influences were from the Dutch Masters and his contemporaries. Widely read, van Gogh first learned about French painting, and especially Delacroix, through books which provided an interpretation of colour theory important to van Gogh's own painting. His enthusiasm for French artists lay chiefly with the older generation like Millet and Daumier. During his stay in Paris, a passing interest in Impressionism and Neo-Impressionism encouraged him to lighten his palette and eschew the sombre, tonal renderings of his Dutch period, and he wrote in 1888: 'I should not be surprised if the Impressionists soon find fault with my way of working, for it has been fertilized by the ideas of Delacroix rather than by theirs. Because, instead of trying to reproduce exactly what I have before my eyes, I use colour more arbitrarily so as to express myself forcibly.'

Van Gogh was from his earliest years an avid experimenter in new techniques. His work in the early 1880s was predominantly graphic, involving a variety of media. He developed a strength and variation of mark with Japanese reed pens and often used a perspective frame to aid his rendering of space in drawing and painting. He preferred an ordinary weight canvas, and frequently used commercially primed types in a range of pale tints, especially grey and putty. He also experimented with raw, unprimed canvas and heavy sackcloth fabrics. In addition van Gogh liked to use both pink and white grounds.

Unlike the Pont Aven artists, like Gauguin, who stressed the importance of the imagination, van Gogh's work was rooted in the study of nature, and he stated that he retained 'from nature a certain sequence and . . . correctness in placing the tones, I study nature so as not to do foolish things . . . however, I don't mind so much whether my colour corresponds exactly, as long as it looks beautiful on my canvas'. Van Gogh used the power of complementary contrasts to make his colour emotive, as described in a letter from Arles in 1888: 'to express the love of two lovers by a marriage of two complementary colours, their mingling and their opposition, the mysterious vibrations of kindred tones.'

1. A hessian canvas was used, its colour a warm, orange-brown.

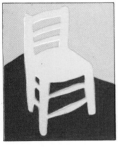

2. Opaque paint was applied directly onto the raw hessian and the composition loosely established without underdrawing.

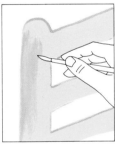

3. Separate areas were then reworked and built up using wet-in-wet handling of the paint.

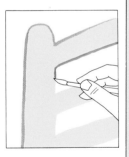

4. The outlines were then reinforced with decisive strokes of colour into wet paint.

5. Still life details were finally added when the picture was dry. Van Gogh preferred matt surfaces, and thus few of his mature paintings were varnished.

For his mature works, such as *Chair with Pipe*, van Gogh used a palette of: red lake (**1**), vermilion (**2**), cadmium yellow (**3**), ultramarine blue (**4**), cobalt blue (**5**), cobalt violet (**6**), emerald green (**7**), viridian green (**8**), lead white (**9**). In addition he also used some earth colours.

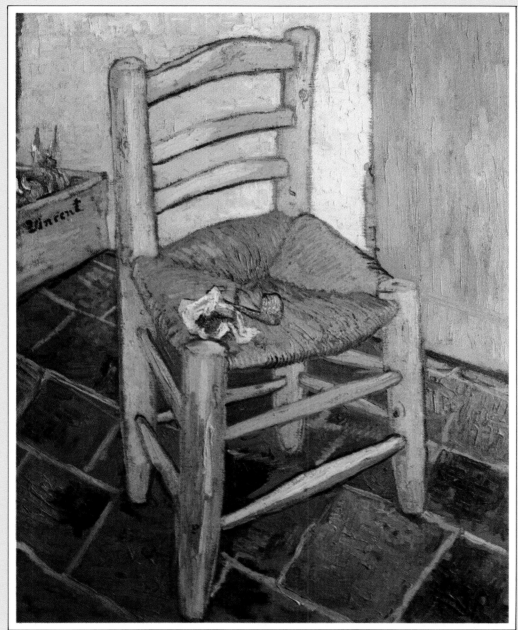

An unprimed canvas was used and left in places to read as an outline. The basic colour areas were established in undiluted paint which, because canvas is absorbent, appears dull and stiffly dragged where not reworked. The brush strokes vary and are worked predominantly wet into wet. The paint quality is rich and buttery where most thickly applied, and this contrasts with a dry, sunken quality where the paint is thinnest near the contours. The tiles are heavily worked with tapestry-like, crisscrossed brush strokes; and the outlines were added into the wet paint with long sweeping strokes. Contrasts of red and green have been slurred together in the floor. Orange-yellow and violet-blue were used in the chair. The pipe and bulbs are late additions over dry paint.

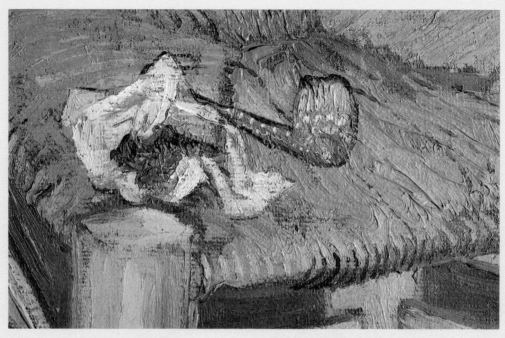

The autobiographical motif of tobacco and pipe were not apparently conceived as part of the original composition, but were superimposed at a very late stage in the painting. They were added when the paint of the chair was already dry, which, with a surface as impasted as here, would involve considerable delay. Curved, hatched brushstrokes with a narrow brush were used to accentuate the rounded edge of the rush seat.

Actual size detail
This detail shows van Gogh's strong brushwork and vibrant use of colour contrasts. Both raw hessian canvas and dark blue outlines have been exploited to define and strengthen the forms; the blue lines were laid down with the initial painting and reinforced later on. The paint quality is thick and stiff, especially in the chair, and rich and buttery where more paint has been re-worked in the floor. Van Gogh's vigorous brushwork defines form and contour with forceful, hatched strokes. A narrow, stiff-haired brush was used to draw in the chair's rush seat while broader criss-cross strokes enliven the surfaces of wall and floor. Van Gogh's crude contrasting colours can be seen in the blues and yellows of the chair and the complementary red and greens in the floor.

The reds and greens were worked together with green applied last for the outlines of the tiles. The staggered pattern of the tiles flattens to the rear of the chair leg where the four corners accidently coincide. The irregular shape and recession of the floor tiles are evident, and creates an overall barrel effect with the floor curving up and dipping away almost vertically in the immediate foreground.

Edvard Munch

(born 1863, died 1944, Norwegian artist)
Jealousy
painted 1895, oil on canvas, 26 × 39in (67 × 100cm)

Edvard Munch, Norway's greatest painter and one of the major precursors of Expressionism, is remembered above all for a thematically related group of paintings executed in the 1890s which he called, after 1918, his *Frieze of Life*. Munch's *oeuvre* was concerned with conveying passion and emotion. For example, he wrote of the *Frieze of Life* 'These paintings are the moods, impressions of the life of the soul, that at the same time form a development in the battle between men and women that is called love.' *Jealousy*, painted in Berlin in 1895 as part of the series, is an outstanding example of Munch's genius for creating unforgettable images endowed with universal appeal and meaning out of autobiographical subject matter, and for conveying complex and conflicting mental states and ideas through the subtleties of his technique.

On 9 March 1893 Munch introduced a young Norwegian music student, called Dagny Juell, into his Berlin circle of friends. Juell immediately acted as a catalyst in the break-up of the group because seven of them, including the dramatists August Strindberg and Stanislaw Pryzybyszewski, the principal protagonist in the painting, fell in love with her. However much the group may have advocated free love, their mutual jealousy turned the affection of close friends into hate. Przybyszewski eventually married Dagny on 24 September 1893. As if to have practical confirmation of his medical theories on the power of subconscious emotions over the intellect, he allowed Dagny to continue to have affairs with other men, including Munch himself. Munch and Dagny are seen together as Adam and Eve in the background of the painting. The painting universalizes these events into a modern allegory on the destructive power of love and its regenerative potential to triumph over death.

It is difficult to generalize about Munch's technique because the emotional content of the painting dictated his approach to the painting. Munch's approach was also highly symbolic. For instance, the crimson lily on the left of the picture in the foreground is apparently Munch's symbol for art. Although Munch's approach may look spontaneous and unplanned, the organization of the canvas was carefully rehearsed in preliminary drawing which was carried out on the canvas itself.

1. The close-grained linen canvas was sized to give an overall warm mid-tone. In the finished work, the ground can be seen in the face in the foreground and on either side of the tree.

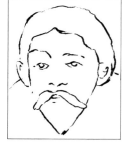

2. The charcoal underdrawing was next applied to the canvas. It was evidently detailed and remains clearly visible in the face.

3. Munch used a wide variety of techniques to apply the paint. These included turpentine washes, scumbling, overdrawing and scratching into the paint surface with a dry, bright hog's hair brush.

Here the green and red juxtaposition which characterizes the whole work can be clearly seen. The paint has been applied in a crude way in order to convey the passion which was the work's subject. For Munch, changes in technique were related to the emotional content of the work. The crudity of the technique here is evident in the clear alteration to the position of the woman's arm and the overlapping of the thick blue and white of the sky.

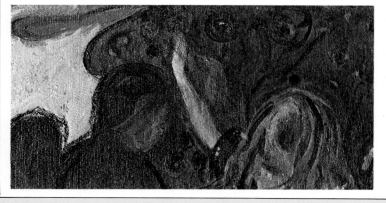

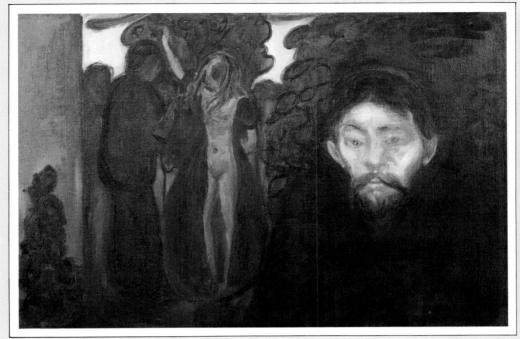

In *Jealousy*, psychological contrasts are expressed through contrasts of colour and technique. The picture is divided into two halves, one light and one dark; red is shown against green, and thin washes against thick opaque paint. Przybyszewski's disembodied presence is indicated in washes of paint and his face, drained of colour, is juxtaposed against the thick opaque vermilion of the woman's red robe. The three figures are connected by red — the red of the woman's robe links up with the red contours around the two male figures. Despite the apparent freedom in the application of the paint, there are no major changes in the painting's composition, indicating that Munch worked with absolute assurance. Munch used a wide variety of techniques varying from turpentine washes to scumbles and from scratching into the paint layer with a dry brush to overdrawing. For example, the deep claret red washes on Przybyszewski's smock were applied in such a liquid state that they have, in places, run down the canvas.

Actual size detail
The face which dominates the foreground of the painting shows the important part played in the final depiction of form by the charcoal underdrawing which shows through clearly in the eye on the right. Munch also uses the warm mid-tone of the ground as part of the local colour of the face. The paint is applied with great sensitivity. For example, the opaque white is subtly differentiated on the eyebrows by the addition of touches of red, and, on the eyes, with tinges of blue. The white is applied thickly to the forehead area and cheeks where a little additional yellow lends an almost ghostly pallor to the whole countenance.

Paul Cézanne

(born 1839, died 1906, French Post-Impressionist)
Nature Morte avec l'Amour en Plâtre (Still Life with Plaster Cast)
painted 1895, oil on paper mounted on panel, $27\frac{1}{2} \times 22\frac{1}{2}$in (70×57 cm)

Cézanne spent much of his life between his birthplace, Aix-en-Provence, and the environs of Paris. He first arrived in Paris in 1861 where he met and worked with the artist Pissarro, who introduced him to open air landscape painting. Thanks to Pissarro, Cézanne lightened his palette, and his passionate subject matter gave way to more tender and imaginative scenes which culminated in his later monumental studies of bathers.

Using the Impressionist ideals of colour and a commitment to nature, and wishing to imbue his work with a sense of permanence and monumentality, Cézanne developed his 'constructive' brushwork, in which separate, parallel strokes often with a diagonal bias were used to create structural solidity. To this end, he chose a neutral grey light which gave the truest impression of colour, or a diagonal sunlight as seen in mid-morning or mid-afternoon, which gave landscapes a calm stability.

Cézanne used pale grounds, visible through gaps in the paint layer. As in Renoir's work, cream grounds were enhanced and warmed by the adjacent placing of cooler tints. Particularly in the later landscapes and wooded scenes,

Cézanne used these pale grounds to create the lights, thus obviating the need to overload the surface with paint. Thin, translucent paint films frequently appear in Cézanne's mature works and his experiments with overlaid transparent water-colour were incorporated into a number of his oil paintings. By contrast, other works in oil were heavily built up with layers of paint standing out in relief from the canvas surface. The densest paint follows the contours of the form, and the thinner applications, often revealing the ground, were used for form and contours. Cool colours, mainly blues, were used for the shadowy areas, while warmer pinks, reds, and yellows appear to create the roundness of the forms.

Cézanne used interlocking planes of subtly modulated, contrasting colours to create the complex spatial arrangements of his paintings. His slow, methodical way of painting meant that he often spent years on a work, returning to and adjusting it many times over. When re-working a painting Cézanne often worked from a different viewpoint. His revised perceptions of the subject would often be incorporated into the picture making it more complex.

1. Paper was bought commercially primed with a cream-coloured ground. This was pinned to a rigid support.

2. Original outlines were drawn in graphite and overlaid with a dilute blue paint, possibly ultramarine.

3. Wet-in-wet application of paint was begun before the outlines were dry, and reworking and adjustments took place continuously throughout the painting process.

4. Brushstrokes of thin opaque colour were applied following the contours of the form and modelled with contrasting warm and cool tones.

5. The ground was often left uncovered and used to define highlights.
The painting was not varnished.

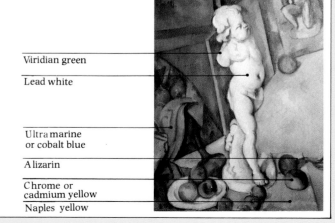

Viridian green

Lead white

Ultramarine or cobalt blue

Alizarin

Chrome or cadmium yellow

Naples yellow

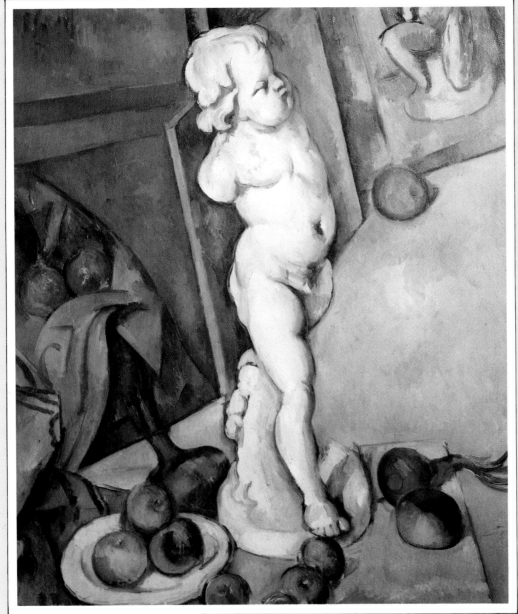

The high viewpoint and enlarged proportions of the cupid suggest this work was done with the subject very close to the painter. The paint layer is remarkably thin with the cream ground showing through in a number of places. The basic outlines were drawn in a fluid blue paint. The painting was begun before the outline was dry, as witnessed in the blue dragged into adjacent colours. The painting is not heavily worked and has an immediacy and surety which often eluded Cézanne. The palette is simple and included ultramarine or cobalt blue, emerald and viridian greens and vermilion, Naples and chrome yellows, lead white and alizarin crimson. Cézanne has used many sophisticated techniques to create this spatially complex picture. The left wall is lined with pictures placed to direct the viewer's eye into the pictorial space. The placing in the background of an apple which is the same size as those in the foreground has the effect of halting the recession and flattening the surface. These two effects vie for the viewer's attention, and the tilting plane of the floor changes to accommodate both. The painted still life in the canvas on the left is both separate from the 'real' still life and indistinguishable from it. The onion on the table has shoots which extend into the painted still life, while the apples and blue fabric on the table reappear, with no apparent disjunction, in the painted still life.

This detail shows the growth of the onion on the table 'into' the painted still life of the canvas to the left. Although the shoots belong to this onion they also merge with the picture; a line describing the lower edge of this canvas disconcertingly cuts the onion shoot just as it changes to green, compounding the ambiguity of the illusion which plays on our notion of 'real' and 'painted' realities. The bottom of the statue is here separated from the similarly pale hues of the floor by strong dark outlines.

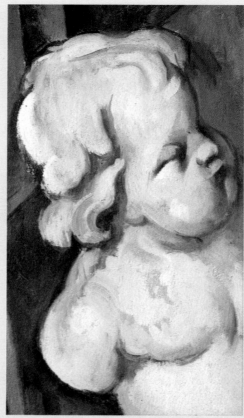

The plaster cupid, which survives today in Cézanne's studio in Aix, is in reality much smaller than it appears in this painting; its actual height is 18in (46cm), while the painted cupid measures 24in (61cm). Cézanne's deft handling of the opaque, subtly coloured greys sculpts the form in broad hog's hair brushstrokes which follow and describe features such as the hair. Shadows are mainly attenuated with diffused light, but, where deep, are treated simply and opaquely. Delicate, separate but blended patches of colour build up close-toned hues on the chest, which appear cool against the exposed cream ground.

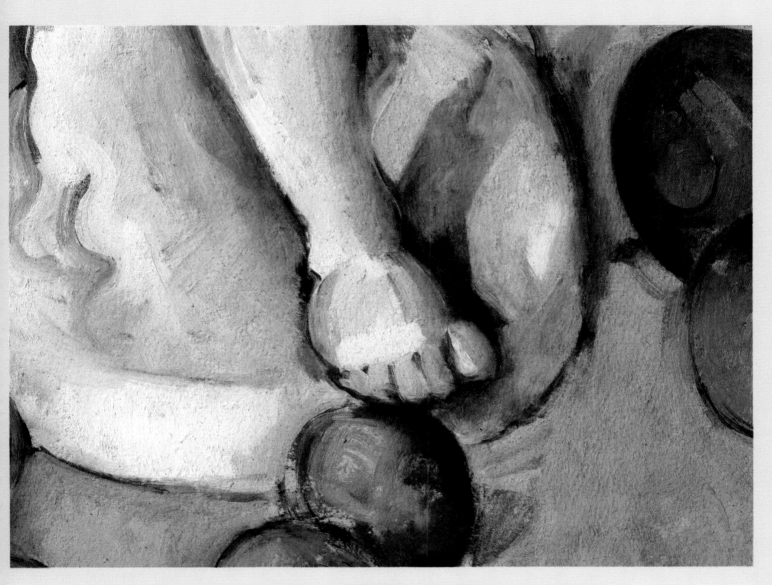

Actual size detail
This detail reveals how Cézanne used both colour contrasts and a variety of brush–strokes to describe objects in space. This gives his work an overall solidity and monumentality. Although the painting appears to have been executed quickly and with confidence, Cézanne was known to work with meticulous care. The brushwork and fluid colour in the apples is particularly interesting and reminiscent of Cézanne's watercolours.

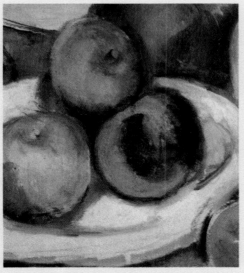

Cézanne's characteristically reiterated contours are visible here, especially in the apple to the right of the plate, where exposed ground and fine graphite lines can also be seen. The irregular oval of the plate shows that Cézanne preferred to respond to visual sensation rather than simply depicting objectively the actual shapes of everday objects. A red lake glaze on the righthand red apple has darkened and coagulated with age.

Paul Gauguin

(born 1848, died 1903, French Post-Impressionist artist)
Christmas Night or The Blessing of the Oxen
painted c.1896, oil on canvas, $28\frac{1}{4} \times 32\frac{3}{4}$in ($72 \times 83$cm)

Gauguin began painting in 1873 while still working in the Paris Stock Exchange and only began as a professional when he lost his post there in the slump of 1883. His childhood in Peru and subsequent travels in the Navy gave him a taste for the exotic and primitive cultures; after visiting Martinique, from 1890 he lived mostly in the South Seas. Highly eclectic, Gauguin's sources of inspiration ranged from the art of Degas, Manet, Cézanne, and Pissarro to the Buddhist art of Java, Japanese art, and Oceanic mythology. The French mural painter Puvis de Chavannes, with his simplified, majestic treatment of the human form and flat planes of colour, was another strong influence in Gauguin's painting style.

In the late 1880s, with other artists in Brittany, Gauguin evolved his personal symbolist style which involved a simplification and exaggeration of form, line, and colour to express anti-naturalistic spirituality. Gauguin was also experimenting with other media like woodcarving and ceramics, and these influenced his painting. These and his work with lithography encouraged a use of simple, strong contours and flat planes of colour.

Gauguin often used unprimed, heavy sackcloth-like fabrics, exploiting both their ability to produce dull, matt surfaces and their texture, which he allowed to read through a thin but opaque paint layer. When he used primed canvas, the layer was thin and pale. Gauguin also felt that the use of absorbent grounds was important as these gave a sunken and dull appearance to the paint which was similar to unprimed cloth.

Although Gauguin's paint was chiefly brushed on — sometimes as stiff colour and sometimes as scumbles — on some occasions he used a palette knife. He also added wax to his paint to stiffen and make it more matt. The commercial addition of wax to artists' colours was common at this time, to stabilize the paint and reduce the amount of pigment required. During the 1880s, Gauguin bought minimally hand-ground colours. These had a granular texture very different from the smooth quality of machine-made pigments.

His palette included the cadmium and chrome yellows, yellow ochre, viridian and emerald greens, ultramarine and cobalt blues, cobalt violet, red lakes, vermilion and white.

1. A strong, herringbone twill canvas was used which plays an important role in the painting.

2. The contours were outlined directly on the primed canvas in vermilion and dark ultramarine or Prussian blue paint.

3. The modelling was built up in flat areas of contrasts with outlines and contours reinforced. Within the broad colour areas the tones were unified with blues.

4. The colour was applied wet over dry to exploit the texture of the canvas by dragging layers of opaque colour over one another and allowing previous colours to show through.

Gauguin's palette for this work included: white, possibly zinc white (1), Prussian blue (2), ultramarine or cobalt blue (3), vermilion (4), viridian green (5), yellow ochre (6), alizarin red (7), mixed greens, or emerald or cobalt green (8), Naples yellow (9), and perhaps cadmium yellow (10).

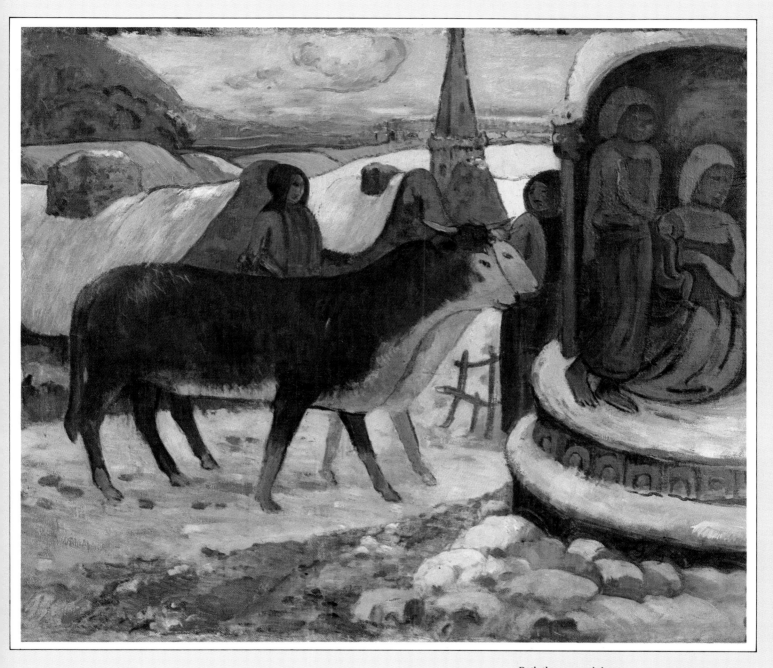

Both the unusual shape and fabric of this canvas suggest that the picture was done in the South Seas rather than Brittany. A thin ground has left the canvas weave in evidence, and Gauguin has used this by applying a thin paint layer and dragging stiffish paint across the textured surface. The subject was apparently sketched in without preliminaries in muted vermilion and dark, probably Prussian, blue. Both lights and shades are flat and opaque; no glazing and little scumbling are apparent. The handling of the paint is lively and varied with subtly modulated overlays of colour, with wet over dry predominating. The brushwork is texturally evocative with the figures sculpted with colour and brushstrokes.

The dark outlines of the oxen's heads have been filled in, and partially overlapped, with the wet-in-wet colours representing their faces. On both muzzles, a hint of vermilion appears among the blue lines. The pale snowy background was worked in around the figures, obscuring one horn and obliterating the outline at the near ox's chin. Where the paint is thinnest, the tapestry-like canvas texture broke the movement of the brush, producing decorative irregularities and stressing the two-dimensionality of the picture surface. The faces were treated as flat, stylized types, the clothes as simple shapes of little modulated colour. The original and reinforcing contours outlining the oxen remain discernible, and the snowy ground was clearly filled in around them. The unifying blues in the picture are enhanced by contrasting areas of pale pinks and greens — alizarin crimson, vermilion and viridian green, each mixed with a generous amount of zinc white.

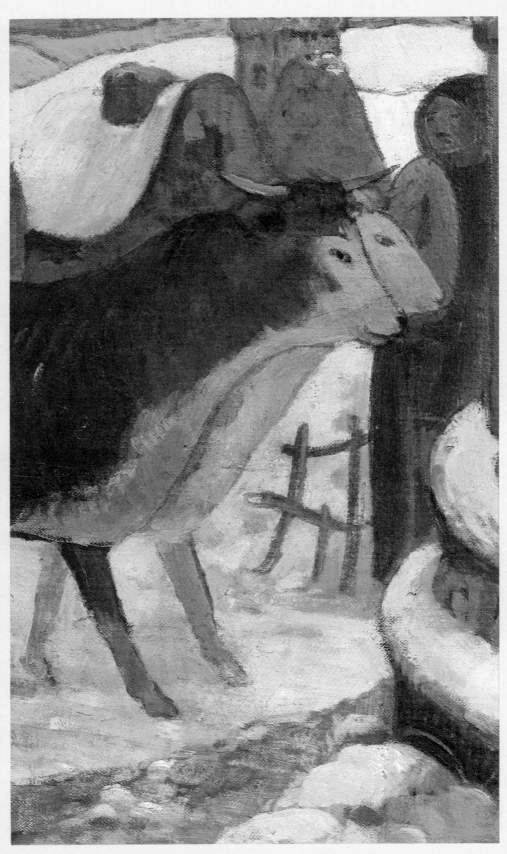

Blue and green are streaked wet-in-wet to depict the snow-covered roofs, and the skyline softens in blurred hazy deeper blues. Alizarin crimson, vermilion and green worked with white indicate the sky coloured by the sunset. The clouds are decoratively outlined in pale blue.

Actual size detail
In this detail, the herringbone texture of the canvas is apparent and exploited by the thin paint layer and dabs of stiffish paint which catch on the irregular surface. Along the bottom edge, the ground appears as a warm grey or dirty white which suits the dull winter atmosphere. There is a delicate over-laying of paint in the path with some wet-in-wet work seen in the blue-whites of the snow, which overlaps the dry ochres and greens. The paint layer is flat and opaque, with individual, brush-shaped marks of whitened viridian, blue, vermilion and orange adding texture to the rocky foreground.

131

Henri Matisse

(born 1869, died 1954, French artist)
Portrait of André Derain
painted 1905, oil on canvas, $15\frac{3}{10} \times 11$in (39.4×28.9cm)

Matisse's long painting career, which was, for the most part, divided between Paris and Nice, formed an almost continuous attempt to extend his means of expression in colour. In developing his technique, Matisse studied widely. In the 1890s he copied works in the Louvre by the eighteenth century French painter Chardin and other Old Masters in the restricted tonal palette of Matisse's early still lifes and interiors. He also studied works by Impressionists, Cézanne and the Post-Impressionists. By the summer of 1905, Matisse had evolved a technique of striking contrasts, of unmixed hues, flat planes of colour and striking, expressive brushstrokes. This soon earned him and other like-minded artists, including André Derain, the subject of this portrait, the name 'les Fauves' which means 'the wild beasts'.

The Fauve technique can be seen as a synthesis of elements of the Post-Impressionist palette, particularly the expressive brushstrokes of van Gogh and Gauguin's flat planes of saturated colour. The Fauve approach also marked a reaction to the polished perfection of the smooth finish characteristic of much nineteenth century French painting, and to photographic realism. The Fauves concentrated on the expressive potential of the traditional means at the painter's disposal — canvas surface, quantity and quality of paint, brushmark and line. In 1929 Matisse summarized the ideas which had occupied him in the Fauve years as 'Construction by coloured surfaces. Search for intensity of colour, subject matter being unimportant. Reaction against the diffusion of local tone in light. Light is not suppressed, but is expressed by a harmony of intensely coloured surfaces'. Although Matisse soon moved away from his Fauve technique, which his *Portrait of André Derain* exemplifies so excellently, the lessons learned at this time remained the basis of his organization of colour.

Matisse's conception of colour as light allowed him to create what he termed 'the equivalent of the spectrum' through a balance of colour relationships established on a colour circle. In this portrait, the warm hues of the figure are juxtaposed against the background, with a further system of colour contrasts and harmonies focusing the attention of the viewer on the sitter's head.

1. Matisse often used a portable easel on which he would work indoors or outside with equal facility. The fine-grained canvas is not a standard French format.

2. The ground made of size, oil, chalk and a white pigment was applied in a thin layer over the whole surface excluding the folded-over edges. The ridges of the canvas threads are bare in places.

3. The main features were drawn in using a tint of cobalt blue applied with a small round brush.

4. The paint was applied *alla prima*, wet into wet. The background was broadly brushed in tints of blue and green.

5. Derain's smock was painted fairly thinly in long brushstrokes, and the greatest weight of pigment applied to the head and neck.

Unmixed viridian green

Scarlet lake mixed with white

Cobalt blue mixed with white

Cadmium orange and vermilion red

Viridian green mixed with white

Most brushwork and greatest weight of pigment concentrated on head and neck

Ground showing through

Chrome yellow mixed with white

Cobalt violet signature

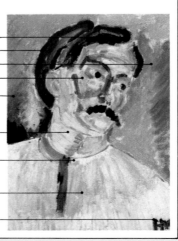

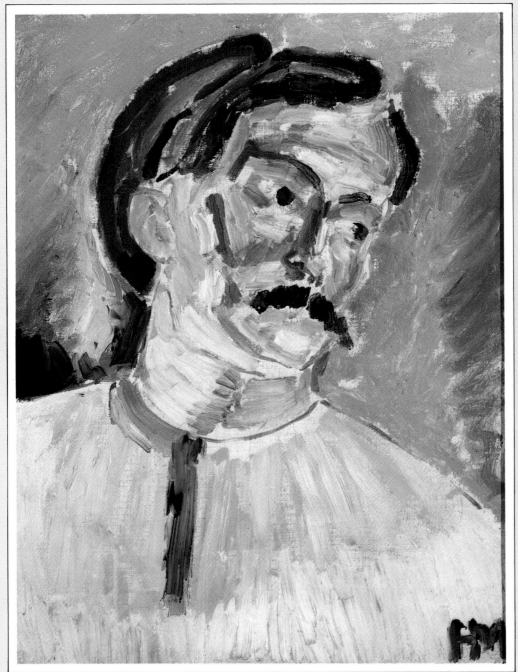

In this portrait, there is a clearly definable series of colour relationships. The warm reds, yellows and oranges of the figure are juxtaposed against the cool greens and blues of the background. The triad of yellow, green and blue around the figure is juxtaposed with the two near complementary pairs — red against green and orange against blue — which combine to concentrate the viewer's attention on the sitter's head. The freedom with which the paint was applied contrasts with the methodical organization of the colour. Derain's smock is relatively sparsely painted in long brushstrokes of yellow with tints of green and reddish brown. The greatest weight of pigment is reserved for the head and neck, the background, by contrast, being broadly brushed in tints of cobalt blue and viridian green.

The ground was thinly applied and the ridges of the canvas threads were left bare in places; the ground plays an important part in creating atmospheric unity, in separating areas of pigment and in making the torso look more three-dimensional. Matisse usually used standard French format canvases unless he required a particular proportion for his subject, as was the case in this work.

Matisse painted Derain's smock relatively sparsely. The traces of the long brushstrokes are clearly visible. The smock makes up the yellow section of the colour triad. In places, the ground can be detected and some of the ridges of the canvas threads are bare.

Actual size detail
In this picture, Matisse has interestingly adapted the standard academic technique of painting the shadows thinly and the highlights thickly. The greatest weight of pigment is concentrated in Derain's head and the shadows are relatively thinly painted. The head was outlined with a small brush in liquid blue paint, which can still be clearly seen on the ear and hairline. The paint was applied wet into wet, as on the neck where the colours have mingled visibly.

The signature was painted in last. Its cobalt violet colour adds weight to the bottom righthand corner of the painting. Cobalt violet is complementary to the yellow of the smock.

In this work Matisse has created two concentric colour circles. The outer triad consists of chrome yellow, viridian green and cobalt blue and the broadly complementary inner colours of cadmium orange, vermilion red and scarlet lake.

Chrome yellow

Cadmium orange

Vermilion red

Scarlet lake

Viridian green

Cobalt blue

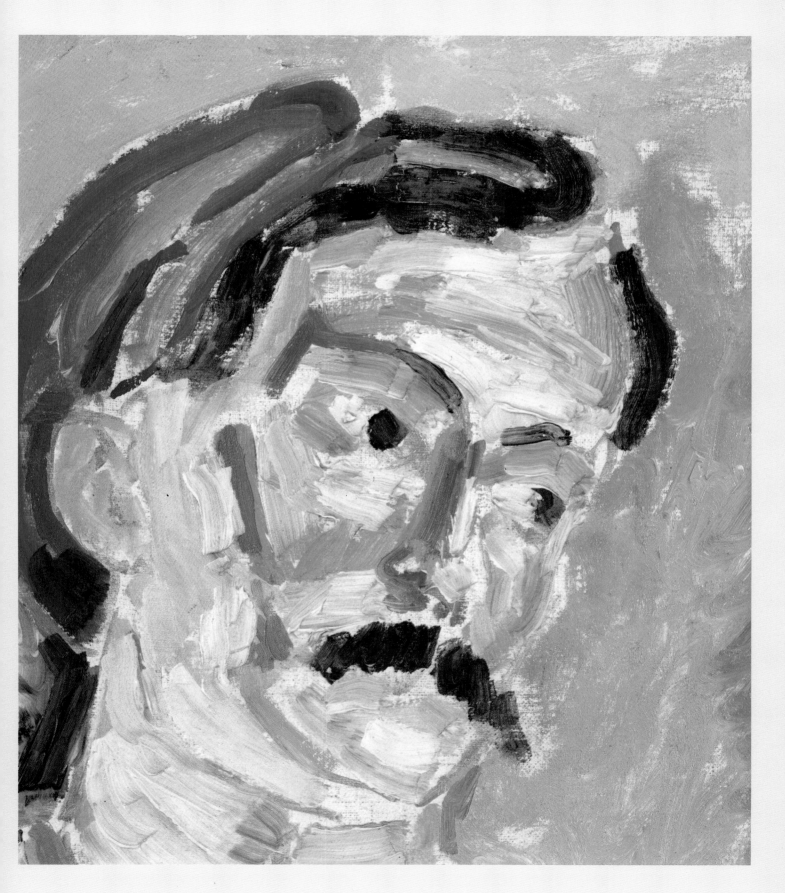

Pablo Picasso

(born 1881, died 1975, Spanish artist)
Still Life with Chair Caning
painted 1912, oil and oilcloth on canvas, $10\frac{3}{4} \times 13\frac{5}{8}$in ($27 \times 35$cm)

Picasso's great technical contribution to painting came with his and Braque's development of Cubism in the early years of this century. Cubism, which Picasso described as 'an art dealing primarily with forms', sought to dislocate space, eliminate perspective and split forms up in order to relate each one to an overall pattern in new ways. The Cubists did this, for example, by depicting several planes or surfaces of an object rather than portraying it from a single viewpoint. Picasso summed up his view of the goal of Cubism as 'To paint and nothing more. And to paint seeking a new expression, divested of useless realism, with a method linked only to my thought — without enslaving myself or associating myself with objective reality.'

However, *Still Life with Chair Caning* introduced another major Cubist development — collage. Indeed, Picasso's inclusion of an actual piece of oilcloth patterned with wickerwork chair caning amongst the painted objects on a café table can perhaps be regarded as the major technical innovation in painting of this century. This new technique, called collage from the French verb *coller* meaning 'to glue', broke with the traditional integrity of the oil medium and the notion of beauty associated with the skilful counterfeit of photographic realism. It set a challenge for painters to explore new techniques and to use any materials available in the achievement of their ends. The technique of collage evolved from Picasso and Braque using lettering as an integral part of the construction of a painting. In this work, for example, the letters 'JOU' from the word for newspaper, *journal*, are used to indicate the picture plane, while also hinting at the French word for play, *jouer*. Similarly the oilcloth with its wickerwork pattern has several functions in the painting. It suggests either a seat or some wallpaper; it is something 'real', taken from life, and yet it is only a printed illusion of a piece of wickerwork. Collage became a versatile and influential technique.

Still Life with Chair Caning was one of a sequence of oval still lifes painted in Spring 1912. Like another in the series, it was placed by the artist in a frame made of rope. Picasso described his working methods thus: 'I usually work on a number of canvases at a time. . . . I like to work in the afternoons, but best of all at night.'

1. Picasso used an off-white ground on a fine-grained canvas to lend the work its overall light tone.

2. The paint surface was built up in layers worked wet into wet. Forms such as the shell were achieved by applying moulded impasto over an initial layer of ochre and then overdrawing in black with a brush to represent the scallop.

3. The oilcloth was attached to the canvas with fixative and brought into the general paint surface by the large brushstrokes applied across it.

4. The picture was framed with rope, which forms an integral part of the finished work.

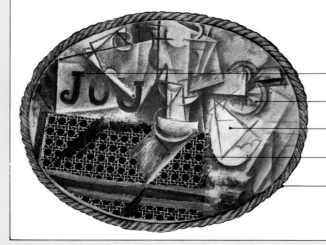

Use of lettering apparently painted without a stencil

Opaque lemon yellow

Heavy white impasto

Collaged oilcloth chair caning

Frame made of rope

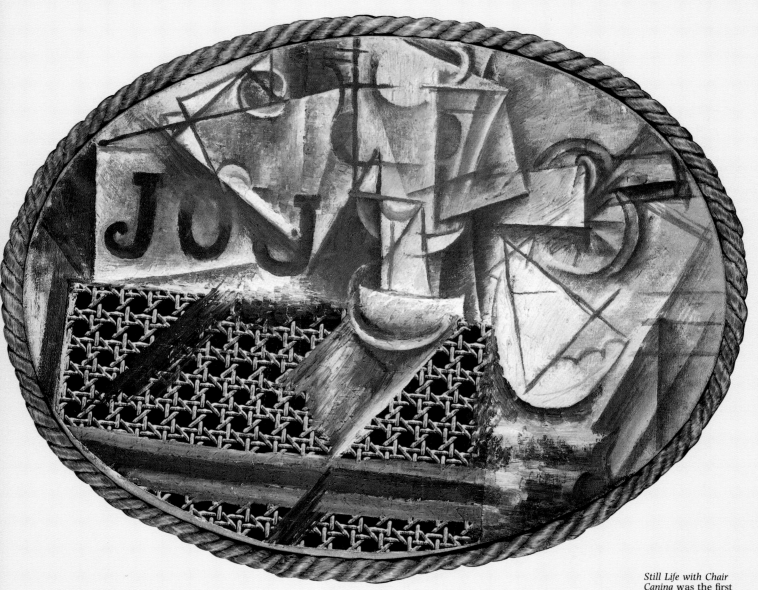

Still Life with Chair Caning was the first picture to use collage. The palette, with the exception of the opaque touches of lemon yellow to represent the sliced lemon, is restricted to a range of ochres and siennas. The collaged element, the oilcloth chair caning, is integrated into the overall image by the paint applied to it. The rope framing the oval emphasizes the fact that the painting is a constructed object, and perhaps is making reference to a raised edge around a café table. The oval shape itself also suggests a circular plane seen in perspective.

Among the innovatory features of this work are the piece of oil cloth chair caning which was the first use of collage in a painting, and the lettering. The letters 'JOU' spell the beginning of the French word for newspaper, *journal*, and also of the French word for play, *jouer*. The lettering and the oilcloth are integrated into the overall image by the broad brush-strokes across them, which possibly signify shadows.

Actual size detail
The wickerwork-patterned oilcloth, which was the first collaged element to be included in a painting, is absorbed back into the overall image by the exaggerated horizontal brushstrokes across it, which perhaps indicate the edge of the café table, and by the base and shadow of the wineglass placed across it.

Still Life with Chair Caning was one of a series of still lifes which Picasso painted in 1912. He framed the work in a piece of rope. When looking at a picture in an art gallery, for example, it is easy to assume that the artist selected the frame to suit the picture. However, in very many instances, the pictures are framed by the gallery. In the case of this Picasso work, the unusual material and its texture form an integral part of the picture and its overall effect.

Wassily Kandinsky

(born 1866, died 1944, Russian-born abstract artist)
With Black Arch
painted 1912, oil on canvas, 73 × 76in (186 × 193·3cm)

At the age of 30, Kandinsky abandoned a career in law in order to study art in Munich. From 1909 onwards he struggled to achieve an abstract art of emotional and spiritual intensity derived from the mingling of forms and colours. It is worth emphasizing Kandinsky's Russian origins because his mystical conception of art as a spiritual presence acting as a link with a higher plane of reality has more in common with his native tradition of religious icon painting than with the European tradition of naturalistic representation. Kandinsky equated naturalism with materialism, and believed that it was the mission of the artist to instil a consciousness of the soul of man and of the hidden laws of the universe into a materialistic society which was doomed to destruction. *With Black Arch*, painted in 1912, can thus be seen as the expression of an inner spiritual struggle.

Kandinsky's principal artistic problem was how far he could reduce the representation of objects without lapsing into mere decorative pattern making. To achieve this, he developed a technique characterized by bold brushstrokes and areas of colour which were inspired by such sources as icon painting and Bavarian peasant glass paintings. It was Kandinsky's hope that the public could be educated to experience his new language of abstract art in the same direct way as music. In 1912 he wrote that music was devoted 'not to the reproduction of natural phenomena but to the expression of the artist's soul and to the creation of an autonomous life of musical sound'. Kandinsky wished to apply this approach to his own art.

Kandinsky described his working methods in the most general and metaphysical of terms 'Each work arises technically in a way similar to that in which the cosmos arose — through catastrophes, which from the chaotic roaring of instruments, finally create a symphony, the music of the spheres'. For his major compositions, Kandinsky did preliminary paintings, watercolours and drawings. However, these are self-contained stages in the process of making the image abstract, rather than studies in the usual sense. The main objective of Kandinsky's approach was to maintain the identity and impact of the pictorial elements. Throughout his long career, Kandinsky was associated with a number of artistic movements including the 'Blue Rider' group.

1. An off-white ground was applied to a large format canvas.

2. A charcoal outline of the forms was then drawn in.

3. Kandinsky next blocked in the main colour areas.

4. The linear structure was then drawn in.

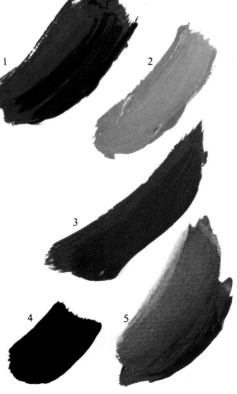

In this work Kandinsky used the following pigments: Prussian blue (1), yellow ochre (2), madder (3), black (4) and madder lake (5).

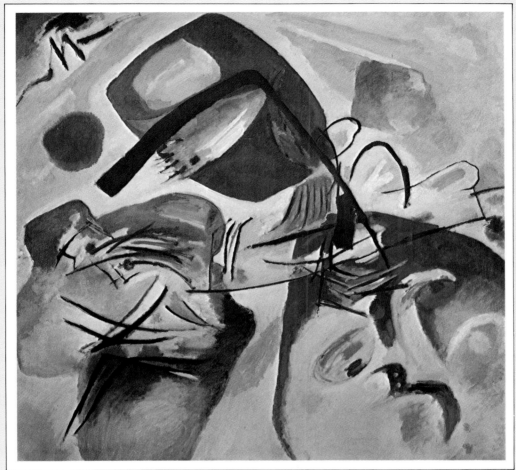

The scale of the picture is large, so that the viewer can experience to the full the 'spiritual vibration' of the colours and forms, as Kandinsky put it. Important use is made of the off-white ground which covers the canvas giving vibrancy and impact to the colours. Kandinsky felt that the abstract forms painted in opaque black denoted negative forces. The movement of the painting is concentrated towards the centre and the illusion of speed is suggested by the technique of leaving the wake of a passing colour in a pale glaze and by the scumbled passages of white. The shapes in the painting cannot be identified with any degree of certainty. Similarly, it is impossible to tell exactly what order the painting was done in.

Actual size detail
The off-white ground can be clearly seen in this detail. Kandinsky's colours are mostly flat and evenly brushed. The paint was modified with subtle movements of the brush. The black lines were not added at the end, as can be clearly detected where the colours overlap. The picture was built up with precise and controlled brushwork.

Pierre Bonnard

(born 1867, died 1947, French artist)

Interior at Antibes

painted 1920, oil on canvas, $46 \times 47\frac{1}{2}$in ($116 \cdot 2 \times 121 \cdot 6$cm)

Bonnard is an outstanding example of a painter whose art evolved through a study of the nineteenth century French painting tradition into something significantly new. Thus, to see Bonnard's work as an eclectic synthesis of Degas' subject matter and compositional methods, Gauguin's imaginative colour and Monet's modified *alla prima* technique would be to underestimate his achievement in conveying the seen world onto the whole canvas surface with vitality and immediacy. He saw technical control as the basis of expression and defined technique as 'the experience of centuries to guard against errors by the knowledge of the means employed'.

Bonnard did not paint directly from life. Memory and preliminary drawings together formed the starting point of a painting in the studio. He apparently never made any sketches in colour, although he did occasionally note on a drawing the intensity of the colour to be used. Any available room served as his studio, and his working methods were equally unconstrained by studio props and a fixed routine. A contemporary description makes this clear 'He had no easel; his only equipment was a little bamboo table on which were strewn the paintbrushes and a chipped plate on which he set out his colours. His canvases, fixed to the wall with thumbtacks, he sometimes left for months without finishing, then one day added to them a little colour smeared with his finger. On more than one occasion, visiting friends, he touched up a canvas sold to them perhaps ten years earlier'. Bonnard sometimes painted several pictures at once on a large piece of canvas tacked to the wall. Intuition dictated the final format and he would, if necessary, cut a strip from the canvas or add one on. His working methods were guided by what he described as the wish 'to show all one sees upon entering a room. . . . What the eye takes in at the first glance'. He further noted that 'To begin a picture there must be an empty space in the centre' and that the artist should 'work a fragment hiding the rest'. However, Bonnard also cautioned that it was necessary to know in advance the effect of the work seen from a distance. Like his working methods, Bonnard's colour scheme relied on personal experience rather than on any predetermined system which might prove too inflexible in practice.

1. Bonnard did not use a standard format canvas he let the painting assume its own dimensions on a large piece of canvas tacked to the wall. He used a finely-grained, closely-woven canvas with a commercially-prepared white ground.

2. Some areas were built up in several thin layers.

3. Others were painted in thicker layers with emphatic brushwork and some impasto.

4. The finishing touches were added to the painting after it had been stretched and placed in its gold frame.

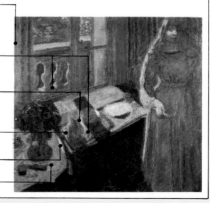

Light created from vermilion and scarlet lake worked wet-in-wet into yellow and green

Repetition of colour from exterior to interior

Edge of jug and saucer built up in white impasto to form highlights

Scraping down with palette knife

Ground showing through

Scumbles of blue on white cloth

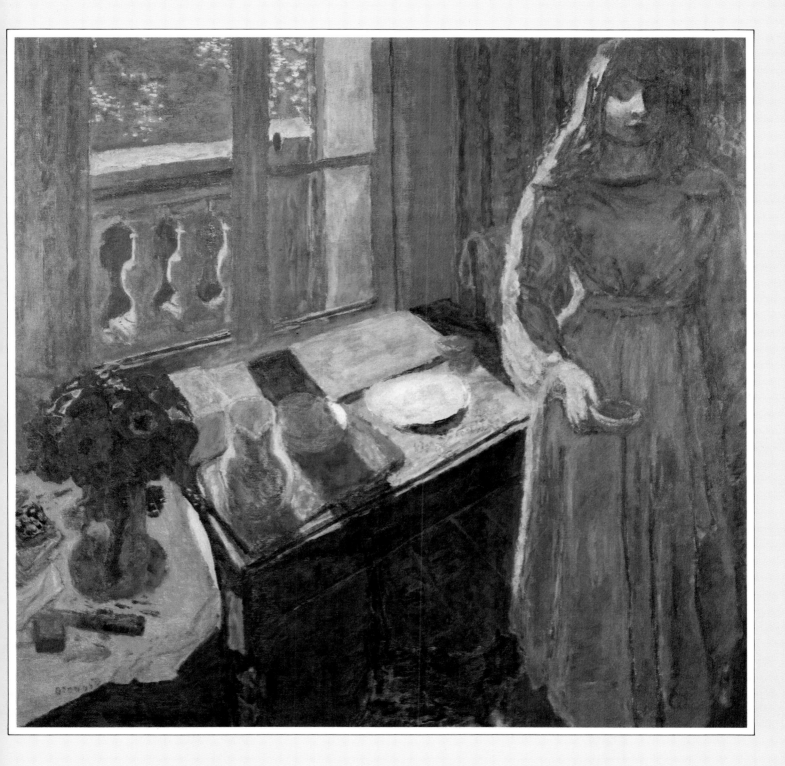

Bonnard's technique is very varied. Some areas are built up in thin layers, while others show thicker layers with emphatic brushwork and some impasto. For example, on the left of the window, the pattern is created by touches of vermilion red and scarlet lake worked wet-in-wet into chrome yellow and a composite middle green. The jug, and cup and saucer in the centre of the painting, on the other hand, are scraped down with a palette knife and then built up to a white impasto. The woman's right hand and sleeve are painted in crusty scumbles of dry paint on the exposed white ground.

On the left of the window the impression of cascading light is created by touches of vermilion and scarlet lake worked wet-in-wet into chrome yellow and a composite mid green.

Actual size detail
This detail shows the full range of Bonnard's technique. The right-hand side of the jug was built up and then scraped away with a palette knife. The blue to the right of the jug was built up using dry paint scrubbed over the surface using a dry hog's hair brush. In the top area the violet was rubbed on over the blue-green paint when it was dry. The main area of the jug was painted in a reddish-violet, overpainted in black, and then the colour was scraped back, so that the canvas threads showed through.

The basic colour is provided by the white canvas ground. Bonnard would work by applying layers of colour and then scraping them down and reworking with paint, so that the residual layers became part of the content of the painting. In this area he worked wet-into-wet, applying a cool red such as scarlet lake and cooling the tone by applying further layers of blue-violet in the shadow areas particularly. Nowhere is Bonnard's approach programmatic.

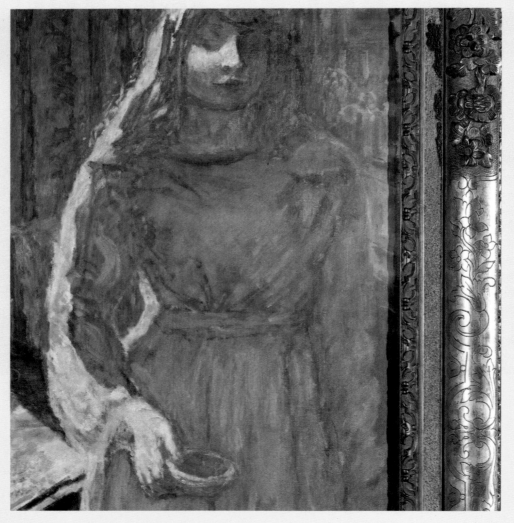

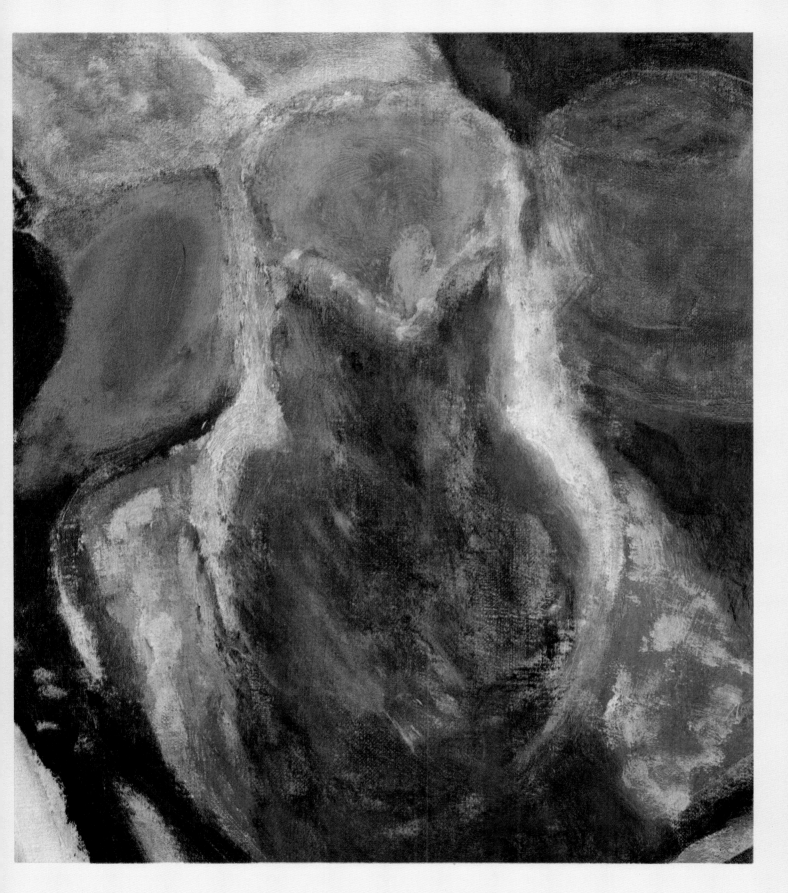

Fernand Léger

(born 1881, died 1955, French artist)
Still Life with a Beer Mug
painted 1921, oil on canvas, 36 × 23½in (92·1 × 60cm)

Léger wanted to develop the ideas about Cubism into an artistic vocabulary commensurate with the machine age. He saw modern life as characterized by dissonance, dynamism and movement, which he felt could only be expressed in painting through contrasts of colour, line and form. In the various works which Léger completed in Paris before 1914, movement meant fragmentation, but after the war, he began to reconcile traditional subjects with his new feeling for the beauty of some manufactured, every-day objects, which were seen in terms of flat planes of bright, contrasting colours. In *Still Life with a Beer Mug*, which was painted during 1921 and 1922, the shaded modelling of the curtain, objects on the table and the interior view of the mug contrasts with the flatly painted geometric shapes and the patterned rendering of other forms. This illustrates Léger's preoccupation with plastic contrasts, which he described as follows in 1923: 'I group contrary values together; flat surfaces opposed to modelled surfaces; volumetric figures opposed to the flat facades of houses . . .; pure flat tones opposed to grey, modulated tones, or the reverse'. Léger did not want simply to copy a manufactured object, but felt that its clean, precise beauty should be accepted as a challenging starting point which would, if necessary, be distorted to achieve the final desired result.

Léger found his source material in what he described as 'the lower-class environment, with its aspects of crudeness and harshness, of tragedy and comedy, always hyperactive'. Léger's work can thus be seen as a response to a view of the world as being in flux and opposition on which, through its being rendered in art, order is imposed through the methodical preparation and execution of the work. The canvas of *Still Life with a Beer Mug* was divided into 24 squares, some of which can still be seen on the canvas. Léger's rather aggressive statements about his work should not obscure the fact that *Still Life with a Beer Mug* is an outstanding example of sensitive and subtle handling of the oil painting medium. Léger took vast pains to achieve exactly the result he wanted. In this work slight adjustments were made in the final paint layer even after the work had been photographed at the Galérie Simon in Paris.

1. Léger began by doing a detailed drawing in pencil, which he squared up preparatory to transferring the design.

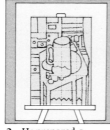

2. He prepared a preliminary painting, for which he used a squared-up grid. This was in a different format to the final version, measuring 65 × 46 cm (26 × 18 in).

3. The support for the final version is an open simple weave, linen canvas. It was heavily sized before the off-white ground was applied thinly and evenly all over the canvas.

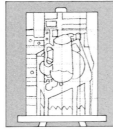

4. The 24 squares were executed in pencil and the design was then also sketched in. The moderately rich oil paint was applied fairly thickly, but without impasto and with little brushmarking.

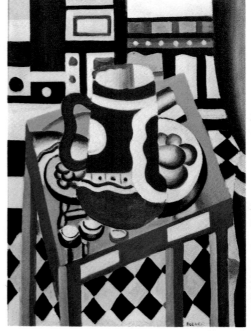

This preliminary study shows how Léger's conception of the work changed in the final painting. In the study, the background tends to draw the viewer's eye away from the central image of the beer mug, while in the final picture, contrasts were added and strengthened.

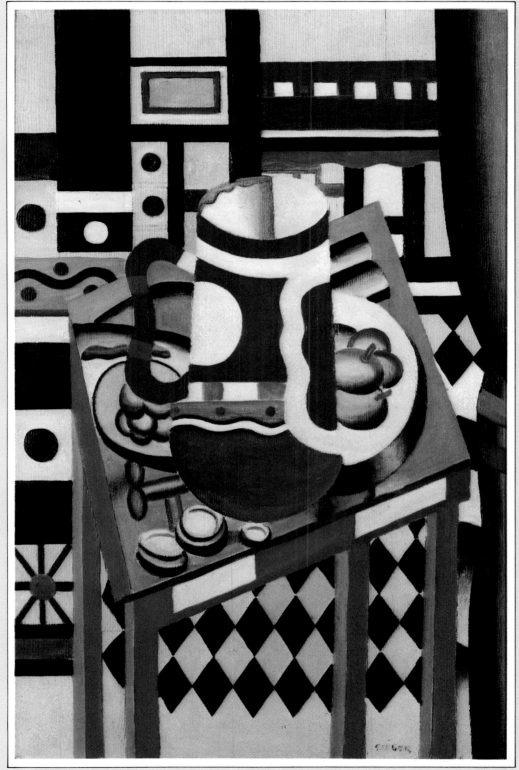

Still Life with a Beer Mug shows an extremely subtle handling of oils. The strong colour contrasts show a range of carefully worked tones. The black tones are played against white. The warm colours, vermilion, cadmium orange and yellow, are played against the cool tints and shades of Prussian blue, and these intense areas are relieved by the delicate interaction of almost creamy washes of pale lemon yellow and pale blue-green in the diamond pattern below the table. The picture retains the fine but emphatic canvas pattern which shows through the ground. Indeed, the ground itself makes up much of the white background.

The strong tonal
contrasts which are
characteristic of Léger's
work can be clearly
seen in this detail. The
brushstrokes on the
beer mug and plate are
also typical. The pencil
underdrawing can be
detected around the
mug and plate.

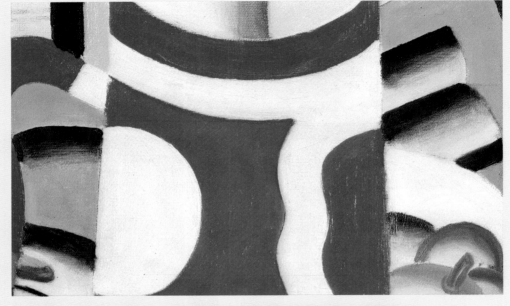

Léger's subtle tonal
variations which
contrast so effectively
with the strong colours
are shown in this detail.
The apparently black
and white floor under
the table is, in fact, a
mixture of pale grey
and cream tones which
changes from square to
square. Similarly the
greys in the objects on
the table also consist of
a careful blend of tones
ranging from black to
white.

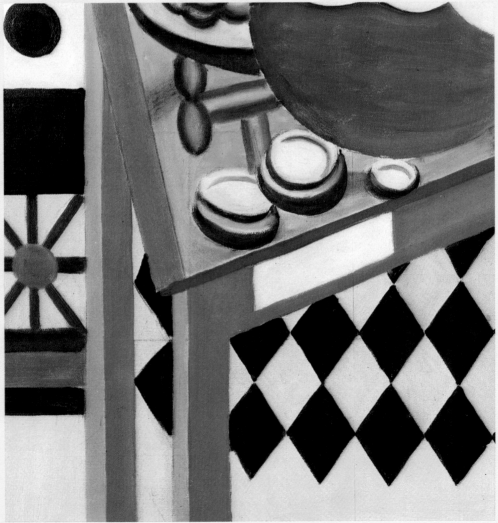

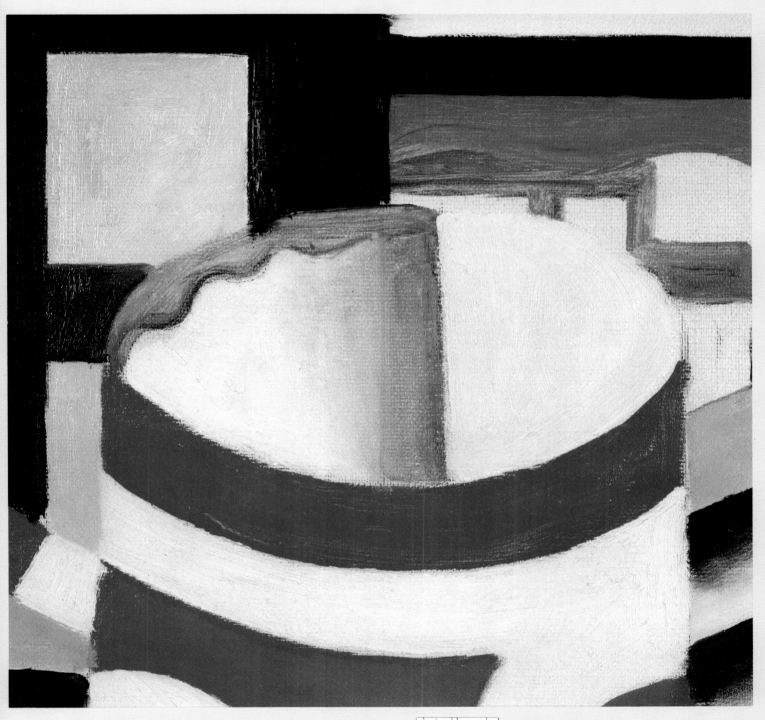

Actual size detail
Léger's brushwork can be clearly seen in this detail. On the right, the ground shows through. The change in position of the orange line can also be detected — Léger made many such changes in order to achieve precisely the effect he desired. The inside of the beer mug is executed using grey shading on one side and leaving heavily brushed white on the other. The greys on the shaded side are much less thickly applied and the canvas texture shows through.

149

Edward Hopper

(born 1882, died 1967, American realist painter)
House by the Railroad
painted 1925, oil on canvas, 24 × 29in (60·9 × 73·6cm)

Edward Hopper is best known for his oil paintings, but they did not generally bring him critical or financial success until he was in his late forties. During the first fifteen years of his career, Hopper was only able to paint in his leisure time and, until 1924, when an exhibition of his watercolours in New York sold out, he had to support himself as a commercial artist and illustrator. He also made over 50 etchings between about 1915 and 1924.

In 1955, Hopper remarked that: 'After I took up etching, my paintings seemed to crystallize'. During the early 1920s, he found a satisfactory way of expressing his ideas in oil and, in particular, concentrated on the effects of bright light on solid forms, which may have stemmed from his use of strong tonal contrasts in etching.

In the early 1920s Hopper made few oil paintings, but, after his initial success in 1924, he began to produce and exhibit several oils each year. In 1960 Hopper, who rarely made any statements about his work, commented on his painting technique: 'I have a very simple method of painting. It's to paint directly on the canvas without any funny business . . . I use almost pure turpentine to start with, adding oil as I go along until the medium becomes pure oil. I use as little oil as I possibly can. It's very simple'. In his early years, Hopper made extensive use of free brush-work and applied paint in a thick impasto. Gradually, however, he suppressed any tendency towards technical display and the surface of his paintings became more evenly textured. In his later work, Hopper created a transparent surface by building up the paint surface in thin layers and scraping down and repainting.

Hopper frequently used a straight, horizontal motif, usually a road or railroad track, to construct the space within the picture and to emphasize the division between the picture space and the viewer's world. Indeed, the more the viewer tries to penetrate the depths of a Hopper painting, the more impenetrable it becomes. What holds the viewer is that the artist's vision seems under control and yet, on closer inspection, the viewer realizes that the visible surface is a tissue of improbabilities and unreadable shifts in space. Hopper's view that nature and the contemporary world were incoherent contributed to his artistic vision.

1. Indications of the structure of the house were brushed in with a minimum of black paint in a turpentine mixture. The columns and windows on the right shadowed side of the house clearly show this.

2. The house was then painted from dark to light; Hopper gradually added more oil paint to the turpentine and built up the forms with free, often diagonal brush-work.

3. The side of the house in bright sunlight was executed less freely with transparent darks and opaque lights. Lines of blue were added after the opaque white to define forms.

4. The railway line and embankment were also executed from dark to light. The orange and ochres on the bed of the track are virtually impasto with short brushstrokes applied in various directions.

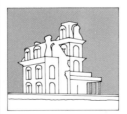

5. Although the sky may well have been indicated from the start of the painting, it appears to have been brushed around the form of the house and may have been the final part of Hopper's painting procedure. In the blue areas, the paint is thin with the grain of the canvas clearly visible. White areas were applied more thickly, but not as thick as those of the house, and brushstrokes are visible.

Actual size detail
The painting was executed working from light to dark and this detail, taken from the bright sunlit side of the house was painted with less freely worked brush-strokes.

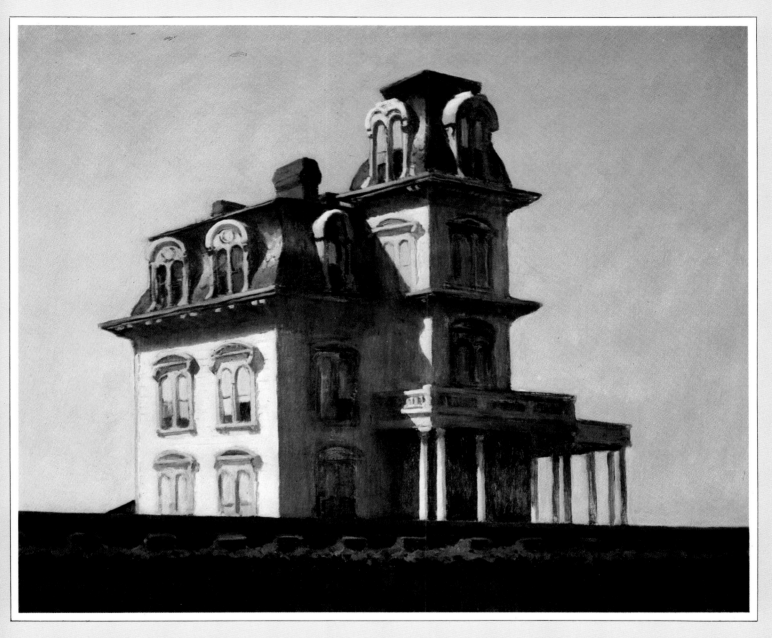

House by the Railroad, painted in 1925, is Hopper's first painting to represent successfully forms defined and modelled in light. In this painting, a solitary Victorian house and railroad track are represented in a way more expressive of Hopper's imagination than of the real world — most of Hopper's paintings are composites with the subject matter derived from several sources. The observer's viewpoint is not indicated and the track which sweeps across and beyond the edges of the canvas serve to disconnect the house from the ground and the observer's side of the railroad. It is also Hopper's method, which drew from, but did not specifically represent, the American scene which contributes to the strange and slightly disturbing effect of the painting.

House by the Railroad has been interpreted as being satirical in intention and it was generally felt that the Victorian houses which Hopper often painted did not provide a serious subject. To this, however, Hopper commented that 'the great realists of European painting have never been too fastidious to depict the architecture of their native lands.' It is clear that Hopper regarded the often grotesque forms of late nineteenth century American architecture as particularly suited to a serious transcription of his vision.

Salvador Dali

(born 1904, Spanish Surrealist artist)
The Persistence of Memory
painted 1931, oil on canvas, $9\frac{2}{5} \times 13$in (24.1 × 33cm)

Salvador Dali was born on 11 May 1904 at Figueras on the Spanish coast not far from Cadaquès where he now lives. 'I have adored this region since my childhood with a quasi-fanatic fidelity', Dali states with the hyperbole which characterizes most of his utterances. He joined the Surrealist movement in Paris in 1929 and evolved an art and lifestyle which have come to personify Surrealism in the eyes of the general public.

Dali developed the deep illusionistic space of the twentieth century metaphysical painter Giorgio de Chirico into a setting for paintings of a dream-like and almost paranoiac quality, and from 1929 to 1932, Dali painted a series of small works of almost unequalled hallucinatory intensity. *The Persistence of Memory*, one of the most celebrated paintings in this series, shows a beach near Port Lligat with the distant rocks lit by the transparent light of the end of the day.

Dali described the appearance of the floppy watches in the painting as 'Like fillets of sole, they are destined to be swallowed by the sharks of time'. He found his inspiration for the image after eating a runny camembert cheese. Dali's work is characterized by disturbing and recurring images. For example, the limp, womb-like creature straddled over the rock in the foreground was an obsessional image for him at the time. Dali's technique sought to duplicate the appearance of touched-up photographs to the point where it became impossible to tell what he called his 'handmade photograph' from a collaged fragment of an actual photograph. In doing this, he was using a technique which people had grown accustomed to accepting as a confirmation of reality, as a means of undermining that reality. Dali's revival of photographic illusionism in the late 1920s and 1930s was seen at the time as an attack on the very notion of art. This challenge appeared to question the basis and status of art — if it was impossible to tell the technique of a painting from that of a photograph, how could the painting be called art? However, in recent years, thanks partly to the re-awakening of interest in Realist painting of the nineteenth century and the growth of such movements as photorealism, Dali's technique is now acknowledged to have made a major contribution to the history of twentieth century painting.

1. Dali used a small French standard format canvas with a closely woven texture.

2. Dali carried out careful preliminary drawings, which were essential for this type of painting.

3. He used small, round sable brushes to build up the surface in opaque colour. He rested his painting arm on a mahl stick. For very close work he used a jeweller's glass to examine the work in progress.

Colour blending

Canvas texture

Thin opaque paint

Fine detailed brushwork

Careful preparatory brushwork

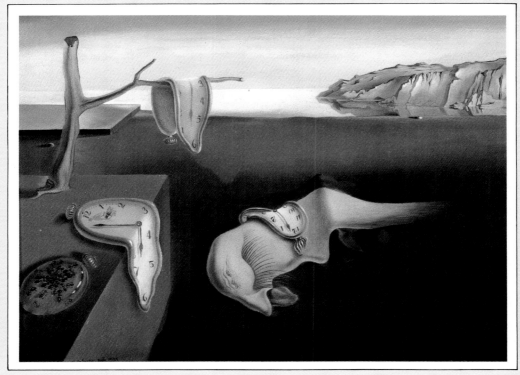

The jewel-like intensity of the image is achieved due to the application of the paint. The luminosity of the work is conveyed by the careful tonal gradation of the paint layers from the dark foreground to the yellow glow of the fading light in the background. Dali's delicate brushwork and painstakingly careful building-up of the paint mark a reaction against the ideas of the autonomy of colour and brushstroke which occupied artists who were contemporaries of Dali. In many ways, Dali's technique looks back to those of the nineteenth century academic painters, or even to Vermeer. Dali combined realistic technique and surrealistic images to portray a credible image of reality, and, simultaneously, to undermine conventional ideas on that reality. For example, soft objects become hard and hard objects soft, and the relative scale of objects is often changed.

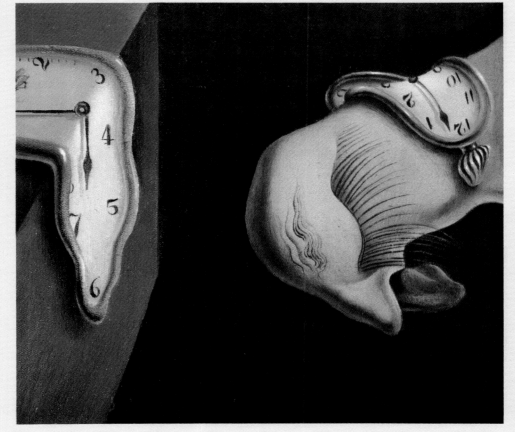

Actual size detail
The paint surface was built up meticulously in opaque paint. In order to achieve the precise counterfeit of 'naturalistic' appearance, Dali used small, round sable brushes and paint of a liquid consistency. He also used a mahl stick and, for particularly close work, a jeweller's glass. Careful preliminary drawings were essential for work of this nature.

Paul Klee

(born 1879, died 1940, Swiss artist)
Ad Parnassum
painted 1932, oil on canvas, 39 × 49in (100 × 126cm)

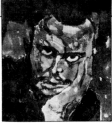

Paul Klee was undoubtedly one of painting's most inventive technicians. He was an astonishingly prolific artist; photographs of his various studios, taken throughout Klee's career, reveal a virtual forest of easels with dozens of works at various stages of development being executed in a wide variety of media. These included, for example, oil on cardboard mounted on wood, oil on plaster-coated gauze on cardboard, oil on canvas mounted on cardboard, oil on canvas coated with white tempera mounted on wood, and even pastel, watercolour and oil on cotton, damask and silk mounted on cardboard. This astonishing technical variety can be explained by Klee's stated belief that a painting should grow like a living organism — 'Art', he wrote, 'is a simile of Creation', and its function 'is to reveal the reality that is behind things'.

Klee's studies in the related fields of natural history, comparative anatomy and anthropology had brought Klee to the belief that nature was characterized by the permutation and movement of fundamental units of construction. He wanted to achieve an equivalent way of working in painting. In addition to his interest in the natural world, Klee also turned to theories of both colour and music. As he worked on the basis of units of construction taken from nature, Klee tried to create linear improvisations which he likened to the melody of the work. Klee evolved a system of colour organization in which all the colours of the spectrum were conceived of as moving around a central axis dominated by the three pigmentary colours — red, yellow and blue.

From 1923 Klee created a series of imaginative colour constructions which he called 'magic squares' in which he applied his theories. This series came to a conclusion in 1932 with *Ad Parnassum*. Klee likened each element in the painting to a theme in a polyphonic composition. He defined polyphony as 'the simultaneity of several independent themes'. In addition, each artistic element in *Ad Parnassum* is itself a distillation of several ideas and personal experiences. For example, the graphic element illustrates the gate to Mount Parnassus, the home of Apollo and the Muses, and also may refer to the Pyramids which Klee saw in 1928, and to a mountain near Klee's home.

1. On a traditional canvas with a white ground, Klee painted in a grid of flat squares in muted casein-based pigments. Casein is a milk-based medium which gives a subtle, slightly opaque effect. The colours were arranged according to Klee's ideas on colour disposition.

2. The mosaic-like dots were organized in smaller units. Each individual fragment was built up with successive translucent glazes on a preliminary white base.

3. Finally the linear element, the 'melody', was painted in in bold lines drawn with a pointed sable brush.

In *Ad Parnassum*, the colours become stronger towards the top right-hand corner, so in the lower detail, the colours are fairly muted. The underlying grid can be seen clearly and the superimposed tones are less crisp and sharp than in the upper areas; indeed this section appears almost shadowy.

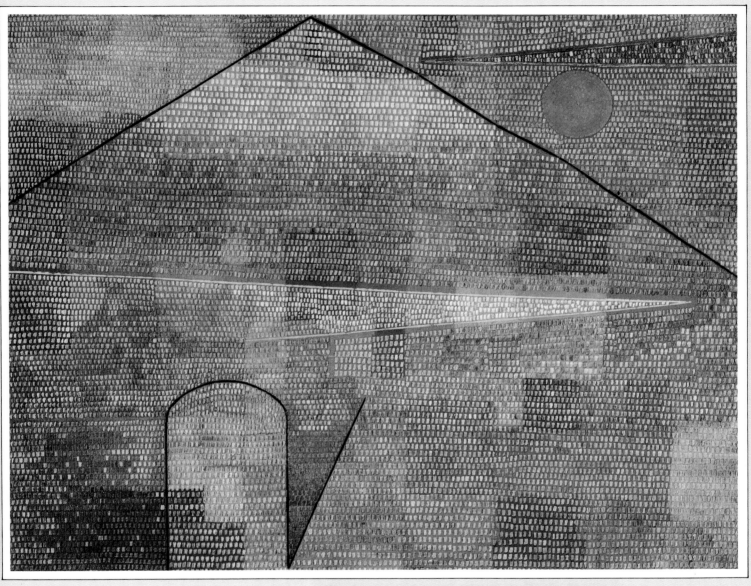

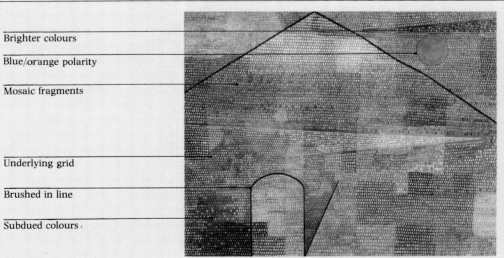

Brighter colours

Blue/orange polarity

Mosaic fragments

Underlying grid

Brushed in line

Subdued colours

Ad Parnassum is by far the largest work which Klee painted before 1937. and. in many ways. it sums up his previous achievements. The colour scheme moves between poles of light and dark. between orange and blue in two distinct layers. There are three main elements in the painting — the grid of muted colours which was laid first. the superimposed layer of mosaic-like shapes. each individually painted in, and the linear element which was painted in last.

In *Ad Parnassum* the colours increase in intensity towards the top righthand corner. The brightest part of the work is the orange circle. This is a vital element in the work. It is the culmination of the structural movement of the painting from rectangle to circle through rotation around a central axis. It also marks the conclusion of the colour progression from blue to orange and from the bottom lefthand to the top righthand corner.

Actual size detail
This detail shows the artist's working method clearly. The painting was developed from the underlying grid framework, which was painted in muted tones of olive green, blue and violet through to the superimposed grid of mosaic-like fragments, or *tesserae*, in luminous tints. These contrast and counterpoint the underlying grid. The black line was added last. Klee's technique of building up the colour in each of the sections allowed him to intensify the colour gradually until he achieved the right relationship with the colour of the underlying grid.

Piet Mondrian

(born 1872, died 1944, Dutch abstract artist)
Composition with Red, Yellow, and Blue
painted c.1937–42, oil on canvas, 27 × 28 in (69 × 72cm)

Piet Mondrian was born in Amersfort, near Amsterdam, Holland, in 1872 and subsequently worked in Holland, Paris and latterly New York where he died in 194 Mondrian was one of the greatest and certainly most single-minded exponents of abstract art. His rigorously abstract style looks extremely simple and an understanding of Mondrian's aesthetic views is important in order to grasp his technique and working methods. It is perhaps surprising that he began his career as a technically very proficient draughtsman and painter in the Dutch naturalistic tradition. However, between 1911 and 1919 Mondrian's art went through a lengthy process of reduction. He had come to equate naturalistic representation with subjectivity and he now wanted to achieve an objective vocabulary for art by abstracting colours and forms to the point where they became fundamental units in the construction of the painting. Colours became opaquely painted flat planes of primary colour (red, blue and yellow) and non-colour (white, black and grey), and forms were reduced to the straight line in what he termed 'its principal opposition', the right angle.

However, within these formal and aesthetic constraints, Mondrian's works remain highly personal. The subjective element asserts itself in the exact placing of the lines and blocks of colour. In *Composition with Red, Yellow and Blue*, for example, adjustments can be seen around the four horizontal lines. These were made to ensure that the lines were in the right balance, in accordance with the artist's views on universal harmony. For implementing these metaphysical ideas, Mondrian used a grid system based on eight squares, like a chess-board.

While he worked in Paris his main tools for working out the painting were, according to his friend Michel Seuphor, a ruler and strips of transparent paper. However, when he went to New York, he began using other types of tape, both coloured and adhesive, which he found extremely easy to move around when he was working on an upright canvas.

In addition to his artistic output, Mondrian is also remembered for founding the influential magazine *De Stijl* in 1917 with his fellow Dutch artist Theo van Doesburg. *De Stijl* provided a forum for Mondrian to develop his theories on abstract art.

1. Mondrian did not use a standard French format canvas. He favoured a vertical measurement which would divide into eight equal units of 9 cm (3·5 in).

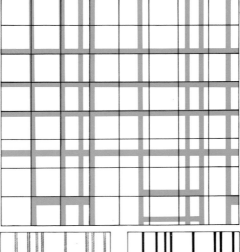

2. The finely woven linen canvas was attached to the stretcher by iron tacks and tape. A commercial ground of size and oil was then applied evenly over the whole canvas.

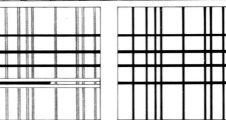

3. The projected grid structure, usually based on small sketches, was drawn on the canvas in charcoal.

4. The 4 main horizontal lines, based on the division into 8 squares, were then painted in. Mondrian probably used strips of tape, possibly adhesive, to help him position the lines.

5. The 8 vertical lines were painted over the 4 horizontal lines and minute adjustments were made to ensure correct positioning.

6. The cadmium yellow rectangle was brushed vertically and the main red square was brushed horizontally, as were the strips of cobalt blue and cadmium red, probably added later.

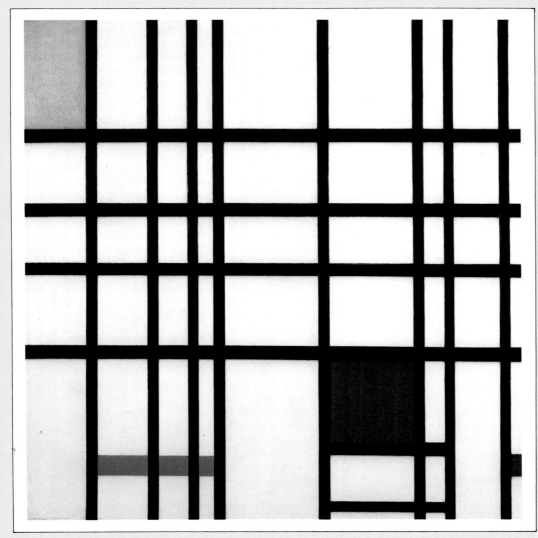

Composition with Red, Yellow and Blue is an interesting example of Mondrian's constant modification and refinement of his technical means. The work was begun in Paris around 1937 and was completed in 1942, after Mondrian's move to New York. Mondrian's Paris studio was described by his friend Michel Seuphor, who thus gives an insight into the artist's working methods: 'The room was quite large, very bright, with a very high ceiling. . . . The actual work was done on the table. It stood in front of the large window facing the Rue du Départ, and was covered with a canvas waxed white and nailed to the underside of the boards. I often surprised Mondrian there, armed with a ruler and ribbons of transparent paper, which he used for measuring. I never saw him with any other working tool.' In New York, Mondrian began to use coloured tapes which could be moved about the canvas easily while it was upright on an easel. His studio walls were covered with constantly changing rectangles of colour to help give him inspiration.

Actual size detail
Mondrian so reduced his technical means that any changes in approach are extremely important. For example, there was an alteration to the bottom black line and the white over-painting can be clearly seen. The brushwork is horizontal in the red section and vertical in the narrower white oblong.

Max Ernst

(born 1891, died 1976, German Surrealist artist)
Vox Angelica
painted 1943, oil on canvas, 59 × 79in (152 × 203cm)

Max Ernst, one of the leading artists in both the Dada and Surrealist movements, can be regarded as perhaps the major technical innovator in twentieth century painting. He adapted and invented a whole variety of techniques. *Vox Angelica*, painted in Arizona in 1943 during his exile from Europe, summarizes his various, often picturesquely named, techniques — collage, illusionism, frottage, grattage, decalcomania and oscillation.

Ernst's first major technical contribution came in 1919 with his adaptation of collage to the transformation of commercial catalogue sources. His first actual 'invention' was frottage, with which he experimented in Cologne in 1920 and 1921, and then developed in France in 1925 in response to the 1924 *First Surrealist Manifesto* by the poet André Breton. Ernst's description of frottage conveys something of the spirit which accompanied the invention. When sitting in a seaside inn, Ernst became 'obsessed' by the appearance of the well-scrubbed floorboards, so, in his words, 'to assist my contemplative and hallucinatory faculties, I took a series of drawings from the floorboards by covering them at random with sheets of paper which I rubbed with a soft pencil.' Frottage, which Ernst used extensively, is a drawing technique. In the winter of 1926 to 1927, Ernst adapted it to painting in a technique he called grattage, which involves scraping pigment over canvas placed on a heavily textured surface. The next significant automatic technique came a decade later with the invention of decalcomania by the Spanish Surrealist artist Oscar Dominguez. This technique involved painting gouache onto a piece of paper, covering it with another sheet and pressing it lightly with the hand. Next, the top sheet was peeled off slowly, like a transfer, and the process repeated until the colour was almost dry. During 1939, Ernst experimented with a similar technique using oil paint and canvas. Ernst's last — and least successful — technical innovation was oscillation, in which a paint-filled tin can was suspended from a piece of thread or string and swung in varying directions over a flat piece of canvas. The Surrealist automatic techniques sought to eliminate the conscious element from the performance of the pen or brush as a way of stimulating or forcing the artist's inspiration.

1. *Vox Angelica* sums up all the main techniques with which Ernst was associated. Collage is referred to parodistically in the illusionistic painting of the leaf, for example, which has been painted so that it appears to be stuck on.

2. Frottage also features in a parodistic way. The appearance of floorboards was created by painting rather than by rubbing through paper with a soft pencil.

3. Ernst adapted the technique of decalcomania. The technique involves pressing a sheet of paper or similar material on to the paint-covered surface and peeling the sheet off again.

4. Grattage involves scraping pigment over canvas which has been placed on a heavily textured surface.

5. Ernst may have used adhesive tapes to create the straight, overlapping lines.

6. Oscillation involves paint being dripped from a can swung on the end of a piece of string.

Vox Angelica was painted on four canvases assembled in the same way as had been the parts of Grünewald's masterpiece, the *Isenheim Altarpiece* from a section of which Ernst's work took its name.

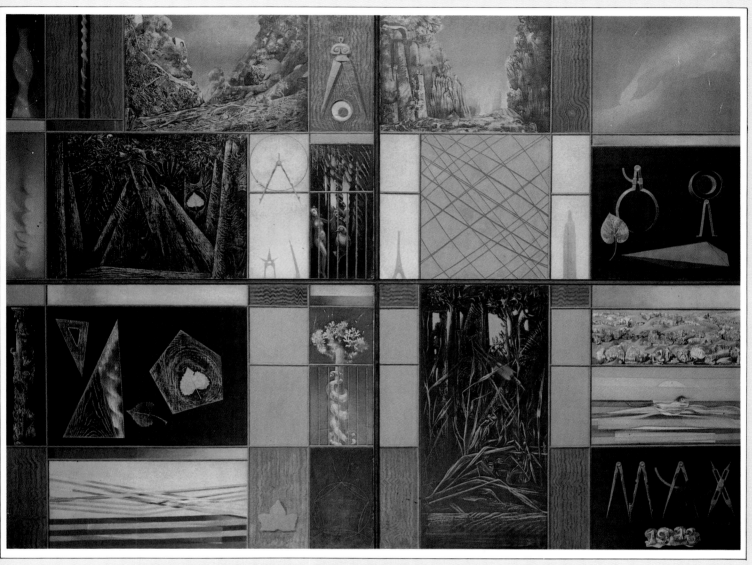

Vox Angelica demonstrates all the techniques with which Max Ernst was associated – collage, frottage, decalcomania, illusionism, grattage and oscillation. However, the apparently collaged and frottaged elements were, in fact, painted in.

Decalcomania

Oscillation

Frottage

Grattage

Illusionism

Collage

Vox Angelica is made up of four canvases each measuring 30 × 40 in (76 × 101·5 cm). The canvases were assembled like the great *Isenheim Altarpiece* painted around 1515 by the sixteenth century German artist Mathias Grünewald. One part of the altarpiece is called *Concert of Angels*, and it was from this that *Vox Angelica* received its name. The work illustrates the vivid variety of effects which can be achieved through the conjunction of alien elements. The symmetrically structured painting is built up out of polarities of light and dark, and of ultramarine blue and yellow. *Vox*

Angelica can even be seen as a parody on Ernst's previous achievements – it includes reference to all the techniques for which he was known. Paris and New York are juxtaposed in the Eiffel Tower and Empire State Building. Images recur in the painting, for example the geometrical instruments and the drill. The image of the drill is paralleled in the images of the snakes entwined around trees, which are perhaps references to the serpent in the Garden of Eden.

This detail shows the fine brushwork with which the impression of frottage was evoked. It is possible that the texture of the spiral in the righthand set square was created using the grattage paint-scraping technique; but it is also possible that, like many of the other techniques in *Vox Angelica*, the effect of the actual procedure was mimicked rather than actually used.

Actual size detail
This detail shows the great precision of Ernst's technique. Here he has painted a leaf in an illusionistic way and placed it on top of a painting of a piece of wood. Although this image is painted, it is given the appearance of having been created using the technique of frottage, which involved making rubbings of floorboards for example. So, by painting a frottaged image, Ernst can be seen as parodying his previous achievements.

This detail of *Vox Angelica* shows the overall yellow-blue contrast which characterizes the painting. The central section was painted using the oscillation technique, the pattern of lines being built up from paint dripped from a swinging can on the end of a piece of string. The juxtaposition of the Eiffel Tower and the Empire State Building symbolizes Ernst's own 'oscillation' between Paris and New York.

Jackson Pollock

(born 1912, died 1956, American Abstract Expressionist)
Autumn Rhythm
painted 1950, oil and enamel on canvas, 8ft 10in × 17ft 8in (2m × 5m 38cm)

In 1947 Jackson Pollock began to create a series of paintings which filled the canvas with interlaced trickles, spatters, and puddles of paint which, as Willem de Kooning said, 'broke the ice' for what was to become Abstract Expressionism.

Prior to that time, Pollock's work had been figurative, symbolic and mythological. In 1946, after Pollock had finished with Jungian psychoanalysis, the mythological titles then gave way to titles referring to nature. It is apparent in these works that Pollock had begun to realize that the process of picture making could possibly take priority over the end results.

It was at this stage that Pollock felt the need to open up his paintings and, because he wanted to paint pictures beyond the range of outstretched arms, abandoned working from an easel. By placing his canvases on the floor or wall, adopting a drip technique and using dried out brushes, sticks and trowels as tools, Pollock was able to maintain an upright position and distance himself from the canvas. As he moved around the picture, working from all sides, the rhythm became expansive and involved long sweeping movements of the arm and hand to control the application of the paint. In 1951 Pollock said that 'My painting is direct . . . The method of painting is the natural growth out of a need . . . Technique is just a means of arriving at a statement. When I am painting I have a general notion as to what I am about. I can control the flow of paint: there is no accident just as there is no beginning and no end.' Technique was an inevitable solution to Pollock's search for self-expression and his methods and motives are best expressed in a statement made by him in 1948: 'My painting does not come from the easel. I hardly ever stretch my canvas before painting. I prefer to tack the unstretched canvas to the hard wall or floor, I need the resistance of a hard surface. On the floor I am more at ease. I feel nearer, more a part of the painting, since this way I can walk around it, work from the four sides and literally be *in* the painting . . . I continue to get further away from the usual painters' tools . . . I prefer sticks, trowels, knives and dripping fluid paint for a heavy impasto with sand, broken glass and other foreign matter added, . . . the painting has a life of its own. I try to let it come through.'

1. Unprimed canvas was either spread on the floor or tacked to a wall.

2. Pollock began painting in black enamel laying down the basic structure in a whirling net of splashes, splatters and dribbles.

3. Light brown paint was used predominantly for splattering and staining the canvas; white paint was used similarly to black, and blue was used to make lines.

4. A thin line could be achieved by trailing the paint over a smooth dry area and thickened by allowing it to pass over and mix with still wet areas.

5. Large areas of bare canvas were used as a neutral colour to stress the activity of the paint surface.

6. There is less paint around the edges with a noticeable easing of activity.

7. The dimensions of the painting were determined only on completion of the painting process. Finally Pollock stretched the canvas.

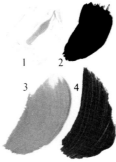

In this work, Pollock used the following colours: white oil paint (1), black enamel (2), and light brown (3). Blue (4) was also used for lines.

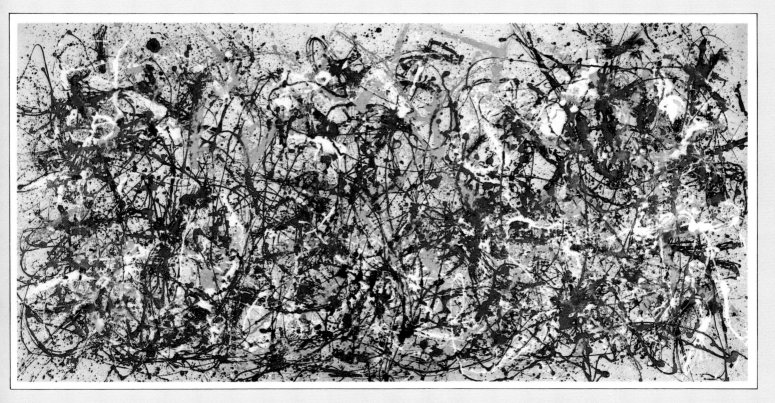

Autumn Rhythm was executed in 1950 and shows Pollock's drip technique at its most elegant. Pollock worked from all sides of an unprimed canvas and emphasized each part of the painting equally but differently. Varying marks were made according to different methods of paint application. At what is now the top edge, the black and brown paint was thrown on to the canvas and splattered on impact, but the marks are also clearly directional. Along the lower edge the blacks and browns were allowed to run off a stick or brush and are more flowing, undulating and curvilinear. In some places, the paint was applied so thickly as to form pools which, in drying, formed skins in rippled surfaces. The skin which formed on the surface of open cans of paint was often either flung or carefully dropped on to the canvas.

Lessening of paint around edges

Blue paint used for lines

Light brown paint

Black paint

White paint

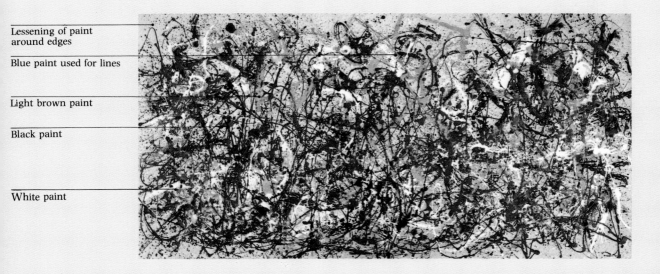

As painting at an arm's length could not be sustained in Pollock's method of painting, he adapted his tools — dried brushes, sticks and trowels — to facilitate the painting process. Pollock would work his way around the canvas using his entire body to lay down the paint carefully but spontaneously. Gravity and the increased fluidity of the paint ensured that a picture made in this way would contain the kind of unexpected effects which Pollock desired. Concerning the prodigious control which Pollock exercised over his paintings, a friend stated that he had 'an amazing ability to quicken a line by thinning it, to slow it by flooding, to elaborate the simplest of elements — the line.'

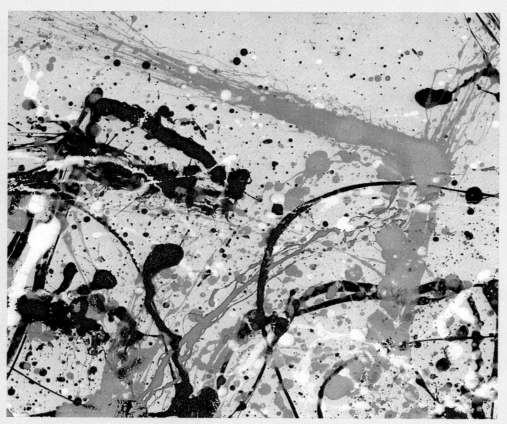

Pollock used four colours to paint *Autumn Rhythm*. The viscosity of each of the paints determined to some extent the use which he made of it. Pollock started painting with black enamel, laying down a basic structure, a whirling interlaced net of splashes, splatters and dribbles which he then worked on in other colours.

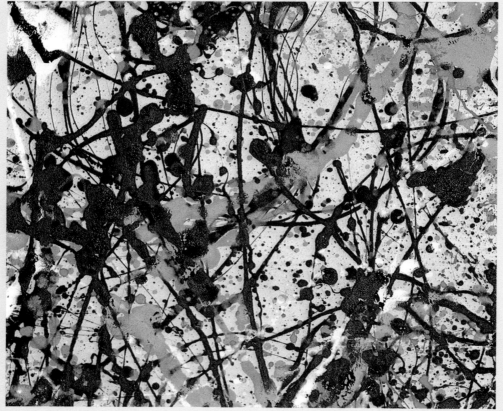

Actual size detail
This detail of the top left edge of *Autumn Rhythm* clearly illustrates Pollock's innovative 'drip' technique. This method was used to achieve this spontaneous and flowing effect. The paint was thrown, splattered and dribbled on to the surface. However, while the paint was applied spontaneously and loosely, there is also a controlled and directive element. The black enamel has been used largely to create an active, flowing movement while the brown splatters create an effective background. The texture of the unprimed canvas provides the neutral surface for the paint which is the active element in the work. The painting was purposely stretched to continue around the sides to compensate for a lessening of paint activity at the outer edges of the canvas.

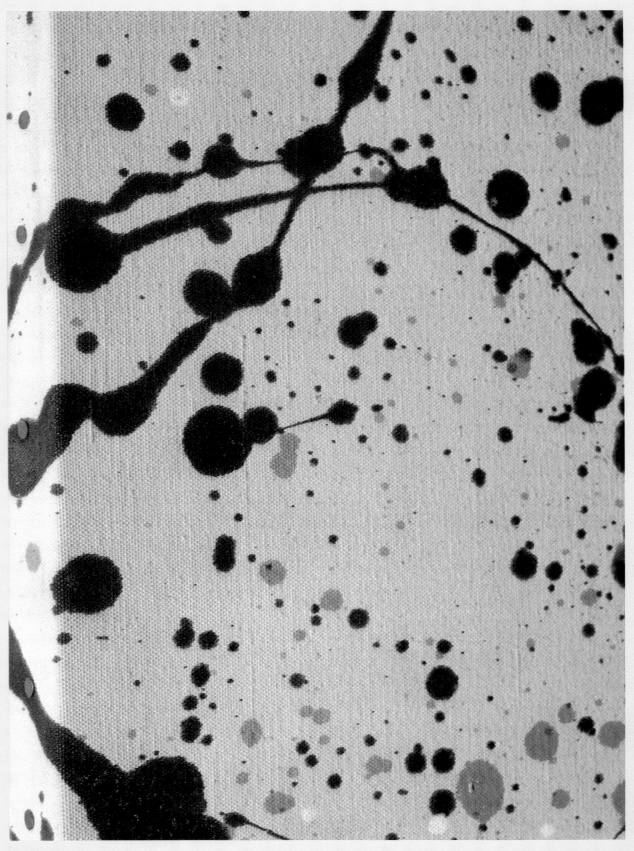

Jasper Johns

(born 1930, American abstract expressionist)

Flag

painted 1955, encaustic, oil and collage on canvas, $42\frac{1}{4} \times 60\frac{5}{8}$in (106 × 152cm)

Jasper Johns began work on *Flag* at the end of 1954, but most of the picture was painted in 1955. *Flag* can be seen, in part at least, as Johns' reaction to the paralysis felt by many American artists during the Cold War. Johns started to work on the picture in a year of hysterical patriotism, and the picture can be interpreted either as a celebratory, chauvinistic gesture or an ironic comment. *Flag* is an extremely ambiguous and ambivalent work, as Johns himself asked, 'Is it a flag or a painting?' On the one hand, it has all the required elements of the national emblem of the United States of America – the red and white stripes which signify the 13 original colonies and the white stars on a blue background which denote the various states of the Union. On the other hand, *Flag* also has all the expected features of a work of art. Johns has maintained the flag was 'just a way of beginning, the painting was always about a flag, but it is no more about a flag than it is about a brushstroke, or about a colour, or about the physicality of paint'. A third ambiguity – that of Johns' relationships with his contemporaries, the Abstract Expressionists – also remains unresolved.

The apparently simple, two-dimensional structure of *Flag* recalls the formalist approach of the American Abstract Expressionist painter Barnett Newman, and the gestural marks and drips seem to have been derived from the work of such Abstract Expressionists as the American Philip Guston and the Dutch-born American Willem de Kooning. However, Johns' relationship to Abstract Expressionism is still ambiguous. While *Flag* uses some of the approaches of this movement, it also questions the Abstract Expressionist conviction that painting must be either a representation of the artist's state of mind, anxieties and tensions or some kind of transcendental revelation expressed through brushwork and colour. However, the most obvious reaction against the former generation was in the introduction of recognizable subject matter. Beginning with *Flag*, Johns started to develop a vocabulary of signs which eventually included not only American flags but targets, stencilled numbers and letters, words, the primary colours and their names, and objects from the home and studio. The art of the 1960s, particularly Pop Art, owes much to Johns.

1. The painting was begun in either enamel or oil paint on a bed sheet.

2. Johns was unsatisfied with this approach and changed to encaustic painting. The colours were made by mixing pigments with molten beeswax.

3. The colours were kept fluid and applied with either brushes or spatulate instruments.

4. Johns also used collage, applying cut and torn pieces of newspaper with the hot wax. Paint was also applied using the collage material.

Encaustic colours are made by mixing pigments with molten wax and, perhaps, a little resin. They are kept fluid and applied with either brushes or a palette knife. When all the colours have been applied, the panel or canvas is set face-up on a table and the colours are fused into an even film using a radiant heat source, such as an electric fire. As the paint cools, the resin helps to harden the paint film which can be given an extra gloss by polishing it with a soft cloth. Johns' technique, however, omits the thermal treatment. Johns chose to use this technique because of its speedy drying properties, so that he could superimpose brushstrokes quickly without those underneath being altered.

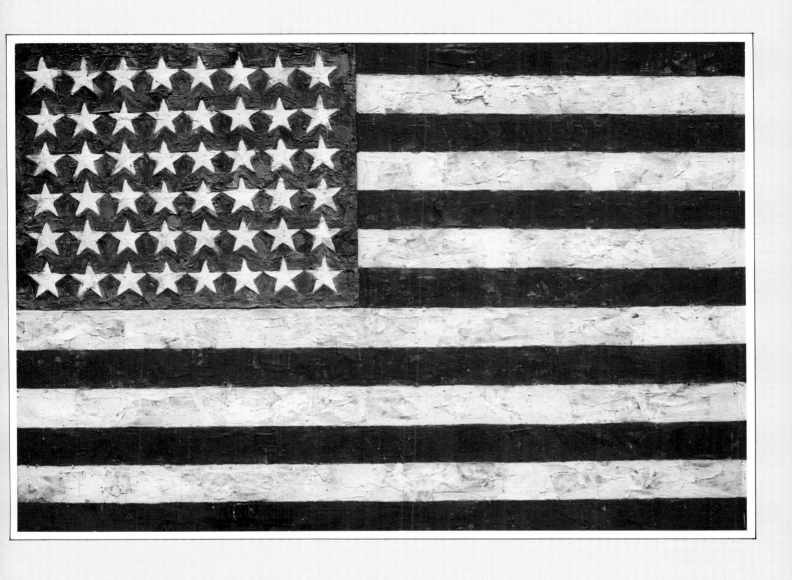

The complicated structure of *Flag* belies the apparent simplicity of the image.

Stars made as positive shapes set on top of blue or set into the blue field, as negative shape

Smaller pieces of collage laid on in different directions

Hem of the sheet

Large pieces of newsprint including a frame from a comic strip

Having begun to paint *Flag* in enamel or oil paint, Johns changed to using an encaustic technique. He explained his reasons for this 'I wanted to show what had gone before in a picture, and what was done after. But if you put on a heavy brush-stroke in paint and then add another stroke, the second stroke smears the first unless the paint, is dry. And paint takes too long to dry. I didn't know what to do. Then someone suggested wax. It worked very well; as soon as the wax was cool I could put on another stroke and it would not alter the first.' Johns outlined the processes he used in painting *Flag*. These involved 'dipping pieces of paper and cloth into hot encaustic and fixing them to the surface before the encaustic solidified. In this way, some areas may or may not include the use of the brush. The two ways of applying paint — with a brush or with material dipped into the hot medium — have equal value and follow no particular sequence.'

Flag has been built up in a relatively uniform web of brushstokes and encaustic, cut and torn collage elements which are laid over one another. In this way, Johns achieved an all-over textured surface. Drips and dribbles of encaustic run across edges of the stripes and link different parts of the design. The encaustic collage, which forms the red and white stripes, is less intricate than that used for the stars. The collage fragments are also longer, and set horizontally and vertically so that the lines of collaged text parallel and oppose the bands.

Each star in *Flag* is unique. They are either cut out of a single piece of newsprint and brushed with white or they form negative shapes using the small pieces of newspaper which make up the blue field.

Actual size detail
Flag is made of three separate canvases – one is used for the rectangle of stars, the second for the stripes immediately to the right of the stars and the third for the lower area of stripes. The transparency of the encaustic means that, in certain places, some of the collage material can be seen. One of the most obvious pieces of newsprint comes from a comic strip bearing the date February 15th 1956, which is at variance with the 1955 date Johns gave the painting. Evidently, *Flag* was damaged in Johns' studio in 1956 and was repaired by him with some contemporary pieces of newspaper.

These stars are made so that they are set into rather than on top of the blue field. The collage fragments are smaller and denser than those in the bands. They are also multi-directional and more varied in their coloration and tone.

170

Frank Stella

(born 1936, American artist)
Getty Tomb ll
painted 1959, black enamel on canvas, 84 × 96in (213 × 243cm)

In 1958 Frank Stella began work on a series of pictures known as the *Black Paintings*. By 1960 he had completed 23 pictures, a body of work which proved to be the cornerstone of abstract art during the 1960s and 1970s. In 1958, Stella found the solution to certain problems in his painting practice in the paintings of the American artist Jasper Johns. He was impressed by the way in which, in his *Flag* painting, Johns 'stuck to the motif . . . the idea of stripes – the rhythm and interval – the idea of repetition.' The regulated symmetry Stella used in the *Black Paintings* kept the pictures flat and non-illusionistic. Stella's next problem was 'to find a method of paint application which followed and complemented the design solution.' This was achieved by the use of house painting techniques and tools.

Stella painted his pictures as he would a door or a wall, with a directness of approach – the paint was used straight from the can – and working from start to finish in one operation. Stella said of this technique: 'The painting must convince you at the level of the overall effect rather than by technical niceties, particularly the uniformity of the surface . . . If you look at my paintings, the technique was always at a fairly pedestrian level . . . They were never 'well painted' by any standards . . . but I do think that a good pictorial idea is worth more than a lot of manual dexterity.' Although Stella was convinced that virtuoso handling whether skillfully spontaneous or skillfully controlled, counted for nothing in the quality of his art, this did not mean that he was not concerned with the technical aspects of painting: 'I may have a flat-footed technique, or something like that, but still to me, the thrill, or the meat of the thing, is the actual painting. I don't get any thrill out of laying it out . . . I like the painting part, even when it's difficult.'

What type of object a painting was became a major issue among avant-garde artists of the 1950s and 1960s and Stella in particular was a subject of much controversy. Although Stella seemed to emphasize the status of his paintings as 'objects' by his use of colour and common materials, the method by which he addressed his work as a 'thing' and his later use of unconventional, shaped canvases, he has always seen his work within the tradition of abstract painting.

1. Stella used 3 in (7·5 cm) deep stretchers, which contributed to the picture's three-dimensionality.

2. Earlier *Black Paintings* show no signs of underdrawing although later works initially had guidelines pencilled in.

3. A commercial black enamel paint was applied to raw, unprimed canvas. The enamel was absorbed into the canvas and the gloss quality consequently diminished.

4. The paint was applied directly from the can using 2½ in (6·25 cm) wide house-painter's brushes. Stella did not use masking tape to delineate the edges of the bands and no attempt was made to hide accidents or inconsistencies.

5. Stella worked from the outside edge of the painting inwards, painting each band individually.

Stella used commercial black enamel paint and applied it to the raw, unprimed canvas with a standard household paint brush. The enamel was absorbed by the cotton duck canvas and its gloss quality thus considerably reduced. The finish of *Getty Tomb II* varies according to how many layers of paint were applied. The degree of gloss increases if paint is applied on top of previous layers of paint, as opposed to directly onto the canvas.

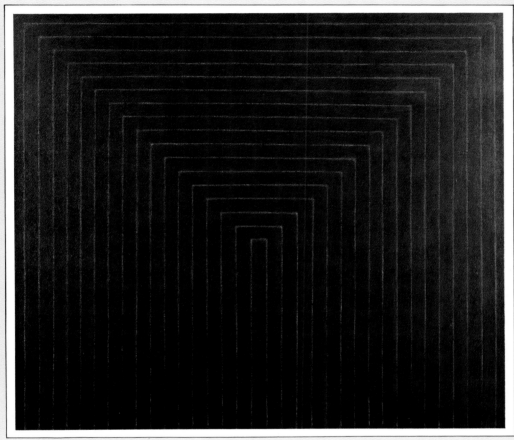

Getty Tomb II was painted in two versions as Stella felt the first painting looked 'lopsided' and 'crooked'. The second version was 'blacker and straighter'. *Getty Tomb II* conveys a range of effects from matt to dull or low-gloss according to how many layers of paint were applied, the density of the paint in a particular area, and the effects of illumination. The paint has been applied directly with wide house painting brushes. In the earlier *Black Paintings* Stella worked directly on the canvas executing the bands from the outside edge to the centre and rarely knew when he started a picture how many bands it would comprise.

Stella's movement towards three-dimensionality in his paintings was stressed by his preference for deep, wide stretchers which brought the painting into the realm of sculpture. Stella, however, always disagreed with this interpretation of his art: 'The deep stretchers lifted the pictures off the wall surface, so that they didn't fade into it as much. They created a bit of shadow and you knew that the painting was another surface. It seemed to me to actually accentuate the surface – to emphasize the two dimensionality of the painting's surface.' Stella later added to this controversy by departing from the traditional canvas formats and stretching his canvas in unconventional shapes.

Actual size detail
The contrast, shown in this detail, between the painted black bands and the unpainted interstices in Stella's paintings led some journalists to talk about the 'white pin stripes' or 'pin stripe painting'. Stella reacted against this interpretation in a letter written in 1961. Though humourous, the letter is not without its serious aspects and shows the importance which the artist attached to not using the brush to draw with: 'My own work . . . uses fairly broad stripes of black, and, more recently, aluminum or copper paint . . . I have never seen a 'white pin-stripe painting' . . . there is a distinction between what any artist DOES and does NOT do; and however it may lack journalistic appeal, this boundary is precisely the necessary limit without which no work of art can exist. With respect to my painting the case seems particularly simple: it is an observable fact that I have laid down paint in certain spaces, and have not done so in others.'

Richard Hamilton

(born 1922, British 'Pop' artist)
Towards a Definitive Statement . . .
painted 1962, mixed media, 24 × 32in (61 × 81·3cm)

Richard Hamilton's art training began prior to World War II at the Royal Academy in London, and after the war, he continued his studies at the Academy and the Slade School of Art. However, it was not until the 1960s that he gained recognition through his association with the 'pop culture' of that period and as a founder of the Pop Art movement. Hamilton's return to more figurative work around 1951, as part of a search for contemporary relevance, was characterized by his use of visual sources such as photographs and graphics of commercial art. He commented that 'The return to nature came at second hand through the use of magazines rather than as a response to real landscape or still life objects or painting a person from life.'

He evolved an approach wherein elements were assembled from a plethora of daily visual material. This involved not only the juxtaposition of common images into new relationships, but also the mixing of visual conventions such as photography and technical drawing with more traditional styles and techniques of painting.

A consequence of using many elements composed of various materials is that their appearance alters to different degrees and in different ways over a period of time. For example, in *Towards a Definitive Statement . . .* which Hamilton painted in 1962, the colour of the printed material taken from magazines and journals will fade with the exposure to light, and the white of the household undercoat paint which Hamilton used for this work will yellow more rapidly than will, for example, high-quality white artist's oil paint. This results in the uneven changing and alteration of relationships within the picture and the subsequent creation of new and unpredictable images. In this sense, the picture becomes a fluid and ever-changing vehicle. This demonstrates an attitude towards art which marks a radically different approach from the more traditional desire of the artist to retain the painting's original intentions and composition by the use of various solidifying agents such as varnish. Hamilton wanted the picture to remain an independent, constantly changing object and this element, combined with his use of non-traditional materials has marked him as an influential and innovative artist.

1. The hard-edged forms were taken from an optical diagram of a cine camera. First, pressure sensitive tape was applied to the unpainted ground.

2. The design was drawn onto the tape.

3. The drawn design was cut out with a scalpel.

4. Excess tape was removed leaving the shape of the form.

5. The area was painted over with silver paint.

6. When the paint had dried, the tape was peeled away leaving the desired shape as unpainted ground.

7. Linear elements were ruled in pencil and then white paint.

8. The letters 'CCCP' were applied by burnishing transfer lettering on to the painting.

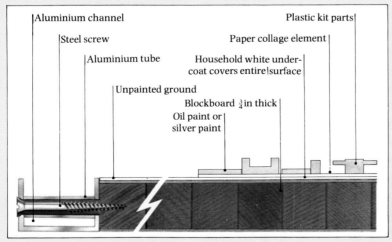

Aluminium channel

Steel screw

Aluminium tube

Unpainted ground

Plastic kit parts

Paper collage element

Household white under-
coat covers entire surface

Blockboard $\frac{3}{4}$ in thick

Oil paint or
silver paint

The picture is on a support of wood block-board prepared with an absorbent white under-coat. The ground has soft brushmarks and scratches and remains uncovered in many areas. The original design is in pencil. The photographic images are cut from colour publications and stuck on to the board with paste and modified with overpainting. The painted areas are done in oil paint and 'silver' paint (probably an aluminium pigment in a synthetic resin medium). The application ranges from thick and opaque to thin glazed films. The hard-edged forms are achieved by stencilling. The metallic theme is carried in to the frame. 'The trick', said Hamilton, 'was to achieve a unity of disparate elements of similar size and shape.'

This sketch for the later work uses metal foil for the metallic effects. In the actual work, the softer, hazier effects are obtained from brushed silver paint. The reflections from this material are more in sympathy with the other surface qualities of the picture than the harsher silver foil.

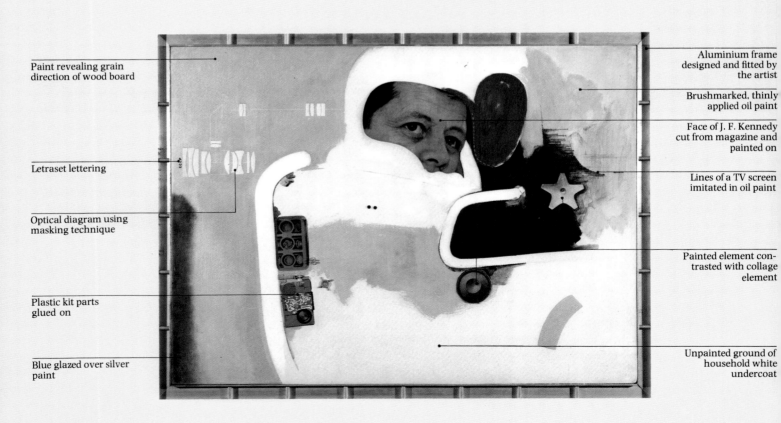

Paint revealing grain direction of wood board

Letraset lettering

Optical diagram using masking technique

Plastic kit parts glued on

Blue glazed over silver paint

Aluminium frame designed and fitted by the artist

Brushmarked, thinly applied oil paint

Face of J. F. Kennedy cut from magazine and painted on

Lines of a TV screen imitated in oil paint

Painted element contrasted with collage element

Unpainted ground of household white undercoat

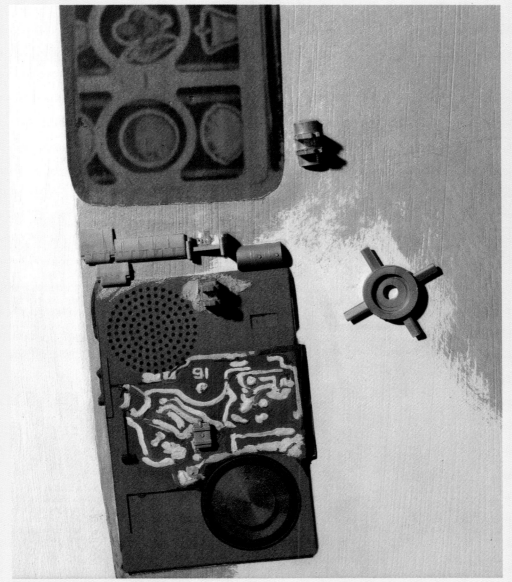

Actual size detail
This detail is a good example of Hamilton's ability to mix and harmonize a variety of objects and techniques. He has incorporated a combination of graphic images, 'found' objects, and traditional paint media successfully to integrate and balance the picture plane. The uncovered ground which Hamilton used can be easily seen.

This detail shows the vertical grain direction of the wood panel. The optical diagrams along the lower edge were created using a masking technique. The lettering is commercial dry transfer lettering. The hard-edged forms have been created by using a masking tape stencil and then overpainted to define the forms.

In this section on the picture, the painted shape in the top right-hand corner contrasts with the collaged element in the bottom lefthand corner. This juxtaposition of apparently disparate elements was one of the main techniques employed by Hamilton in this work.

Roy Lichtenstein

(born 1923, American 'Pop' artist)
Whaam!
painted 1963, magna on canvas (two canvases), 68 × 106in (172 × 269cm)

Roy Lichtenstein's work based on comic strips began in 1960 and marked a complete departure from his previous work which had been broadly in the Abstract Expressionist manner. By 1961 Lichtenstein's interest in cartoon elements, which had begun as a half-serious attempt to copy a cartoon without alteration, had come to dominate his work. In the period from 1961 to 1965, Lichtenstein made paintings derived from advertising imagery and common objects, of which the comic strip pictures are the most complex. They fall into three main groups — love and romance, science-fiction, and war and violence. The war paintings, of which *Whaam!* is one, are cinematographic close-up images of land warfare and aerial combat which emphasize explosions, the trajectories of bullets and the sounds of battle.

Lichtenstein does not simply magnify a frame from a comic strip. In some works he combined elements from several models, others, like *Whaam!*, were inventions. Lichtenstein uses the subject matter, stereotyped characters and situations of the comic strips. He also adapts certain linguistic conventions and mimics the mechanical printing process. However, Lichtenstein was not generally interested in using dialogue to tell a story; the words simply anchor the image. In *Whaam!*, the word on the right panel is not only the work's title but also expresses visually the sound of the explosion which is the subject of the picture.

Whaam!, like several of Lichtenstein's other war pictures, is made up of more than one canvas panel. It was painted in Magna, a type of acrylic. It is not difficult to tell a Lichtenstein from a comic strip, even if it is only reproduced in a book, while in an art gallery it is impossible to ignore the picture's size. Lichtenstein has not reproduced the mechanical dot shading and colouring technique used in comic-book production. In comics, the dots are of such a size and density that they are meant to be overlooked. In Lichtenstein's picture, the dots form clearly discernible abstract patterns on a two-dimensional surface. The two panels of *Whaam!* use images derived from war comics in a confident and technically very controlled way; they also have the humour, as Lichtenstein himself said, of 'one painting shooting another'.

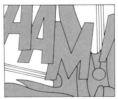

1. The artist first made a small pencil drawing which served as a guide for the major lines of the composition and colouring.

2. When the small drawing was transferred to the canvas, changes were made – two panels were used instead of one. The plane and burst of flames were greatly enlarged and the colours indicated on the drawing were altered.

3. The dots were applied next. The areas which were not to receive the dot pattern were masked off.

4. A perforated metal screen was placed on the canvas. The screen had regularly spaced holes through which the paint was brushed with a toothbrush.

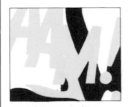

5. Lichtenstein then painted the areas of solid colour, beginning with the lightest and working through to the darkest. For this, Lichtenstein used the primary colours associated with the comic strip.

6. Finally, the black lines were painted over the primary colours and dots.

Lichtenstein used a metal mesh screen to create the dot pattern in *Whaam!*. The screen was laid on the canvas and the paint brushed through the holes in it. When the screen was lifted off, the dot pattern was revealed.

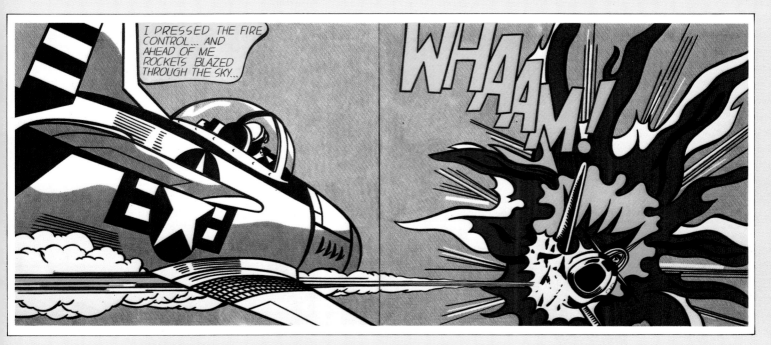

Below
This preparatory drawing for *Whaam!* shows that Lichtenstein did not adhere rigorously to his initial ideas. He had begun by thinking in terms of a single canvas; the two canvas format developed as the drawing was carried over onto a second piece of paper. Changes were also made as Lichtenstein transferred the drawing to the canvas. Both the plane and the burst of flames were enlarged so that they almost filled their respective canvases and so as to bring them closer together. The colours indicated on the drawing were also altered. 'Whaam!' on the sketch was noted as white, but was painted in yellow. The caption above the plane was also added.

Above
Lichtenstein wanted his picture to look programmed and, at first, his handling of paint might seem rigid and impersonal. However, this is not 'hard edge' painting; rather, *Whaam!* is freely drawn and painted. The black lines show the inflections of arm and wrist movements. The colour areas often reveal the trackings of the brush, and pencil lines are rarely entirely concealed or eradicated. In some places the dots become paler and less clearly defined as the artist's stippling brush runs out of paint.

This detail shows several of the elements in Lichtenstein's method of working. The white areas are created by masking them out with tape before the dots are applied through the screen. The blocks of solid colour are applied next with a brush — the brushmarks can be seen in the yellow areas. The black lines are painted in last, and the relative freeness of the lines can be seen, as can rather smudged areas on some of the white. Lichtenstein used oil colour and Magna acrylic on canvas. 'Magna' is the trade name for a brand of acrylic colours. Acrylic colours are made by dispersing pigments in an acrylic resin medium. Acrylics have gained quickly in popularity since they were first readily available commercially after the Second World War. These paints dry rapidly, do not yellow, and are easy to remove. The last quality enabled Lichtenstein to remove the paint if he wanted to make changes on the canvas, and to conceal any blemishes or stains by painting over in the same colour as the canvas or the ground.

Masking would probably have been used in this area. When Lichtenstein painted in the areas of solid colour, he began with the lightest and worked through to the darkest. Explosions featured prominently in Lichtenstein's close-up comic strip images of warfare which were painted mainly between 1961 and 1965.

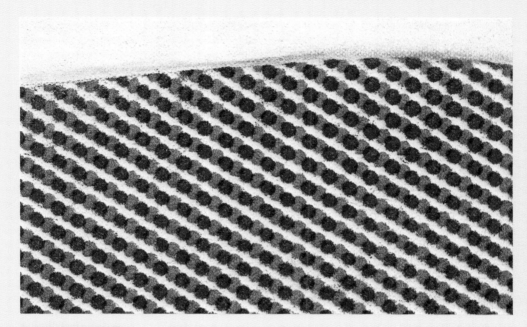

Actual size detail
Lichtenstein does not reproduce the mechanical printing process in his work. In printing comics, the colour is achieved using the Ben Day dot system in which dots, in a limited range of colours – black, red, yellow and blue – are overlaid to produce different tones. Flesh colour, for example, is either red dots on yellow or red on white. The dots are applied individually using a screen. When combined, these give the appearance of different tones. However, this actual size detail shows that Lichtenstein places the dots of solid colour side by side. This detail also shows the underdrawing which still shows through on the finished painting.

The pattern of dots was created using a metal screen. The red and blue dots were laid side by side. Even when viewed from a slight distance, they begin to merge in the viewer's eye. The black lines were added last, after the solid blocks of colour. Brushmarks and differences of pressure and line can be detected in them. The lines of the pencil underdrawing are rarely completely covered or eradicated.

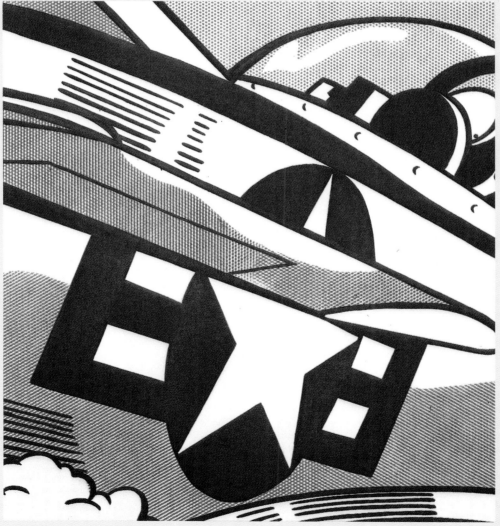

181

David Hockney

(born 1937, British artist)
Mr and Mrs Clark and Percy
painted 1970, acrylic on canvas, 120 × 84in (304 × 213cm)

As a painter, draughtsman, and illustrator, David Hockney has a popular reputation which extends worldwide. Throughout his painting career, Hockney has gathered subject matter from his own life, while his eclectic styles are largely borrowed from traditional art sources. In the early 1960s, Hockney's work, although largely figurative in content, made no attempt to provide a consistent illusion of reality. The expressionistic qualities of his painting are constantly brought to the viewer's attention through the way he used a wide variety of technical and stylistic devices.

In the middle 1960s, Hockney renewed his interest in literal representation and began to work increasingly from life. As well, he changed from oil paints to acrylics, which better suited the type of painting he wished to achieve.

During the 1960s and 1970s, portraiture began to occupy an increasingly important place in Hockney's work. None of these portraits were commissioned, but were generally of friends depicted in their normal, everyday environments which Hockney used to give hints to the sitter's character. These are not, however, 'snapshots' of life, but very carefully planned and organized pictures in which Hockney exploited his use of the acrylic medium to its limit. Hockney's portraits combine the concern for formality of his earlier works with an increasing interest in representational art and depicting natural space and colour. They involved many preliminary drawings and paintings done both from photographs and real life. As many as a dozen studies of a particular part of the painting would be made before work on the final painting was begun.

Hockney paints on both primed and unprimed canvas and makes use of the different textural effects achieved by the two. He consistently uses successive applications of paint, each layer modifying rather than obscuring those beneath. Where extensive reworking has been done, the paint sometimes obliterates the texture of the canvas. To cope with the fast drying of the paint which hinders blending, Hockney devised the technique of spraying the surface with water to keep it wet. The painting, if executed on gessoed canvas, is usually covered with a generous film of acrylic medium, giving the painting a uniform glossiness and smoothness of finish.

1. The painting was done on a plain weave cotton duck canvas, which was stretched over a pine stretcher and attached at the back with wire staples. It has been restretched, as Hockney used to unstretch and roll the canvas up in order to transport it.

2. The canvas was primed with thin white acrylic gesso, which was thin enough when applied to penetrate the back of the canvas in places. The priming reduces the effect of the canvas texture and provides a brilliant white reflective ground on which to paint.

3. Preliminary work involved making small compositional drawings squared up to be transferred later to the canvas.
Photographs were taken of the room and sitters so that preliminary drawings could be made.

4. Individual objects, such as the vase of flowers, would be set up in the studio. Many portrait studies were done both from photographs and life.

5. The compositional design was sketched on the canvas with the aid of preliminary studies.

6. Hockney painted the sitter's heads from life.

7. Soft edges were achieved by blending thin layers of acrylic with a fan brush.

8. The final painting was sprayed with acrylic gloss medium or varnish. This saturated the colours and gave the surface a fairly uniform gloss.

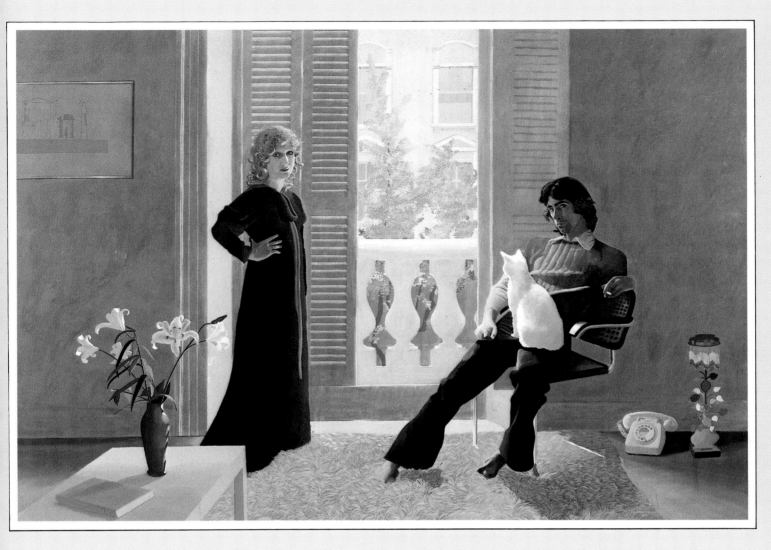

The exterior view is tonally lighter than the rest of the picture except for the highlights. It has a thin, white scumble over most of the surface.

Mrs Clark's dress is treated as a silhouette against the pale background.

The open section of the central window is the light source for the entire painting.

The few objects in the painting are greatly simplified in form.

Before starting this painting, Hockney worked extensively from photographs and life. The initial layout was done in pencil

Thin glazes and opaque layers are floated over one another to create a diffused light.

The eye level of the picture appears to be at the height of Mr Clark's head.

Mr Clark is orientated along the diagonal running from the centre of the bottom edge to the top right corner.

which remains visible in parts of the painting. Many thin glazes and opaque layers of paint were used to create the diffuse light of the background. The view through the window with its atmospheric unity was achieved by scumbling with a thin, white layer of paint. While the heads of the sitters have received more attention than the rest of the painting, freshness and translucency were retained by avoiding hard edges and the deft overlaying of thin layers of paint which Hockney blended quickly with a fan brush. The surface has been covered with a film of gloss medium which gives the painting a uniform glossiness.

Hockney did many preparatory drawings for this painting which included sketches for the general composition showing the positions of the main figures (**top**). He also sketched the figure of Ossie Clark (**middle right, centre**) as many as a dozen times. Hockney used photographs of the figures. Here he has drawn a grid on top of the photograph (**middle left**). This was to help transfer the image to the canvas.

There is a very close resemblance between the head of Ossie Clark in the painting and the photograph The portrait retains a freshness and translucency because the artist avoided painting hard edges by deftly overlaying thin applications of paint. While the uniformity and translucence of the painting allow the viewer to enter directly into the picture plane, he or she is brought abruptly back to its physical solidity by objects like Mr Clark's cigarette.

Left
These photographs show Hockney working on the picture. In the first (**top**), the table and vase of flowers create the illusion that Hockney is himself inside the picture. Hockney painted the vase of flowers from life in his studio, in which he also recreated the lighting conditions of the Clarks' room. The second photograph (**below**) shows Celia Birtwell posing. Hockney recalls that both Celia and Ossie posed for a long time. The vase and flowers were painted in Hockney's studio. Care was taken to reproduce the light and atmosphere of the Clark's home even in the studio.

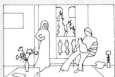

Actual size detail
The portrait heads of Mr and Mrs Clark have received more detailed work and reworking than other areas of the painting. The texture of Mrs Clark's hair was achieved by fine, linear arabesques applied in a light gold colour over a darker underpainting. Other textural areas were also depicted by using a drawing brushstroke rather than a thick application of paint or glazes.

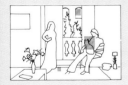

Right
The texture of the rug was created by laying down rhythmic curled strokes of cream over a dark grey. These give a sense of fullness and depth.

Middle
The open section of the central window forms the light source for the scene. It is tonally lighter than most of the picture and has a white scumble worked over it.

Left
In some parts of the painting, the gloss finish has been applied so liberally that it runs down the surface, as can be seen on the cat. A few areas of the painting have not been varnished at all and these are lighter and cooler in tone and have the eggshell finish characteristic of unvarnished acrylic.

Glossary

Abstract art An art form which is not dependent upon a fundamentally naturalistic approach to the subject matter for the expression of form, space and colour.

Abstract Expressionism A form of *abstract art* which originated in America in the 1950s in which the artist involved chance and the subconscious in the creation of the painting.

Alla prima An Italian term meaning *at first*, a technique in which the artist works directly on the surface without preliminary *underpainting* or drawing.

Arriccio A rough plaster surface consisting of lime and sand mixed in water. This is applied to a wall in the initial stages of *fresco* painting.

Azurite A blue mineral derivative of copper often substituted for the very expensive *ultramarine*.

Alizarin A reddish purple *pigment* obtained from the root of the madder plant. Combined with salts of metals it creates the lake colours.

B

Baroque A style of architecture, painting and sculpture which originated in Europe in the late sixteenth century and which lasted until the eighteenth. The movement succeeded *Mannerism* and turned away from the straight line and reason, in favour of curves, emotion and unidealized naturalism. Caravaggio, Rubens, Rembrandt and Velazquez represent different strains of Baroque art.

Bitumen (asphaltum) This transparent rich brown *pigment* never dries completely and causes deterioration and *craquelure* if used in *underpainting*. It was used, with frequently disastrous results, in the late eighteenth and

nineteenth centuries. Rembrandt, amongst others, used it as a glaze, for which it is suitable.

Bladders Before the invention of metal tubes for artists' colours, leather bladders were used for storing paint. These were pricked by the artist when the paint was needed and then resealed to keep the paint fresh.

Blocking-in An *underpainting* technique by which the artist roughly describes the forms and composition of a painting.

Blue Rider (Der Blaue Reiter) An influential group of German Expressionists formed in Munich in 1911 by Wassily Kandinsky, Paul Klee, August Macke and Franz Marc.

Broken colour A term covering a number of techniques in which several colours are used in their pure state rather than being blended or mixed. Usually the paint quality is stiff and thick and, when the paint is dragged across the surface, layers beneath show through. This term can also refer to the *Pointillist* technique.

C

Cadmiums Brilliant permanent *pigments* which are suitable for most techniques. Cadmiums turn black when mixed with copper colours, such as *emerald green*, and brown when mixed with lime. The colours include cadmium yellow, green and red. The latter is considered the best substitute for *vermilion*.

Camera obscura A technical aid, widely used in the seventeenth and eighteenth centuries, which consisted of a darkened box or tent containing lenses and a mirror. The artist could project the image of an object or landscape onto the painting surface and

then trace it out in charcoal or graphite.

Casein A strongly adhesive substance made from the curd of fresh milk.

Cennini, Cennino A fifteenth century Florentine painter best known for his book *Libro dell'arte (The Craftsman's Handbook)*. Written c.1390, it contains valuable information on early *tempera* and *fresco* techniques.

Chiaroscuro The literal translation of this Italian term is *light-dark* but the term has come to mean the skilful exploitation of light and shadow within a painting. Rembrandt and Caravaggio are the artists particularly associated with the use of chiaroscuro.

Chrome yellow A brilliant colour, chrome yellow is made from lead chromate. It covers and dries well but tends to change tone with time.

Classicism The term given to a style of art which is ultimately derived from the study of Greek and Roman artists. Classicism is often considered the antithesis of *Romanticism*.

Collage Derived from the French verb *coller* meaning 'to stick', collage is the technique of pasting cloth, paper or other materials onto a canvas or surface. It was first used by the Cubist artists.

Craquelure This is the term used to designate the tiny cracks and fine lines covering the surface of most old paintings. They are caused by the shrinking and movement of the ground and the paint surface.

Cross-hatching A technique in which paint or another medium is laid down or drawn in a series of criss-crossing strokes to build up depth and tone.

Cubism An innovatory

and influential abstract art movement begun in Paris around 1907 by Picasso and Braque. As a reaction against previous naturalistic painting traditions, the Cubists simultaneously depicted many different views of an object. They often represented forms as superimposed geometric planes with the intention of expressing the idea of an object rather than any particular aspect.

D

Distemper An impermanent type of paint in which the pigments are mixed with *size*.

E

Emerald green This very poisonous colour derived from copper arsenate will turn black if mixed with sulphur pigment. The Masters were aware of this danger and thus overpainted emerald green with varnish.

Encaustic A technique in which molten wax, mixed with pigments and sometimes resin, is applied to a surface. When dry, the colours have a glossy shine. This technique was most used in the first and third centuries, but has more recently been adapted by artists such as Jasper Johns.

Expressionism A term applied to an art movement, founded in the twentieth century, which opposed the imitation of nature and *Impressionism*. Expressionists tend to stress emotion and feeling with strong colour and line. Van Gogh is considered the great forerunner of Expressionism.

F

Fat over lean A painting technique which allows the bottom layer of paint to dry before further application. 'Fat' painted is mixed with oil to create a thick paste while 'lean' paint is thinned with a diluent such as

turpentine to make it dry more quickly.

Fauvism An art movement in the early twentieth century, whose main exponent was Matisse. A group of artists, including Matisse, exhibited at the Paris Salon show of 1905 and were nicknamed *les Fauves* or 'the wild beasts' as their works were full of distortion, pure colour and frenzied brushstrokes.

Fête galante A term first used in the eighteenth century to describe a painting of a dreamlike pastoral setting which shows people, often in extravagant costume, amusing themselves with dancing, music making and courtship. Watteau is referred to as a painter of 'fêtes galantes'.

Fixative A thin varnish sprayed onto drawings and pastels to adhere the chalk to the surface and prevent rubbing and blurring.

Florentine School From the thirteenth century, the Florentines held a prominent position in the art world. They were particularly concerned with problems of design and their approach to art was scientific and intellectual. Giotto and Leonardo are among the many artists that Florence produced.

Fresco A method of wall-painting on a plaster *ground*. *Buon fresco*, or true fresco, was much used in Italy from the thirteenth to the sixteenth centuries. First, the *arriccio* is applied and upon this the design, or *sinopia*, is traced. An area small enough to be completed in one day – the *giornata* – is covered with a final layer of plaster, the *intonaco*. The design is then redrawn and painted with *pigments* mixed with water. *Fresco secco* is painting on dry plaster and suffers, like *distemper*, from impermanence.

Fugitive colour A phrase used to describe a *pigment*'s impermanence and tendency to fade or change colour under the influence of natural effects such as sunlight.

G

Gamboge A gum resin often used in watercolour. If applied in thick layers, it creates a gloss finish but it is not considered suitable for oil colours.

Genre painting A type of art which depicts scenes from everyday life. Two of the better known genre painters are the Dutch artist Vermeer and the Spaniard Velazquez.

Gesso A white, absorbent ground used in *tempera* and *oil* painting. In Italy during the early Renaissance, panels were first prepared with several coats of *gesso grosso* which is gesso mixed with *size*. On top of this coarse gesso was laid a coat of *gesso sottile*. This plaster and size mixture was brilliant white and gave a smooth surface.

Giornata A name given to an area in *fresco* painting which can be completed in one day.

Glazing A painting technique by which thin, transparent layers of paint are applied over an opaque layer to modify that layer's colour. It is sometimes difficult to determine exactly the glazes used by the Old Masters because of previous restoration or cleaning, and also because of the similarity between the appearance of a glazed paint layer and varnish.

Gold leaf Gold which has been beaten into very thin sheets. This was often used to highlight and define forms in medieval manuscript illumination.

Gouache An opaque, water-based paint in which the pigments are bound with glue.

Green earths These colours are similar to ochre and are among

the oldest known painting colours. They were important in the Middle Ages and early Italian painting as middle and shadow tones in flesh.

Ground A ground is used to provide a satisfactory painting surface. In *oil painting*, the ground is usually either an oil-based mixture or, more commonly, *gesso*. The ground must not be too absorbent, and it must be durable and not crack. Grounds may also be tinted to give a painting more colour.

Gum arabic Gum obtained from the acacia plant. It is used as a binding agent in watercolours, gouache and pastels.

H

Hessian A type of canvas which generally has a coarse, thick weave.

I

Impasto Paint which is applied very thickly. When the paint is thick enough to create lumps or reveal distinct brushstrokes, it is said to be heavily impasted.

Impressionism A loose association of painters formed in Paris in 1874 for exhibiting purposes and as an alternative to the dry, academic Salon school. Monet, Renoir and Pissarro, amongst many others, depicted the natural, atmospheric effects of light in nature by painting out-of-doors in *broken colours*. They also painted shadows of objects in *complementary colours*. The Impressionist colour theories have influenced all subsequent art movements.

Infra-red photography A method of photography which can be used to examine thinly applied paint layers in a painting. The infra-red waves, which lie beneath the red end of the visible spectrum, penetrate the layers and can sometimes reveal the artist's original drawing.

Intonaco A smooth layer of fine plaster which is placed on top of the *arriccio* in *fresco*.

L

Limning An archaic term meaning to draw or paint, used particularly with reference to manuscript illumination and miniature painting.

Lining A conservation term for placing a new canvas on the back of a deteriorating original.

Linseed oil An oil, derived from the flax plant, which is mainly used as a painting medium and in tempera emulsions. Linseed oil gives a smooth effect to paint but it tends to yellow with age. As the Old Masters relied on a heavy layering of the paint surface, linseed oil was the best medium because of its fast drying time.

M

Madder lake This purplish colour is derived from the root of the madder plant and is impermanent. *Alizarin madder lake* is an artificial pigment and it is more permanent than natural madder lake.

Mannerism The artists of the Mannerist period (c.1520–1600) flouted the traditional 'rules' of classical and Renaissance art. The chief characteristics of the style are vivid and unnatural colours and elongated and exaggerated figures. Mannerism was supplanted by the *Baroque* period.

Mastic resin The best type comes from the pistachio tree. Mastic resin is used for making varnish and it prevents wrinkling, shrinkage and decay. It also gives depth and clarity to colours.

Medium Specifically, the liquid used to bind pigments to make paint. The term has also come to mean a type of paint. *Oils*, *tempera* and *watercolour*, for example,

can all be described as painting media.

Megilp A drying oil which gives colours a buttery consistency.

Miniature painting A small painting, usually a portrait, executed in gouache or a water-based medium. Miniatures were popular in the sixteenth and seventeenth centuries.

Mordant An adhesive used when pressing a material onto a surface, such as in the gold leafing of panels in medieval painting.

N

Naples yellow A colour which was popular with the Old Masters. Naples yellow is heavy and dense and so it has excellent covering properties. It is compatible with all other colours, unaffected by light and rarely cracks.

Neoclassicism A movement which began in Rome in the mid-eighteenth century as a reaction against the *Baroque* and *Rococo* periods. The aim of the Neoclassicists was to recapture the splendour of Greece and Rome. The artists made a conscious effort to duplicate the antique both in style and subject.

O

Ochres Yellowish earth colours which tend to be impure. These pigments have a fairly good covering power and drying capacity, and they are very permanent when pure.

Orpiment yellow A brilliant, poisonous yellow used by the Old Masters. *Cadmium yellow* has come to replace this *pigment*.

P

Palette This refers to both the surface on which the artist lays out paints and also the colours which are used.

Panel A painting term for a rigid *support* such as wood. If wooden panels are used, they

must first be *sized* to prevent the paint from being absorbed.

Pentimento Derived from the Italian meaning 'repentance', pentimenti are the changes in composition which a painter makes while producing a painting. These alterations are visible in *infra-red photographs* and are sometimes useful in determining forgeries.

Picture plane The region of the painting which lies directly behind the frame and separates the viewer's world from that of the picture.

Pigment Any substance which, when mixed with a liquid, creates a colour which can be used for painting. Pigments are generally organic (earth colours) or inorganic (minerals and chemicals).

Pointillism A painting technique developed by Georges Seurat out of the *Impressionist* theory of colour. Dots or blobs of colour were placed beside one another to create an 'optical mixture' in the viewer's eye. If a blue dot was placed beside a yellow one, it was said to create a more brilliant and intense green than if the two colours had been mixed on a *palette*.

Pop art The dominant form of art in England and America in the late 1950s and early 1960s; the term is derived from the word 'popular'. Pop artists, such as Roy Lichtenstein, used material from comic-strips, advertising and films. The movement has been considered a direct challenge to *Abstract Expressionism* which preceded it.

Pre-Raphaelite Brotherhood A group of nineteenth century English artists who sought to revive the ideals of fourteenth and fifteenth century Italian art. Their work generally involved the use of elaborate symbolism, bright colours and highly

detailed painting.

Prussian blue A deep blue which has very strong colouring power and which is very permanent.

Q

Quattrocento This term, the Italian word for 'four hundred', is used to denote the fifteenth century in Italy.

R

Realism Not to be confused with the naturalism of the landscape and rural painters, Realism was a nineteenth century movement in painting and literature which insisted that everyday life was a suitable subject for art. Courbet was the first major Realist painter.

Red bole, Armenian This natural clay was sometimes used as a ground in oil painting by artists such as Caravaggio. Since the Middle Ages, red bole has been used as a ground for gilding.

Red iron oxides Artificial pigments made from iron ore or waste materials. They are closely related to the red earths and have similar properties such as good covering power and a quick drying time.

Rococo Derived from the French word *rocaille* meaning 'shell-work', Rococo is a phase of decorative art which emerged in France during the reign of Louis XV. As a reaction against the Baroque style, Rococo artists, such as Watteau, emphasized pretty, ornamental curvilinear design.

Romanticism In art, a school of painting which was part of a far-reaching revolution which affected all artistic fields in the late eighteenth and early nineteenth centuries. Romantic paintings are often what their name implies, with their subject matter frequently derived from

an extravagant, 'unreal' view of reality, particularly of the past. The French painter Delacroix was a major exponent of Romanticism.

S

Saturation A technical term used by artists to describe the degree of purity in a colour. This is established by comparing a sample of the colour with a colourless area of equal brightness.

Scumbling A painting technique in which dry, thickish paint is applied to a surface in a loose, direct manner often creating areas of *broken colour* and allowing previous layers to show through in places.

Sienna A pigment named after the Italian city where it originated. Raw sienna is a yellowish brown ochre. Due to the amount of oil needed to create the paint, it may cause darkening. Burnt sienna is roasted to give a rich reddish brown colour. It was often used with iron oxide by the Venetians to add warmth to flesh tones.

Sinoper This is a very light red ochre from Asia Minor. Used in ancient times and the Middle Ages, particularly in *fresco* painting, it is no longer available.

Size A mixture of powdered pigment and hot glue which is applied to the canvas to seal it against the corrosive action of subsequent layers of paint.

Smalt A blue pigment made by powdering silica glass coloured with cobalt oxide. As this colour has poor covering power and tends to deteriorate, it is not generally used and cobalt blue is preferred.

Stand oil Oil boiled with carbonic acid without the addition of a drying medium so that it dries more slowly than *linseed oil* but gives colours a high gloss. For

painting, stand oil must be mixed with other mediums as it is very thick and fatty.

Stretcher The wooden frame on which a canvas is stretched. Stretched canvas is less prone to change with atmospheric variations and less susceptible to damage than unstretched canvas.

Surrealism One of the most influential of twentieth century artistic movements, Surrealism set out to free the mind from all preconceived ideas by allowing the subconscious to assert itself. The Spanish Surrealist Salvador Dali is one of the major exponents.

Symbolism An artistic movement founded by a loose association of artists in the late nineteenth century. In a reaction which

developed from *Impressionism* and *Realism*, Symbolists aimed to be both decorative and mystical. They tended to use bright, unnatural colours to express their ideas.

T

Tempera This word actually describes a type of binder added to powdered pigment, but now refers to the egg tempera paints which were popular until the late fifteenth century. Being a quick-drying medium, tempera is difficult to work with but it dries to an almost impenetrable surface. The addition of oil to tempera emulsions brought about the eventual development of oil painting.

Tenebrism From the Italian *tenebroso* meaning 'murky',

Tenebrism is a style of painting which features an emphatic use of *chiaroscuro*. Spanish painters in the early seventeenth century who were influenced by the work of Caravaggio have been called Tenebrists, although they did not form a distinct group.

Tesserae The cubes used in creating mosaics.

Titanium white Also known as titanium dioxide, this is a relatively new colour with a good covering power. However, it does not dry well and it tends to yellow.

Turpentine This is the most common diluent in oil painting. It has no binding properties and, if too much is used, it tends to absorb colours creating a dull, dusty effect. Turpentine evaporates quickly and is used to accelerate

drying. However, the paint surface will deteriorate if an excess is used.

U

Ultramarine Made by powdering the semi-precious stone lapis lazuli, it has always been an expensive pigment which was only used sparingly.

Underdrawing, under-painting The preliminary technique of *blocking in* or laying in the drawing, composition, and often the tonal values of a painting. Occasionally colour may be indicated in under-painting but it is generally used to lay down the basic structures of the picture before the more complex work begins.

V

Vellum The skin of an

animal, normally calf, which was often used in manuscript illumination in the Middle Ages and in *miniature painting* by artists such as Nicholas Hilliard.

Venetian School In the sixteenth century, artists such as Giorgione and Titian preferred a gentler, more sensuous approach to painting than had been adopted by the *Florentine School*. The Venetians used warm atmospheric tones.

Vermilion The favourite red of the Old Masters. When exposed to sunlight, vermilion tends to blacken so the Masters would often glaze *madder lake* over it to preserve and enhance its colour.

W

Wet-in-wet A painting technique which

involves the application of wet paint to an already wet surface.

White lead A white pigment, also known as flake white, which is lead carbonate. The purity of the colour is determined by the purity of the lead used. White lead has excellent covering, drying and mixing properties but it tends to yellow.

Z

Zinc white This was first introduced as an artist's colour in 1840. It is economical, permanent and it does not yellow. Zinc white is an excellent pigment for tempera, water-colour and fresco painting.

A

a secco 10
abstract art 140, 158, 172
Abstract Expressionism 164,
 artists 168
 style of 178
acrylics 178, 180, 182
Ad Parnassum 154–157
Adoration of the Magi, The 28
After the Bath, Woman Drying Herself 110–113
alizarin 112, 124
 see also crimson, red
alla prima 60, 65, 72, 132, 142
altarpieces, wooden 34
aluminium paint 173
Amersfort 158
Amsterdam 56, 158
Antwerp 52
Après le Bain, Femme s'Essuyant 110–113
Arena Chapel 10, 12
arricio 10
Artist's Studio, The 61
Autumn at Argenteuil 102–105
Autumn Rhythm 164–167
azurite 10, 12, 29, 31, 46, 56, 60

B

badger-hair softener 42
Baptism of Christ, The 22–25
 compared with *St Michael* 25
Baroque period 44, 56
Bathers, Asnières 114–117
beige, for ground 102
Ben Day dot system 181
bistre 56
black
 accents 16
 charcoal 44, 46, 47
 details 14
 enamel paint 164–167
 lines 173, 179
 overdrawing 136
 underdrawing 13, 22, 30, 74, 150
 use of 31, 38, 56, 57, 58, 62, 66, 70, 75, 85, 88, 89, 91, 94, 95, 159
Black Paintings 172, 173
bladder, paint storing 70, 84, 102
Blake, William 74–75
 The Body of Abel Found by Adam and Eve 74–75
Blessing of the Oxen, The 128–131
blockboard, as support 175
blocking-in
 highlights 42
 in egg tempera 22
 initial layers 18, 89, 96

light areas 44
main areas 40, 48, 66, 99, 102, 104, 114, 140
 with scumbles 98
blue 38, 123, 131, 164, 165
 Cerulean 114
 cobalt 94, 95, 102, 106, 107, 114, 117, 118, 124, 125, 128, 132, 133, 134, 158
 Prussian 66, 67, 72, 74, 128, 129, 140, 147
 ultramarine *see* ultramarine
Blue Rider Group 140
bodegones 48
Bonnard, Pierre 142–145
 Interior at Antibes 142–145
Borch, Gerard Ter 60
Borgo San Sepolcro 22
Bosch, Hieronymous 30–33
 The Carrying of the Cross 30–33
Boudin, Eugène 102
Braque, Georges 136
Breton, André 160
Brittany 128
brown 56, 94, 164, 165
 transparent 56, 58
brushes
 badger-hair softener 42
 blending 40, 48
 bright 122
 ermine 48
 fan 80, 182, 183
 flat 13, 84
 hog's hair 44, 45, 46, 72, 86, 103, 122, 126, 144
 house-painter's 172
 minever 26
 minever and bristle 13
 round 84, 132
 sable 26, 77, 86, 152, 154
 squirrel hair 38
 stoat 48
 toothbrush 178
buon fresco 10
burnishing, gold 14
burnt ivory 38

C

camera obscura 60
canvas
 cotton duck 172, 182
 double 85
 flax 41
 herringbone 128
 hessian 118, 120
 linen 65, 92, 122, 146
 ready primed 88, 92, 94, 106
 twill weave 34, 100
Caravaggio 40–43, 48, 49, 51, 56, 60
 The Supper at Emmaus 40–43
cardboard, as support 154
carmine 66
Carrying of the Cross, The 30–33

cartoon 23, 31
casein 154
Cennini, Cennino 11, 12, 13, 15, 74, 75
ceramics 128
ceruse 59
Cézanne, Paul 106, 124–127
 Nature morte avec l'Amour en Plâtre (Still life with Plaster Cast) 124–127, 128, 132
Chair with Pipe 118–121
chalk
 ground 52, 60, 132
 sketches 49, 70
 to make ceruse 56, 58
 underdrawing 80, 88
charcoal
 black, in ground 60
 shading in pastels 111
 underdrawing 14, 88, 110, 122, 123, 140, 158
 used in pouncing 22
Chardin, Jean Siméon 88, 132
Chavannes, Puvis de 128
Chevreul 83
chiaroscuro 39, 76, 80, 82, 89, 94
Chirico, Giorgio de 152
Christ driving the Traders from the Temple 44–47
Christmas Night 128–131
Claude 76
cine camera 174
clay models 44, 45
cobalt *see* blue, violet
Cold War 168
collage 136–138, 160, 161, 168–170, 176
Cologne 160
colour
 circle 83, 114, 132, 134
 and light theory 84
 and music theory 154
 theory 82, 114, 118
comic strip
 in collage 170
 influence of 178
commedia dell'arte 64
complementary colours 82, 83, 106, 118, 133, 134
Composition with Red, Yellow, and Blue, 158–159
Concert of Angels 161
Constable, John 76–79
 Chain Pier, Brighton 76–79
Conté crayon 114
copper paint 173
copper resinate *see* verdigris
Corot, Jean-Baptiste-Camille 106
cotton, as support 154
Courbet, Gustave 94–97, 106
 The Meeting or Good-day Monsieur

Courbet 94–97
craquelure 65, 67, 70, 74, 86
 caused by bitumen 81
 caused by mastic varnish 93
crimson, alizarin 102, 104, 125, 130, 131
cross-hatching 31
Cubism 136, 146

D

Dada Movement 160
Dali, Salvador 152–153
 The Persistence of Memory 152–153
damask, as support 154
Daumier, Honoré 118
Death of Acteon, The 34–37
decalcomania 160, 161
Degas, Edgar 102, 110–113, 128, 142
 Après le Bain, Femme s'Essuyant (After the Bath, Woman Drying Herself) 110–113
Delacroix, Eugène 76, 82–85, 106, 110, 114, 118
 Taking of Constantinople by the Crusaders 82–85
Déjeuner sur l'herbe (Manet) 98–107
 smaller version 99
 Monet's version 102
Derain, André 132
Descamps 54
Devereux, Robert 39
diluent
 turpentine 18, 52
distemper 74
distilled water 38
Doesburg, Theo van 158
Dominguez, Oscar 160
drying catalysts 18, 37, 66
drying times
 of acrylic 180, 182
 of encaustic 168
 of oil 18, 20, 37, 66
 of tempera 14, 16
Duccio 14–17
 The Virgin and Child with Saints Dominic and Aurea 14–17
Duke of Anjou 38
Dutch Masters 118
Dyck, Sir Anthony van 66

E

earth pigments 34, 40, 49, 81, 88, 89, 94, 95, 118
 Cologne 56
 green 13, 14, 16, 22, 23, 25
 red 10, 13, 34
 transparent 76, 77, 78
easel 61, 154
 portable 132
Effet d'Automne à Argenteuil 102–105
Eiffel Tower 161, 162

El Greco 43, 44–47
 Christ Driving the Traders from the Temple 44–47
Elizabeth I 38
emerald green 102, 106, 114, 118, 125, 128
 first introduced 92
emulsion, oil and glue 60
enamel paint 164, 166, 167, 168, 169
 commercial 172
encaustic 168, 169, 170
Ernst Max 160–163
 Vox Angelica 160–163
ermine
 for brushes 48
Empire State Building 161, 162
Expressionism 122
Eyck, Jan van 18–21, 30
 The Arnolfini Marriage 18–21

F

fat over lean 103
Fauves, Les 132
Feast of Belshazzar, The 56–59
Fêtes Vénitiennes 64–65
Field, George 92
First Surrealist Manifesto 160
fixative 110
 in collage 136
Flag 168–171, 172
flat wash 25
flax 41
Flemish painting
 influence of 22, 64
Flight into Egypt 12
Florence 160
foil, metal and silver 176
Fragonard, Jean-Honoré 106
frames
 gold 84, 92, 142
 rope 136–138
 wood 92
French Revolution 88
fresco 10, 11, 12, 34, 74, 75
 pouncing in 22
 techniques 13
Frieze of Life 122
frottage 160, 161, 163

G

Gainsborough, Thomas 70–73, 92
 Portrait of the Artist's Wife 70–73
Galérie Simon, Paris 146
gamboge 74, 75
Gauguin, Paul 118, 128–131, 132, 142
 Christmas Night or The Blessing of the Oxen 128–131
gauze, as support 154
genre painting 48, 49
 Dutch 60
gesso 14, 15, 22, 26.

acrylic 182
 for ground 34, 44, 74
 grosso 14
 sottile 14
Getty Tomb II 172–173
Giorgione, Giorgio Barbarelli 34
giornata 10, 11
Giotto 10–13, 15
 The Nativity 10–13
 Flight into Egypt 12
Giovene, Palma 34, 37
glazes 20, 27, 30, 31, 36, 40, 44, 45, 47, 56, 57, 58, 59, 62, 64, 66, 67, 68, 75, 76, 77, 78, 82, 85, 127, 154, 183
glue 22
 animal skin 14, 18, 30, 34
 carpenter's 74
 for ground 52, 56
 rabbit skin 74
Gogh, Vincent van 118–121, 132
 Chair with Pipe 118–121
gold 15, 29, 74, 84
 for background 16
 highlights 22, 24
 leaf 14, 16
 shell 75
Good-day Monsieur Courbet 94–97
Gooseherdess, The 90
gouache 74, 110, 160
Goya, Francisco 48
grattage 160, 161, 162
green
 cobalt 128
 earth *see* earth colours
 emerald *see* emerald green
 viridian *see* viridian
grey 29, 44, 60, 126, 148, 149, 185
 charcoal 112
 grounds 61, 64, 65, 98, 102, 106, 107
grounds
 brown 41, 42, 45, 48, 56, 60
 chalk 18, 30, 52, 132
 commercially prepared 124, 142, 158
 dark 35, 53, 54
 earth coloured 94
 gesso 44
 grey 61, 64, 65, 106, 107
 gypsum 34
 hard 23
 pale 38, 98, 102, 103, 136, 140, 141, 146, 149
 red bole 14
 white 67, 68, 88, 92, 94, 114, 118, 132, 144, 147, 154
Grünewald, Mathias 160, 161
 Isenheim Altarpiece 160, 161
 Concert of Angels 161
guilds
 carpenters' 14
 Delft painters' 60
Guitar Player, The 60–63
gum 74

gum arabic 38
Guston, Philip 168
gypsum 14, 34

H

half tones 34, 70, 80, 98, 99
Hals, Franz 58
Hamilton, Richard 174–177
Towards a Definitive Statement . . . 174–177
hatching 13, 14, 16, 24, 25, 39, 47, 100, 106, 109, 112, 114, 115, 120
Hilliard, Nicholas 38–39
A Youth Leaning Against a Tree Among Roses 38–39
Treatise on the Art of Limning 38
Hockney, David 182–185
Mr and Mrs Clark and Percy 182–185
Holbein, Hans 38, 114
Holman Hunt, William 92–93
The Awakening Conscience 92–93
Hoogh, Pieter de 60
Hopper, Edward 150–151
House by the Railroad 150–151
Hudson, Thomas 66

I

icon art
Byzantine 44
Russian 140
illuminated manuscript 38
illusionism 160, 161
photographic 152
impasto 34, 43, 56, 57, 58, 60, 62, 66, 72, 76, 77, 78, 88, 90, 95, 98, 102, 103, 106, 120, 136, 142, 143, 150, 164
Impressionism 36, 47, 50, 98, 102, 106, 110, 118, 124, 132
influence of 114
indigo 72
infra-red photography 20, 60, 64
Ingres, Jean-Auguste-Dominique 80–81, 110, 114
Oedipus and the Sphinx 80–81
Interior at Antibes 142–145
intonaco 10, 11
iron oxide red 88, 89, 94
Isenheim Altarpiece 160, 161

J

James I 38
Japanese prints 102, 128
Japanese reed pen 118
Javanese art 128
Johns, Jaspar 168–171, 172
Flag 168–171, 172
jeweller's glass 152, 153
Juell, Dagny 122

K

Kennedy, John Fitzgerald 176
Kooning, Willem de 164, 168
Kandinsky, Wassily 140–141
With Black Arch 140–141
Klee, Paul 154–157
Ad Parnassum 154–157
knifework 77, 78, 94, 95

L

lake 37, 38, 47, 66, 67, 70
crimson 35, 54
madder 114, 140
red 56, 76
scarlet 132, 134, 142, 143, 144
transparent 47, 108
vermilion 54
yellow 75
Lamothe, Louis 110
lapis lazuli 16, 60
Le Départ pour le Travail 88–91
lead white *see white*
Léger, Fernand 146–147
Still Life with a Beer Mug 146–147
Leonardo da Vinci 26–29
The Adoration of the Magi 28
The Virgin of the Rocks 26–29
Virgin and Child with Carnation 29
Letraset lettering 176
Leyden 56
Lichtenstein, Roy 178–181
Whaam! 178–181
lime white *see white*
limning 38
linen 14
lining paste 35
linseed oil *see oils*
lithography 128
Louvre, Paris 26, 132

M

madder 74
pinks 112
lakes 114, 140
Madrid 48
magazines used in collage 174, 175
Magna acrylic 178, 180
magnifying glass 38
mahl stick 61, 152, 153
mahogany 74
malachite 10, 20, 31, 35
Malta 40
Mander, Karel van 30
Manet, Edouard 98–101, 102, 106, 128
Déjeuner sur l'Herbe (The Picnic) 48, 50, 98–107
Olympia 98
Mannerist painters 44
Marchi 68
Martinique 128
masking 176, 177, 178, 180
Matisse, Henri 132–135
Portrait of André Derain 132–135
Medievalism 92
medieval painting 14, 18
medium
aqueous 18, 30
lean oil 52, 53
quick drying 110
thick oil 45
wax 66
Meeting, The 94–97
megilp 68
Merisi, Michelangelo *see Caravaggio*
metals 32
Metsu, Gabriel 60
Michelangelo 44, 66, 88
Millais, John Everett 92
Millet, Jean 88–91, 118
Le Départ pour le Travail (Walk to Work) 88–91
The Gooseherdess 90
minever brushes 13, 26
miniature painting 38
Mondrian, Piet 158–159
Composition with Red Yellow and Blue 158–159
Monet, Claude 94, 98, 102–105, 106, 110, 114
Effet d'Automne à Argenteuil (Autumn at Argenteuil) 102–105
Déjeuner sur l'herbe 102
alla prima technique 142
mordant 14, 16
mosaic effect 154, 155, 156
Mr and Mrs Clark and Percy 182–185
Munch, Edvard 122–123
Jealousy 122–123
Frieze of Life 122
murrey 38
mythology, Oceanic 128

N

Naples 40
naptha 37
National Gallery, London 22, 26
Nativity, The 10–13
order of painting 11
Naturalism 18
Nature Morte avec l'Amour en Plâtre 124–127
Neoclassicism 80, 81, 82
Neo-Impressionism 118
Netherlandish painters 18, 40
painting of 30, 52
techniques of 53
New York 158, 161, 162
Newman, Barnett 168
newsprint for collage 168, 169, 170
Nice 132
Northern painting 30, 33

O

oak panels 18, 30, 52, 53
ochres 10, 31, 41, 49, 56, 58, 74, 91, 94, 97, 131, 136, 137
red 44, 56
orange 104
yellow 52, 66, 114, 128
oils 18, 29, 30, 40, 43, 45, 47, 52, 132
linseed 18, 26, 37, 40, 43, 44, 48, 52, 68
poppy 72, 92
stand oil 92
walnut 25, 26, 37, 43, 52
Old Masters 66, 74
influence of 76, 84, 92, 98, 132
Olympia 98
orange 82, 131
cadmium 132, 134, 147
in pastels 111, 112
orpiment 35, 66
oscillation 160, 161, 162
overdrawing 123, 136
overpainting 13, 26, 77, 78, 124, 144, 175, 177

P

Pacheco, Francesco 44
painting techniques *see techniques*
paint tubes 102
palette knife 44, 94, 128
for covering ground 48
for scraping down 142, 143, 144
for applying encaustic 168
panel painting 18, 26, 27, 44
Italian 18
on oak 18, 30, 52
paper
coloured 124, 158
as support 110
blotting 110
textured 114
pastel 110, 112
as frottage support
160
as grattage support 160
non-pressed 111
Paris 26, 98, 118, 132, 152, 161, 162
Parmigianino, Francesco Mazola 44
pastels 88, 110–113, 184
effects similar to 102, 107
pens
Japanese reed 118
reed 74
pen and ink 26, 30, 76
pencil 38, 74, 84, 160, 174
underdrawing 76, 172
preparatory drawing 176
perspective 13, 22, 30, 46, 76, 93
Duccio on 22
in Cubism 136
Peru 128
Persistence of Memory, The 152–153
Perugino, Pietro 22
Philip II of Spain 34, 44
Philip IV of Spain 48
portrait of 50
photography 174
Picasso, Pablo 136–139
Still Life with Chair Caning 136–139
Picnic, The (Manet) 98–101
picture plane 37
Piero della Francesca 22–25
The Baptism of Christ 22–25
St Michael 25
pigments *see under individual colours*
Pissarro, Camille 106, 124, 128
plaster 10, 11, 12, 13, 14
Pointillism 82, 114, 116
Pollock, Jackson 164–167
Autumn Rhythm 164–167
Pont Aven artists 118
Pop Art 168, 174
popular wood 22, 23
Portrait of André Derain 132–135
Portrait of Susanna Lunden née Fourment 52–55
porcelain 106
portraiture, French court 38
portrait painting 18, 48, 61, 64, 70, 182
Post-Impressionists 132
pouncing 22, 24
Poussin, Nicholas 88, 110, 114
Pre-Raphaelite Brother-hood 92
primary colours 158, 178
priming
acrylic gesso 182
brown 52
commercial 95
flesh coloured 30
grey 66
tinted 106
Pryzybyszewski, Stanislaw 122, 123
purple 112

Q

Quattrocento 92
quill 13, 38, 74

R

Raphael 92
Realism 88
Realist
movement 94
painting 98, 152
technique 153
realgar 35
red 38, 123
alizarin 106, 114, 128
bole 14
cadmium 158
chalk 26
earth *see earth pigments*
lake 31, 40, 45, 47
reflex camera 60
Rembrandt van Rijn 40, 56–59, 60, 76
The Feast of Belshazzar: The Writing on the Wall 56–59
Renaissance 22, 26, 40
stage design 45
Renoir, Pierre Auguste 102, 106–109, 110, 124
Torse de Femme au Soleil (Woman's Torso in Sunlight) 106–109
resin
for binding ground 56
copal 92
in acrylic colours 180
in encaustic colours 168
for making varnish 37, 52
mastic 68
Reynolds, Joshua 66–69, 70
Mrs Hartley as a Nymph with Young Bacchus 66–69
Rococo 64, 106
Romanticism 84
Rome 10, 40
Rossetti, Dante Gabriel 92
Royal Academy, London 70, 174
Summer Exhibition 1790 84
Rubens, Peter Paul 52–55, 56, 76, 82, 106, 110
Portrait of Susanna Lunden née Fourment 52–55
ruler 158

S

sable brushes 26, 77
St Michael 25

saturation 19, 24
scalpel 174
sculpture, Classical 66
scumbling 52, 58, 70, 72, 75, 77, 78, 83, 84, 86, 88, 89, 90, 92, 94, 95, 98, 102, 106, 109, 110, 122, 123, 125, 141, 142, 143, 183, 184
secco fresco 10, 11, 12
Seurat, Georges 114–117
Une Baignade, Asnières (Bathers Asnières) 114–117
Seuphor, Michel 158
Seville 48
Sicily 40
sienna 114, 137
Signorelli, Luca 22
silk as painting support 154
silver
foil 176
leaf 39
paint 174, 175, 176
sinoper 10, 14, 16
sinopia 10
Sisley, Alfred 106
size 14, 30, 52, 67
for ground 132
on canvas 34, 44, 56, 60, 146
preparation of 34, 64, 65
Slade School of Art 174
smalt 56, 60
sticks for applying paint 164, 166
Stella, Frank 172–173
Black Paintings 172, 173
Getty Tomb II 172–173
stencilling 175, 178
still life 100, 118, 124–127, 132
Still Life with a Beer Mug 146–147
Still Life with Chair Caning 136–139
Still Life with Plaster

Cast 124–127
stoat hair brushes 48
stippling 24, 60, 88
stretcher 60, 61, 76, 158, 172, 173, 182
Strindberg, August 122
supports
bed sheet 168
canvas 34
canvas on cardboard 154
cardboard on wood 154
coloured paper on canvas 154
cotton on cardboard 154
damask on cardboard 154
gauze on cardboard 154
linen 76
movement of 74
playing card 38
silk on cardboard 154
used for colour 39
vellum 38
wood 52
Surrealist
movement 152, 160
images 153

T
tabernacle 15
tape, adhesive 158, 160, 174, 177, 180
techniques
blending 47, 54, 78
dabbing 34, 36, 38, 47, 95, 131
dragging 77, 103
dripping 164, 165, 166, 167
fat over lean 70
glazing 84, 92, 141
scraping down 34, 142, 143, 144, 150
scratching 122
splattering 164, 165, 166
stippling 95, 179

U
ultramarine 16, 23, 29,

wet into wet 66, 67, 71, 95, 98, 100, 102, 104, 106, 107, 109, 117, 118, 119, 124, 130, 131, 132, 134, 136, 142, 143, 144
wet over dry 84, 85, 102, 104, 107, 114, 115, 128, 129
see also hatching, impasto, scumbling, underdrawing
tempera 11, 14, 15, 16, 20, 22, 24, 74, 103, 154
mixing pigments 12
Theophilus 18
Theotokopoulos, Domenikos see El Greco
Tintoretto, Jacopo Robusti 44
Titian 34–37, 56
The Death of Acteon 34–37
Toledo 44
Torse de Femme au Soleil 106–109
Towards a Definitive Statement . . . 174–177
transfer lettering 174, 176, 177
transparencies 72
transparency of pigments 18, 19, 20, 24, 80
Treatise on the Art of Limning 38
trowel as painting implement 164, 166
Turner, William 84–87
Snowstorm 84–87
turpentine 18, 37, 43, 52, 66, 68, 74, 84, 92, 106, 110, 122, 123, 150
turquoise 112

35, 38, 46, 60, 62, 66, 74, 102, 106, 112, 114, 118, 124, 125, 128
umber 38, 52, 60, 70, 78, 96
burnt 88, 89
raw 80, 88, 90
undercoat paint, household 174–176
underdrawing 11, 13, 20, 22, 25, 27, 30, 31, 38, 52, 53, 60, 74, 75, 76, 122, 123, 140, 146, 148, 181
undermodelling 11, 12, 16, 25, 26, 27, 28, 68
underpainting 10, 14, 16, 22, 23, 30, 34, 44, 45, 56, 60, 62, 84, 98, 99, 185
Une Baignade, Asnières 114–117
Utrecht School 60

V
varnish 19, 26, 35, 37, 49, 52, 66, 67, 68, 70, 74, 82, 84, 92, 93, 94, 98
Vasari, Giorgio 34
Velazquez, Diego Rodriguez de Silva 48–51, 98
The Water Seller of Seville 48–51
Philip IV of Spain 50
vellum 38, 39
Venetian
art 34, 82, 84
masters 22, 48, 56, 64
Veneziano, Domenico 22
Venice 34, 44, 45
verdigris 20, 23, 31, 35, 37
Vermeer, Jan 60–63, 153
The Artist's Studio 61
The Guitar Player 60–63

vermilion 35, 41, 54, 56, 58, 66, 67, 74, 75, 86, 102, 106, 114, 118, 123, 125, 128, 129, 130, 131, 132, 134, 140, 142, 143, 144, 147
Veronese, Paolo Caliari 82
Verrocchio, Andrea del 26
violet 67, 140
cobalt 102, 114, 118, 128, 132, 134
Virgin and Child with Carnation 29
Virgin of the Rocks, The 26–29
viridian 94, 95, 102, 104, 106, 112, 114, 118, 124, 125, 128, 130, 131, 132, 133, 134
Vleughels, Nicholas 64, 65

W
Walk to Work, The 88–91
walnut oil 25, 26
warping 18
washes 25, 34, 39, 70, 71, 72, 76, 82, 84, 100, 122, 123
water 88, 182
watercolour 74, 82, 154
Water Seller of Seville, The 48–51
Watteau, Antoine 64–65
Fêtes Vénetiennes 64–65
wax 39, 67, 68, 128
as medium 66, 168
models 44
Whaam! 178–181
white 14, 16, 17, 18, 19, 20, 31, 32, 34,

38, 44, 62, 66, 70, 85, 86, 102, 104, 117, 123, 128, 131, 132, 140, 149, 164, 165, 174, 179, 184, 185
Cremona 72
flake 106, 112
lead 28, 31, 32, 34, 36, 42, 45, 46, 47, 50, 54, 56, 58, 59, 60, 62, 65, 66, 94, 118, 124, 125
lime 12, 13
zinc 128, 130
With Black Arch 140–141
Woman's Torso in Sunlight 106–109
wood as support 14, 15, 18, 22, 52, 74
wood carving 128

X
X-radiograph (X-ray photograph) 28, 34, 36, 40, 42, 51, 54, 62, 64, 110

Y
yellow 20, 32, 38, 44, 45, 84, 85, 86, 123, 179
cadmium 102, 114, 118, 124, 128, 147, 158
chrome 106, 111, 117, 124, 125, 128, 132, 134
lake 75
lead tin 29, 31, 35, 41, 56, 60
lemon 136, 137
Naples 66, 106, 112, 124, 125, 128
ochre 13, 52, 66, 114, 128
Youth leaning Against a Tree Among Roses, A 38–39

Acknowledgements

Key: *P* Portrait; *SP* Self portrait; *W* Main work; *CW* Comparative work; *S* Study; *X* X-ray or infra-red; *PS* Photographic study.

Giotto *P* by Benedetto da Maiano, Duomo, Florence (Photo Scala, Florence); *W*, *CW* Arena Chapel, Padua (Photo Scala). **Duccio** *W* National Gallery, London. **Van Eyck** *SP*, *W*, *X* National Gallery, London. **Piero della Francesca** *W*, *CW* National Gallery, London. **Leonardo da Vinci** *SP* Biblioteca Reale, Turin (Photo Scala); *W* National Gallery, London; *CW* reproduced by gracious permission of Her Majesty Queen Elizabeth II (Windsor Castle, Royal Library); Uffizi (Photo Scala); Alte Pinakothek. **Bosch** *SP* from the Codex de la Bibliothèque d'Arras (Photo Giraudon, Paris); *CW* Berlin-Dahlem Kupferstichkabinett, Inv. no. 550r (Photo Bildarchive Preussischer Kulturbesitz, Berlin); *W* Museum voor Schone Kunsten, Ghent. **Titian** *SP* Museo del Prado, Madrid (Photo M & W Fine Arts, Madrid); *W* National Gallery, London. **Hilliard** *SP*, *W* Crown Copyright, Victoria and Albert Museum, London. **Caravaggio** *P* by Leoni, Biblioteca Marucelliana, Florence (Photo Scala); *W*, *X* National Gallery, London. **El Greco** *SP* Metropolitan Museum of Art, NY; *W* National Gallery, London. **Velazquez** *SP* Uffizi, Florence (Photo Scala); *W* Wellington Museum, Apsley House, London; *X* National Gallery, London. **Rubens** *SP* Graphische Sammlung Albertina, Vienna; *W*, *X* National Gallery, London. **Rembrandt** *SP*, *W* National Gallery, London. **Vermeer** *SP*, *CW* Kunsthistorisches Museum, Vienna; *W* The GLC as Trustees of the Iveagh Bequest, Kenwood, London. **Watteau** *P* by Boucher, Musée Condé, Chantilly (Photo Giraudon); *W* National Gallery of Scotland, Edinburgh (Tom Scott Photography). **Reynolds** *SP*, *W* Tate Gallery, London. **Gainsborough** *SP* National Portrait Gallery, London; *W* by courtesy of the Trustees, Courtauld Institute Galleries, London; *X* Technical Department of the Courtauld Institute. **Blake** *P* by J. Linnell National Portrait Gallery, London; *W* Tate Gallery. **Constable** *P* by D. Maclise, National Portrait Gallery; *S* Crown Copyright, Victoria and Albert Museum; *W* Tate Gallery. **Ingres** *SP* Uffizi (Photo Scala); *W* National Gallery, London. **Delacroix** *SP* Uffizi (Photo Scala); *W* Louvre, Paris; *S* Cabinet des Dessins, Paris.

Turner *SP*, *W* (and paint box) Tate Gallery. **Millet** *W* Glasgow Art Gallery and Museums; *CW* Private Collection, Japan. **Holman Hunt** *P* by W. B. Richmond, National Portrait Gallery; *W* Tate Gallery. **Courbet** *SP* Musée Petit Palais, Paris (Photo Cooper Bridgeman Library); *W* Montpellier – Musée Fabre (Photo Claude O'Sughrue). **Manet** *W* Courtauld Institute Galleries; *CW* Louvre, Paris. **Monet** *P* by Renoir, Louvre (Photo Cooper Bridgeman Library); *W* Courtauld Institute Galleries. **Renoir** *P* Snark International, Paris; *W* Courtauld Institute Galleries. **Degas** *P* Snark; *W* National Gallery, London. **Seurat** *W* National Gallery, London. **Van Gogh** *W* Tate Gallery. **Munch** *SP* National Gallery, Oslo (Photo Cooper Bridgeman Library); *W* Rasmus Meyer Collection, Bergen. **Cézanne** *SP* National Gallery; *W* Courtauld Institute Galleries. **Gauguin** *SP* Norton Simon Collection, Los Angeles (Photo Cooper Bridgeman Library); *W* Private Collection, Lausanne. **Matisse** *SP* Statens Museum for Kunst, Copenhagen; *W* Tate Gallery. **Picasso** *SP* The A. E. Gallatin Collection, Philadelphia Museum of Art; *W* Property of the French Nation, eventually to be housed in the Museum of Picasso. **Kandinsky** *P* Bettman Archive Inc, NY; *W* Museum of Modern Art, Paris. **Bonnard** *W* Tate Gallery. **Léger** *P* Musée National Fernand Léger, Biot; *W* Tate Gallery; *S* Private Collection, France. **Hopper** *W* Museum of Modern Art, NY. **Dali** *W* Museum of Modern Art, NY. **Klee** *SP* Collection Felix Klee, Bern; *W* Kunstmuseum, Bern (Photo Hinz). **Mondrian** *SP* Collection Haags Gemeentemuseum, The Hague; *W* Tate Gallery. **Ernst** *P* Popperfoto, London; *W* Acquavella Galleries, NY (Photo Otto Nelson, NY). **Pollock** *W* Metropolitan Museum of Art, NY. **Johns** *W* Museum of Modern Art, NY. **Stella** *W* Los Angeles County Museum of Art, Purchased with Contemporary Art Council Funds. **Hamilton** *W* Tate Gallery; *S* Private Collection. **Lichtenstein** *P* Popperfoto; *W*, *S* Tate Gallery. **Hockney** *P* Popperfoto; *W*, *S* Tate Gallery © The Artist; *PS* Tate Gallery Archives © The Artist.

© by S.P.A.D.E.M., Paris, 1980: Matisse, Monet, Degas, Picasso, Ernst, Léger, Mondrian
© by A.D.A.G.P., Paris, 1980: Dali, Bonnard, Kandinsky
© 1980, COSMOPRESS, Genève and S.P.A.D.E.M., Paris: Klee